GUIDE TO CAMERA EQUIPMENT
By Mike Stensvold

SPECIALTY PUBLICATIONS

LEE KELLEY
Editorial Director

JACKIE ANDERSEN
Managing Editor

SUSIE VOLKMANN
Art Director

LINNEA HUNT-STEWART
Copy Editor

LINDA SARGENT
Copy Editor

ANNE SLATER
Copy Editor

FERN CASON
Editorial Coordinator

COVERS:

Front cover: Bob D'Olivo, PPC Director of Photography, made this double exposure on Kodak Ektachrome 6118 Professional (Tungsten) sheet film using a Calumet 4 x 5 view camera. The first exposure was of tungsten-lit camera equipment at a slow shutter speed to blur the hand removing the camera. The second exposure was of light coming through a small hole in a black card using a star filter to produce the star effect. The photo shows some of the many types of equipment available and discussed in this book, including various cameras, lenses, filters, meters, lighting equipment, tripods, and camera cases.

Back cover: Mike Stensvold used Ascor studio flash units and a 100mm lens on a 35mm camera to shoot these pictures. The photo of the Larson Reflectasol umbrella mounted on an Ascor studio flash head and the photo of the Olympus OM-2 35mm camera with motor drive, 250-exposure bulk-film back and Olympus and Sunpak flash units were made using Kodak Kodachrome 64 film. The photo of actress Duchess Dale taken with an Omega view camera was made using Kodak Ektachrome 64 film.

GUIDE TO CAMERA EQUIPMENT
Vol. 6—Petersen's Photographic Library

Copyright 1981 by Petersen Publishing Company, 8490 Sunset Blvd., Los Angeles, CA 90069. Phone: (213) 657-5100. All rights reserved. No part of this book may be reproduced without written permission. Printed in the U.S.A. This book is purhcased with the understanding that the information presented is from many varied sources from which there can be no warranty or responsibility by the Publisher as to accuracy or completeness.

Library of Congress
Catalog Card Number 81-82483

ISBN 0-8227-4055-9

PHOTOGRAPHIC MAGAZINE

PAUL R. FARBER/Publisher
KAREN GELLER-SHINN/Editor
ALLISON EVE KUHNS/Art Director
MIKE STENSVOLD/Technical Editor
MARKENE KRUSE-SMITH/Senior Editor
BILL HURTER/Feature Editor

ROD LONG/Associate Editor
FRANKLIN D. CAMERON/Managing Editor
PEGGY SEALFON/East Coast Editor
CINDY GOSSERT/Assistant Art Director
NATALIE CARROL/Administrative Assistant
LINDA NIELSEN/Editorial Secretary

PETERSEN PUBLISHING COMPANY

R. E. Petersen/Chairman of the Board
F. R. Waingrow/President
Robert E. Brown/Sr. Vice President, Publisher
Dick Day/Sr. Vice President, Hot Rod Division
Jim P. Walsh/Sr. Vice President,
National Advertising Director
Robert MacLeod/Vice President, Publisher
Thomas J. Siatos/Vice President, Group Publisher
Philip E. Trimbach/Vice President, Financial Administration
William Porter/Vice President, Circulation Director
James J. Krenek/Vice President, Manufacturing
Leo D. LaRew/Treasurer/Assistant Secretary
Dick Watson/Controller

Lou Abbott/Director, Production
John Carrington/Director, Book Sales and Marketing
Maria Cox/Director, Data Processing
Bob D'Olivo/Director, Photography
Nigel P. Heaton/Director,
Circulation Marketing & Administration
Al Isaacs/Director, Corporate Art
Carol Johnson/Director, Advertising Administration
Don McGlathery/Director, Advertising Research
Jack Thompson/Assistant Director, Circulation
Vern Ball/Director, Fulfillment Services
Jay Hillis/Director, Non Auto Subscription Sales
Robin Sommers/Director, Auto Subscription Sales

Guide to Camera Equipment

Introduction

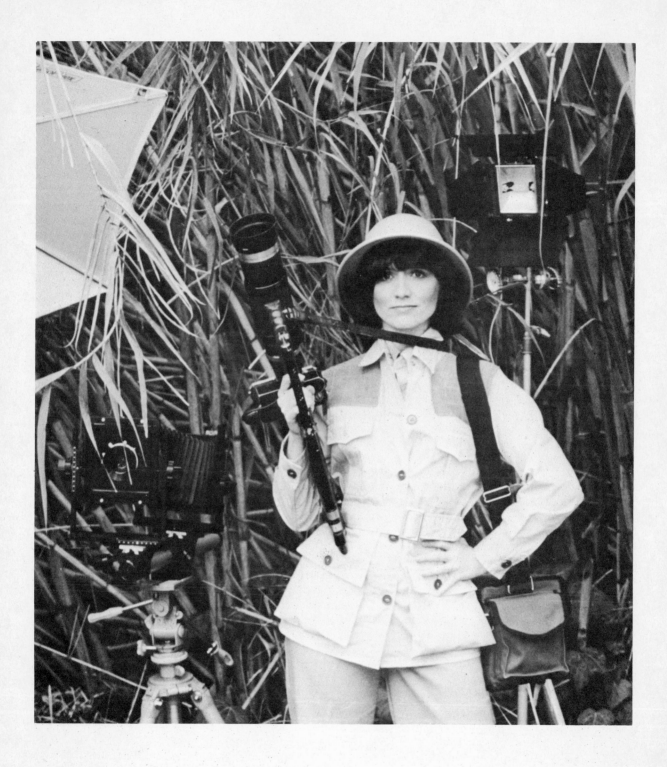

What so many novice (and experienced) photographers seek as they explore the often baffling world of photography, is a book that will explain what types of equipment are available and how they operate. You hear about view cameras, SLRs, bellows, diopters, and so on, but understand little of what they are. Even those who have a vague notion of what they are, may have no idea as to which advantages they do and do not provide.

To the uninitiated, advertisements that sing the praises of dedicated flash, programmed exposure control, and digital spot meters, only serve to further confuse. What exists is an overwhelming abundance of information on various types of equipment you can buy, but there is little on what they are, or how and why they are used.

The purpose of *Petersen's Guide to Camera Equipment* is to inform you of the types of camera equipment that exist, how they function, and what is involved in putting them to use. By learning these things, you will be able to determine what equipment you will need to enable you to produce the photographs you want to produce. You might even get some new photographic ideas from the discovery of a certain piece of equipment.

This book is not a buyer's guide listing or a compilation of manufacturer's specifications and prices. These change so rapidly that the book would be obsolete before we could get it to you. Neither is it a comprehensive explanation of each variety of a certain type of camera equipment.

This book is a user's guide, a how-to guide. While whole books can be written concerning any one of the types of camera equipment available (in fact, Petersen's Photographic Library includes individual books about photo filters, electronic flash, and other equipment and its uses) the purpose of this book is to introduce you to that equipment. After you have read this book, you should have a firm grasp on what there is, how it works, and, best of all, what it can do to expand and enlighten your photographic skills.

What's the Best . . . ?

There is no "best" equipment. Ask ten professional photographers what camera they use, and you are likely to get ten different answers. Ask them what lenses they use, and again you will probably get several answers. Each uses what he has found best suits his specific needs.

Once you know what basic features you want, go to your local camera store and try out various examples of the equipment. See which brand name feels best, which is easiest to use. If it suits your pocketbook, performs as you want it to, and is easy to use, then it is the "best" piece of equipment for you.

Never make a major purchase without actually trying the piece of equipment you intend to buy. The state of the art in photographic equipment design and manufacture today is such that nearly everything is at a fairly high standard. But every now and then, a "lemon" appears, so by trying it before buying it, you can ensure that you aren't stuck with that rare lemon. (If your local camera store won't let you try the equipment in the store, then it should offer a guarantee that if a piece of equipment isn't satisfactory, you can exchange it or have your money refunded. The same goes for mail order—obviously you can't try the equipment before buying it.)

Never forget that camera equipment is merely a collection of tools you use to record what your mind envisions. Your equipment doesn't create a photograph any more than a painter's brushes, palette, and easel create his painting. However, the right tools are important. The painter must have his brushes and mixing palette, and know how to use them, just as you the photographer must know what equipment to use and how to use it, if you are to transform concept into physical form.

Finally, whatever piece of camera equipment you use, read the instruction book that comes with it before putting the equipment to use. This will prevent: 1) something breaking, and 2) a picture being lost because of improper equipment use.

Cameras

The camera is the essential piece of camera equipment. You can make a photograph without any other piece of equipment in this book, but you do need a camera (a pinhole camera will produce a photograph without a lens). Everything else described here merely permits you to create special kinds of photographs, or makes it easier to take them.

Although there are all sorts of cameras, most professional and serious amateur photographers today use just a few types. These are the 35mm single-lens reflex (SLR) camera, the medium-format single-lens reflex camera, the large-format view and field cameras, and the 35mm interchangeable-lens rangefinder camera. There are some pros and serious amateurs who use other types, but these are the most popular among serious photographers.

The 35mm cameras are hand cameras. They

This is a greatly enlarged print made from a small section of a negative. The more you enlarge the image produced by the camera, the fuzzier and grainier the result will be.

are quick and convenient, giving the photographer freedom to move about and capture slices of life. Yet, they are fully capable of producing professional results in almost all types of photography. The 35mm SLRs offer the most extensive systems of lenses and accessories, and can do just about anything except produce a large negative or transparency in camera.

Medium-format SLRs offer some of the quickness and convenience of the 35mm camera, while producing larger negatives and transparencies that yield even better quality enlargements. Large-format view cameras (and their more portable kin, the field cameras) give the knowledgeable photographer complete control over his image.

Camera Formats

One way that cameras are classified is by format—the size and shape of the image they produce on the film. On the facing page are the sizes and shapes of some of the more popular camera formats.

The camera format is important because it has a direct bearing on the quality of the image produced. Using the same kind of film, the larger the format, the better the image quality, because less image enlargement is required to produce a given size print. As you can see from the accompanying photo, if you enlarge the image a great deal, it becomes grainy and fuzzy. That's why the full-frame 35mm format is the smallest format used by professional photographers. Anything smaller will not produce the image quality they need.

Another important advantage to larger formats is that they offer a larger image in the viewfinder, and this larger image is easier to examine for those fine details that can make the difference between a good photograph and a great one.

Of course, the larger the format, the bulkier the camera. When photographing fast-breaking news stories or sports events, you don't have time to examine the image in the viewfinder for fine details; here, speed of operation is of more importance. This is where the 35mm camera really shines. There is a reason for each format, although it may not be right for you. Many professional photographers use 35mm cameras for

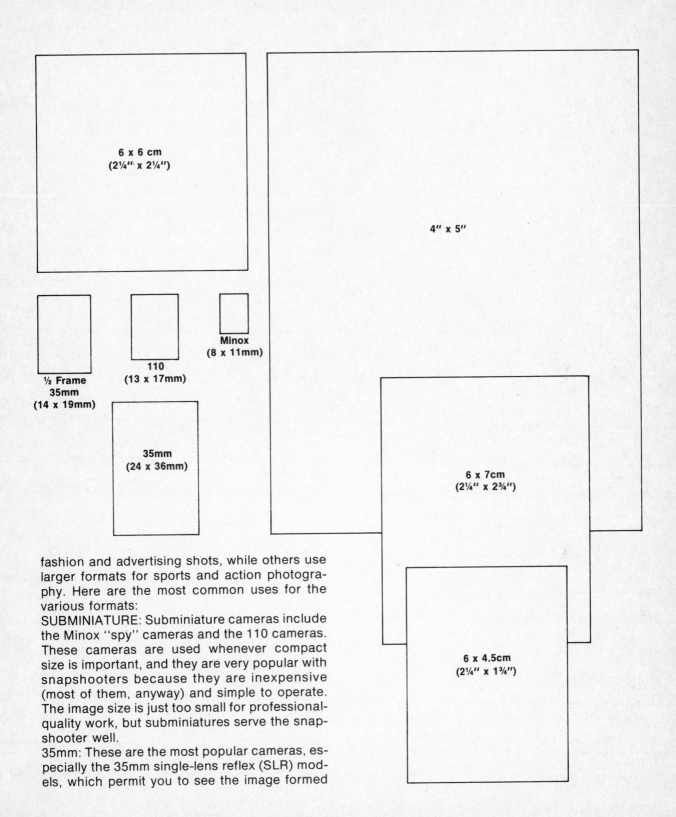

fashion and advertising shots, while others use larger formats for sports and action photography. Here are the most common uses for the various formats:

SUBMINIATURE: Subminiature cameras include the Minox "spy" cameras and the 110 cameras. These cameras are used whenever compact size is important, and they are very popular with snapshooters because they are inexpensive (most of them, anyway) and simple to operate. The image size is just too small for professional-quality work, but subminiatures serve the snapshooter well.

35mm: These are the most popular cameras, especially the 35mm single-lens reflex (SLR) models, which permit you to see the image formed

by the lens when you look into the viewfinder (more on this later). While a 35mm camera won't produce the same image quality as a good larger format camera when the same film is used, it will produce sufficient image quality for a tremendous amount of professional work. The great advantages of the 35mm format cameras include light weight, speed and ease of operation, extensive lines of lenses and accessories, and a great variety of available film emulsions. These cameras come in full-frame and half-frame varieties; the latter aren't nearly so common as they once were, and since their only real advantage is that they get 72 exposures on a 36-exposure roll of film, (and this is offset by reduced image quality), their decline in popularity is not surprising.

MEDIUM FORMAT: These are the cameras that use 120-size film, producing images 6 x 4.5cm, 6 x 6cm, 6 x 7cm and occasionally 6 x 9cm on the film. Medium-format cameras are more expensive than smaller-format cameras, and they offer a substantial line of lenses and accessories (although not as many as 35mm SLRs). Their larger image and viewfinder size and their quality make them quite popular with professional photographers.

LARGE FORMAT: These, for the most part, are the cameras that use 4 x 5-, 8 x 10-, and 11 x 14-inch sheet film. They include view cameras, which provide maximum image control but are virtually impossible to use without a tripod; field cameras, which are lighter, more compact view cameras; and various other cameras that aren't widely available. These cameras are popular with scenic, architectural, studio, commercial, portrait, and "art" photographers who specialize in subjects that don't move.

Loading Film Into Cameras

As the camera format increases in size, the complexity of loading film into the camera also increases. Subminiature cameras are simple to load; just drop the film cartridge into place. The 35mm cameras require threading the film leader onto the camera's take-up spindle; after you've done it a couple of times, it will become second nature.

Medium-format cameras use wider (and therefore more awkward to handle) film that comes in rolls rather than in cassettes like 35mm film, and you have to thread this film into the magazine that holds it. It might take a few more times to get the hang of loading a medium-format camera, but it too will become second nature.

Putting film in a 35mm camera involves a fairly simple series of steps. First, open the camera back for access to the film compartment.

Drop the cassette into its place, and attach a leader to the take-up spindle.

Operate the film advance until the full width of the film catches the sprockets at the top and bottom, then close the camera back and operate the film advance until frame number one appears in the frame-counter window.

When the entire roll has been exposed, be sure to rewind the film into the cassette before opening the camera, or you will fog the film.

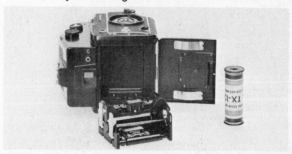

To load a medium-format camera, open the camera back or magazine (as applicable), and remove the film holder.

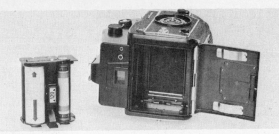

Insert the film roll on the supply side of the film holder, thread the film around the film plate, and attach the end of the film to the take-up spool (see the camera instruction book for specifics for a particular camera).

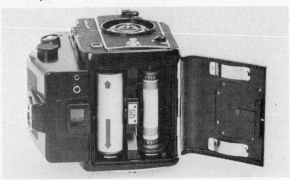

Put the film holder into the camera or magazine, and close the back, then wind the film until number one appears in the frame-counter window. When a 120/220 film roll has been exposed, continue winding until the film comes off the supply spool, and remove from the camera.

To load a large-format sheet-film holder, pull out the dark slide to gain access to the holder. The operation must be done in absolute darkness or the film will be fogged.

Insert a sheet of film, emulsion side facing out. (Since you can't see in the dark, you can identify the emulsion side by feeling the notch in the film. If the notch is in the upper left corner, or in the lower right corner, the emulsion side is facing you. The notch is coded, to tell you what type of film it is by feel.) Be sure to get the film under the slots on both sides of the holder.

Lift the end piece of the holder, and let the film slip under it, then lower the end piece to a flat position on the film.

Reinsert the dark slide, this time with the silver side of the handle out.(Silver indicates unexposed film in holder; the black side indicates exposed film in the holder. You can gently shake the holder to tell if there is film in it.) Now, turn the holder over and repeat the process to load second sheet on the other side.

Loading a Polaroid film holder for a large-format camera is done in light, with the holder on the camera (here, it's shown off-camera for clarity). Put a large silver lever in the load position, and insert a sheet of Polaroid film as far as it will go.

Pull the paper backing out to stop. The film is now ready for exposure.

Slide the paper backing back in as far as it will go after exposure, move the silver lever to the P (process) position, and pull the film sheet out. Rollers in the holder will break the processing pod in the film pack to initiate instant-film processing. Note: Just before the metal tab on the end of the film packet reaches the rollers, flip the lever to the L (load) position, to save wear on the rollers as the tab passes them.

Large-format cameras require loading sheets of film into sheet-film holders, which are then attached to the camera for exposure. The problem here is that this must be done in absolute darkness, by feel rather than by sight, so this is the most difficult loading operation. Each sheet-film holder holds only two sheets of film, so you need 12 of them if you intend to make 24 exposures (something you could do on one roll of 35mm or 220-size medium-format film). Reloading the holders in the field requires use of a changing bag, and this makes the loading operation even more awkward. However, sheet film is not without advantage; each exposure can be processed individually if desired, a great boon to the black-and-white "art" photographer who wants to "custom-tailor" his processing of each exposure to get the best possible results.

Viewing and Focusing Systems

Another way to classify cameras is by the type of viewing and focusing systems they use. There are several types, and each has its pluses and minuses.

REFLEX SYSTEMS: Reflex systems employ a

viewed appears to be on the left, and vice versa. Even more troublesome, a subject moving from left to right will appear to be moving from right to left in the viewfinder. To correct this, virtually all 35mm SLRs have pentaprism viewfinders, which contain more mirrors and produce a laterally correct image in the viewfinder (see drawing No. 2). Many medium-format single-lens reflex cameras offer prism viewfinders as options as well.

There are some disadvantages to the single-lens reflex system. In order for the image formed by the lens to get to the film, the mirror that reflects it up to the viewfinder has to get out of the way. When you press the shutter release on a single-lens reflex camera, the first thing that happens is the mirror does just that—it flips up out of the way, so the light can reach the film (see drawing No. 3). However, in doing so, it has disadvantages. First, it creates some vibration, which can be a problem when doing close-up work at high magnifications or making long exposures with a super-telephoto lens, where everything is magnified, the image, and any camera or subject movement. Second, it makes

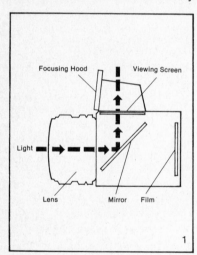
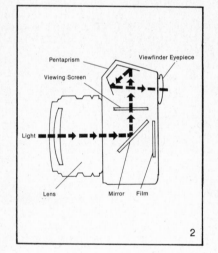
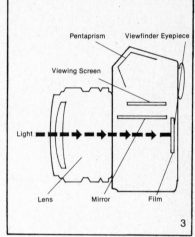

mirror that reflects the image formed by the lens up onto a focusing screen. (Remember: reflex = reflects.) There are two basic types: single-lens reflex, and twin-lens reflex. In the single-lens reflex (SLR) camera, the image formed by the lens is reflected up onto the focusing screen by a mirror, as shown in drawing No. 1. The obvious advantage to this type of system is that what you see in the viewfinder is just what will appear on the film—the image formed by the lens.

Whenever a mirror reflects something, it reverses it laterally—producing a "mirror image"—so that the right side of the subject being

noise, which can be a problem if you want to shoot incognito. Third, it blocks your view through the viewfinder, since you can see through the viewfinder only when the mirror is in the down (viewing) position.

The problem of the blocked view through the viewfinder is minimized in 35mm SLRs by a feature known as the instant-return mirror. On some larger-format SLR cameras, the mirror stays up after exposure until you recock the camera, which means you can't see anything through the viewfinder once you trip the shutter. With the 35mm SLR, the mirror returns to

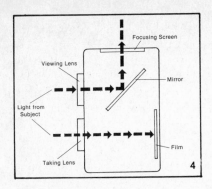

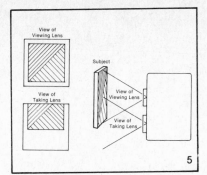

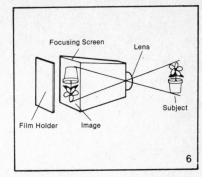

the down (viewing) position as soon as the film has been exposed, so your view through the viewfinder is interrupted only for the moment it takes to make the exposure. This is a handy feature when you're trying to track a fast-moving subject.

The problem of vibration caused by the mirror can be eliminated by the mirror lock-up feature present in some SLRs. Mount the camera on a tripod, compose and focus your scene, then lock the mirror in the up position, wait a few moments for the vibration to subside, and make a vibration-free exposure. Of course, with the mirror locked in the up position, you can't see anything through the viewfinder, so this is an effective technique only with stationary subjects. One especially good use for the mirror lock-up is to eliminate vibration when shooting close-ups using bellows and a macro stand because when you magnify the image, you also intensify the effects of vibration.

Some specialized lenses extend so far into the camera body that they interfere with operation of the mirror; the mirror would strike the rear part of the lens as it flips up out of the way to allow the film to be exposed. With these lenses, the mirror is locked in the up position before the lens is mounted on the camera. Since you can't see through the camera's viewfinder with the mirror locked in the up position, the lenses that require a locked-up mirror generally come with accessory finders that enable you to frame the scene without looking through the camera's viewfinder.

All of these problems related to the mirror movement are eliminated by the twin-lens reflex system. In the twin-lens reflex (TLR), there are two lenses. The top lens is the viewing lens, and an identical lens below it is the taking lens. Drawing No. 4 shows how this setup works.

The advantage to the TLR system is that all of the mirror-motion problems of the SLR are eliminated, because the mirror doesn't move. However, a big disadvantage accompanies the

TLR system: parallax. What you see through the top lens and what the film sees through the bottom lens are not quite the same. At medium and far camera-to-subject distances, this doesn't really matter, but at close distances, if you frame the image perfectly in the viewfinder, you'll be cutting off part of the image on the film (see drawing No. 5). The TLR viewfinder contains parallax correction lines that help minimize the problem, but the vast popularity of the single-lens reflex indicates that most people would rather put up with the moving mirror and not worry about framing problems.

NONREFLEX SYSTEMS: Nonreflex cameras come in several varieties. The first is the direct viewing system, as used on view cameras. Here, the viewing/focusing screen is directly opposite the lens (see drawing No. 6). You see the image formed by the lens exactly as it is. Unfortunately, that's upside down, because when a lens forms an image, it forms it upside down. This takes some getting used to, but once you do get used to it, it's a good system, allowing you to carefully examine everything that's in the scene, and the effects of the camera movements (which will be discussed in the section on view cameras). A second drawback to this system is that when you want to make an exposure, you have to insert a film holder between the viewing screen and the lens, so you can't see anything on the viewing screen. But since you will always be using a view camera for nonmoving subjects, and attached to a tripod, this doesn't matter.

A second nonreflex viewing/focusing system is the rangefinder. This consists of a window, through which you view the scene, and a prism that forms a secondary image in the window you view through. To focus, you just turn the lens' focusing ring until the two images superimpose. The advantages of this system are two-fold: it provides easier focusing in dim light than a reflex system, and there is no mirror to move and cause noise and vibration. Most of the great early 35mm photographers used rangefinder

cameras, in part because that's all there was at the time.

The third nonreflex viewing/focusing system is the viewfinder system. This is merely a clear window that serves as a framing device; to focus, you set the lens to a measured distance (or a guesstimated distance), or, in simple cameras, to a focusing zone symbol. Some cameras have fixed-focus lenses; others have auto-focus.

Shutters

The camera shutter controls the amount of time that light hits the film. When you press the shutter release, the shutter opens for the predetermined amount of time (the time set on the shutter-speed control), then closes to stop the exposure.

There are two basic shutter types in use today: the focal-plane shutter, found in all of today's 35mm SLR cameras and some medium-format cameras; and the leaf shutter, found in other medium-format cameras and large-format cameras.

FOCAL-PLANE SHUTTER: The focal-plane shutter is located in the camera body at the film (focal) plane. Some focal-plane shutters are mechanical, and others are electronic (some of the electronic ones are quartz-timed and extremely accurate, although even the mechanical ones are accurate enough), but all operate on the same principle. Focal-plane shutters consist of two curtains. At slow shutter speeds, the first curtain moves across the frame, uncovering it for exposure, then the second curtain moves

A Gallery of Cameras

Here's a representative sampling of the camera types that exist today.

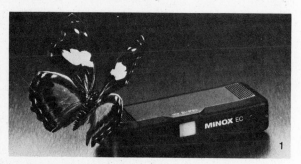

1. Minox EC is the latest version of the famous ''spy'' camera. It features automatic exposure, measures 3x1x½ inches, and weighs two ounces.

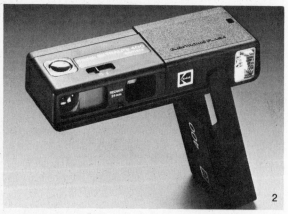

2. The Kodak Ektralite 400 110-format camera features a handy handle/cover and a built-in electronic flash unit.

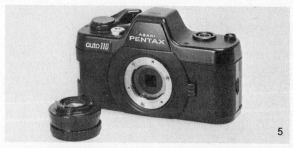

3. The Vivitar Model 845 110 camera has a telephoto lens and a built-in automatic film-advance motor, plus a built-in electronic flash.

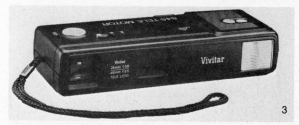

4. The Minolta Weathermatic-A is a watertight 110 camera.

5. The Pentax A110 110-format camera is an auto-exposure interchangeable-lens SLR; motor drive and flash are also available. Lenses include normal, wide-angle, telephoto and zoom.

across the frame, covering it to stop the exposure. At faster shutter speeds (usually starting at 1/125 second), the second curtain starts across the frame before the first one has completely uncovered it, in effect moving a slit across the frame to expose the film. The main significance of this is that when you are using electronic flash with a focal-plane shutter, you must use a speed slow enough that the whole frame is exposed at one time, or only the portion of the film that is uncovered by the moving slit at the time the flash goes off will be exposed (see the section on electronic flash). That's why the camera instruction manual will list a maximum flash shutter speed (usually 1/60 or 1/125 second).

Mechanical focal-plane shutters generally feature speeds ranging from one to 1/500 or 1/1000 second, plus a setting marked B. The B (bulb) setting is used for exposures longer than one second; when the shutter-speed selector is set at B, the shutter will remain open as long as you hold the button down. It's a good idea to use a locking cable release for this, so that you don't jiggle the camera and cause blurred pictures while holding the button for long periods of time. Of course, the camera should be mounted on a tripod for long exposures. Some cameras have a T (time) setting, which is also for time exposures, but this differs in that the shutter will remain open until you press the button a second time; you don't have to hold the button down.

Electronic focal-plane shutters generally have

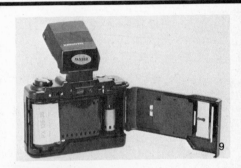

7-9. The Hanimex 35 Micro Flash is a tiny full-frame 35mm camera with a built-in flash. Note its size compared to the 35mm cassette in photo No. 9.

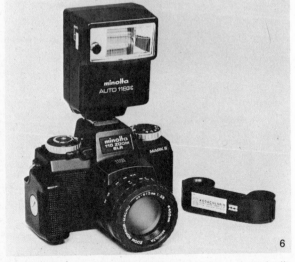

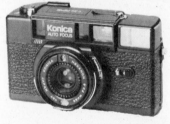

10. The Konica C35 AF2 is an auto-focus, auto-exposure full-frame 35mm camera with a built-in flash. Several manufacturers offer similar models.

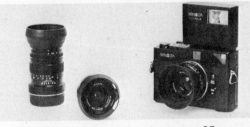

6. The Minolta 110 Zoom SLR Mark II features a built-in zoom lens with macro focusing, automatic exposure control.

11. The Minolta CLE joins Leicas as a 35mm range-finder camera with interchangeable lenses for serious photographers, featuring automatic exposure control.

marked speeds from two, four or even eight seconds to 1/1000 or even 1/2000 second, along with a B setting. If the battery dies, most electronic-shutter cameras also have from one to several mechanical shutter speeds so that you can continue to take pictures, although you will have only a limited range of shutter speeds to choose from.

While shutter speeds on mechanical shutters (and on electronic shutters when not used in automatic-exposure mode) are stepped—that is, each setting is one step higher or lower than the adjacent one (from 1/125 to 1/250 second, for example)—most electronic-shutter automatic-exposure cameras have stepless speeds in au-

tomatic mode. This means that if the required shutter speed for the light level and lens aperture in use is 1/183 second, that's what the camera will provide. The advantage of this is increased exposure accuracy, within the limits of built-in metering (see the section on averaging reflected-light meters).

LEAF SHUTTERS: Leaf shutters operate as a diaphragm, like the lens' aperture. When you push the shutter release, the diaphragm opens for the desired time, then closes. Since the shutter completely uncovers the film at all shutter speeds, you can use electronic flash with any shutter speed on a leaf-shutter camera. The problems with leaf shutters occur at fast shutter

A Gallery of Cameras cont'd

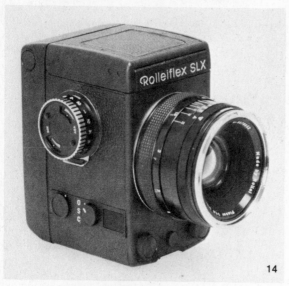

14

14. The Rolleiflex SLX is an auto-exposure 6x6cm-format SLR camera with a built-in motor drive.

15

15. The Pentax 6x7 is a 6x7cm-format SLR that looks like a 35mm SLR, only bigger.

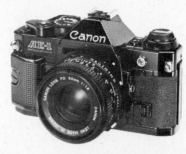

12

12. The Canon AE-1 Program is a 35mm SLR with programmed auto exposure and full manual control.

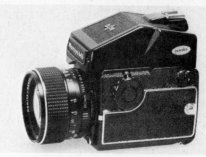

13

13. The Mamiya 645 is a 6x4.5cm-format system camera that is almost as easy to handle as a 35mm SLR.

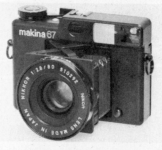

16

16. The Plaubel Makina 67 is a 6x7cm-format range-finder camera with auto exposure control.

speeds. First, because it does take some time for the blades to open, reverse direction, and close, the maximum shutter speed for a leaf shutter is generally 1/500 second. This isn't too bad. However, the problem is that at 1/500 second, a great percentage of the total exposure time is taken up by the opening and closing of the shutter blades, with the result that the film doesn't receive as much exposure as it should when the leaf shutter is set at faster shutter speeds. Another consideration is that the shutter blades don't have to open as far to uncover a small lens aperture as they do to uncover a large one, so the film tends to receive less exposure than you'd expect at large apertures rela-

tive to the exposure it receives at small ones. For these reasons, you should shoot a test with a leaf-shutter camera to determine how much (if any) you must compensate for these potential problems.

Multiple-Exposure Capability

Most 35mm SLR cameras are capable of making multiple exposures, using the following procedure. First, take up any slack in the film by turning the rewind crank until you feel tension. Then make the first exposure, while holding the tension on the rewind crank. Then push the rewind button on the bottom of the camera to disengage the film-advance sprocket. Then, hold-

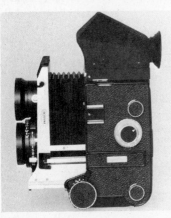
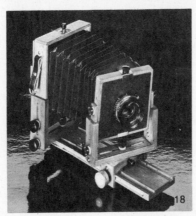
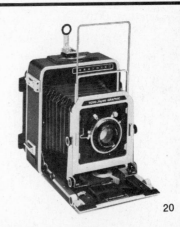

17. *The Mamiya C330 is a 6x6cm-format twin-lens reflex.*

18. *The Calumet Porta Vu 45 is a build-it-yourself inexpensive 4x5-inch view camera that comes in kit form.*

20. *The Toyo Super Graphic from Berkey Marketing Companies is a 4x5-inch camera that features front view-camera movements and a viewfinder and can be hand-held.*

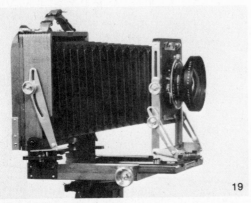

19. *The Zone VI 4x5-inch field camera weighs only 3¼ pounds, folds into a 3½x7¼x8½-inch package, has most view-camera movements, and is available from Zone VI Studios, Maple Hollow, Newfane, Vermont 05345.*

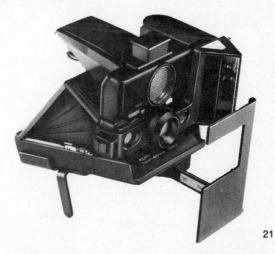

21. *Polaroid's SX-70 (shown on CU-70 close-up stand) produces instant color pictures and features sonar auto-focusing.*

ing the rewind crank tension and the rewind button, cock the shutter with the rapid-advance lever. Make the next exposure (still holding the tension on the rewind knob and holding the rewind button in, if you want to make another exposure on the frame). When you've made the final exposure on that frame of film, release the tension on the rewind knob, release the rewind button, and wind the camera. Make two exposures with the lens cap in place and wind the camera again, and you're ready to shoot your next shot. (The frames shot with the lens cap in place are necessary because the film-advance sprocket doesn't always engage immediately when you operate the advance lever after making multiple exposures.) That's a lot of work,

and it's best to check with a qualified camera repairman before trying it, because some cameras could be damaged by this procedure. And, of course, registration of each exposure on the frame may not be perfect—which is fine for some applications, but not for others.

If the camera has built-in in-register multiple-exposure capability, the process is much simpler. For example, with the Pentax LX camera, just make the first exposure, then push the multiple-exposure button on the bottom of the camera, cock the shutter, make the next exposure, push the multiple-exposure button again, make the next exposure, etc., until you've made all the exposures you want on that frame. When you're ready to move on to the next frame, just

A Gallery of Cameras cont'd

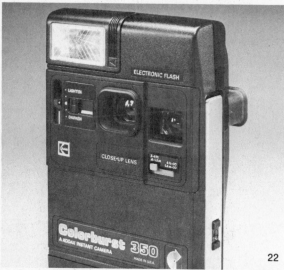

22. The Kodak Colorburst 350 produces instant color pictures and has a built-in electronic flash.

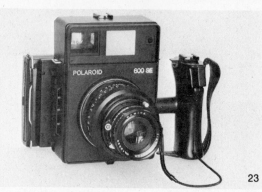

23. The Polaroid 600 SE is a professional instant camera that uses Polaroid film packs and has interchangeable lenses.

24. The Polaroid MP-4 copy camera has a multitude of uses among them copying material, shooting product shots, and shooting type stats.

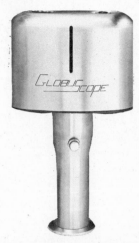

25. The Globuscope 35mm Panoramic/Scanning Camera uses a 35mm cassette to take dramatic 360-degree pictures. For more information, contact Globus Brothers, c/o Media Factory, Inc., One Union Square West, New York, New York 10003.

don't push the multiple-exposure button before cocking the camera. Each exposure on the frame will be in-register.

One important note: If the camera is mounted on a tripod because precise registration of each image is necessary, make sure you mount the camera on the tripod in such a way that you can get at the multiple-exposure/rewind button on the camera bottom. With some wide tripod heads, the camera mounting plate of the tripod head may cover the button on the camera bottom, making it necessary to remove the camera from the tripod in order to push the button, and ruining perfect registration of the images.

The Pentax LX isn't the only 35mm SLR that can make in-register multiple exposures. The Fujica AX-5, Minolta XK, Nikon F3, and others can do it. Look at the owner's manual; it will tell you if the camera will make in-register multiple exposures, and if so, how to do it.

Interchangeable Film Magazines

Some medium-format cameras have interchangeable film magazines. These are advantageous for a couple of reasons. First, they enable you to switch from one type of film to another at any time without wasting so much as a frame of either film. Second, with some camera systems they enable you to switch from one image format to another while using one camera body.

If you're shooting in black-and-white and would like to cover the same subject in color,

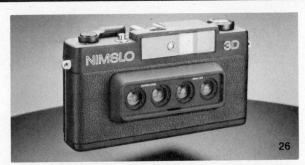

26. The Nimslo 3D camera takes three-dimensional pictures on standard ASA 100 or 400 color film and features programmed automatic exposure control. For information, contact Lesly Associates, Inc., 149 Madison Avenue, New York, New York 10016.

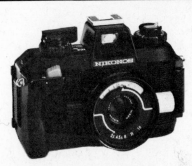

27. The Nikonos IV-A is an automatic-exposure, interchangeable-lens underwater camera.

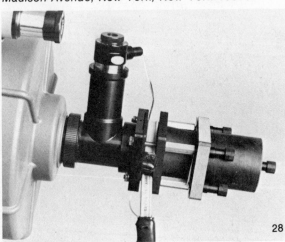

28. The Celestron-Williams cold camera utilizes dry ice to keep film cold and greatly reduce the effects of reciprocity failure in astronomical photography. This camera uses short strips of 35mm film. For more information, contact Celestron, 2835 Columbia Street, Torrance, California 90503.

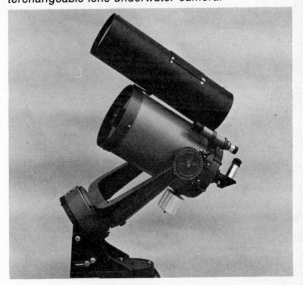

29. The Celestron Schmidt camera, shown mounted on a Celestron C8 telescope, produces sharp results in deep-sky photography. For more information, contact Celestron (address at left).

just remove the magazine loaded with black-and-white film and attach a magazine loaded with color film. If you've been shooting slow film outdoors, and suddenly see a great shot indoors, just attach a magazine loaded with fast film in place of the one containing the slow film, and you're ready to go. When you want to finish the original roll of film, just switch magazines again, and you're ready to continue right where you left off.

If your camera does not have a multiple-exposure device built-in, but it has interchangeable film magazines, you're in business. Make the first exposure, remove the magazine, cock the shutter, reattach the magazine, and make the next exposure. Repeat this procedure as many times as your idea requires, and when you're done, just cock the camera with the magazine attached to move on to the next frame. The multiple exposures will be in perfect register, and there will be no wasted frame because of image overlap when you go to the next frame.

If magazines of different formats are available for your camera, you can use whatever format is the most useful to you. For example, Hasselblad offers a 12-exposure magazine that produces 6 x 6cm square images on the film, and also a 16-exposure magazine that produces 6 x 4.5cm images. Also available are 220 magazines, which hold longer rolls of film that produce twice as many exposures per roll as the shorter 120 film lengths, and a Polaroid magazine that enables you to use Polaroid instant film with the camera. This is quite useful in studio photography, where a Polaroid shot can be made to check lighting, composition and exposure before shooting the scene "for real."

Switching film magazines is a very simple procedure. Just insert the dark slide (a thin piece of rectangular metal that covers the opening in the magazine so the film won't be fogged when the magazine is not attached to the camera), press the release button, remove the magazine, attach the new magazine, remove the dark slide, and you're ready to go. As a safety feature, the magazine cannot be removed unless the dark slide is in place. (Note: In some cases, the magazine and camera shutter must both be "cocked" to remove or attach a magazine—see

It's no problem with square-format cameras, but how do you hold rectangular-format camera with a waist-level viewfinder for vertical-format shots? With the Mamiya RB67, just rotate the magazine from the horizontal to the vertical position, and hold the camera normally.

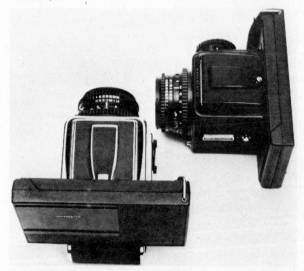

With some camera systems, you can change formats as well as films in mid-roll. Hasselblad offers a Polaroid back for its cameras (shown), which enables the photographer to shoot a Polaroid shot to check the lighting and exposure before shooting the "real" shot. Hasselblad also offers 6x6cm and 6x4.5cm magazines and a super-slide magazine.

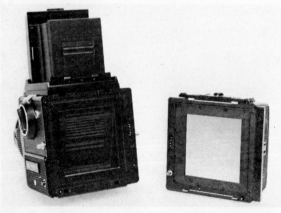

Interchangeable film magazines, like this one for the Bronica SQ camera, enable you to change from one film to another in mid-roll without wasting a frame.

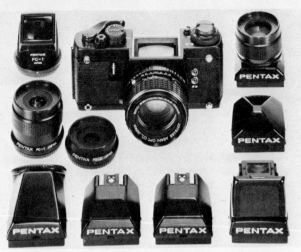

The Pentax LX system includes six easily inter-changeable finders for the camera body, plus the FB-1 System Finder at left, which is a viewing system within the system, since the viewing elements are interchangeable. This includes a waist-level find-er that rotates 360 degrees for total flexibility in the viewing angle.

Some cameras offer interchangeable focusing screens that can be switched quickly by the photog-rapher (such as the Pentax LX, shown), while others must be changed by a camera repairman.

the owner's manual for the camera in use for details.)

Interchangeable Finders

Interchangeable viewfinders enable the pho-tographer to employ the one that is best suited to the job at hand. For some studio subjects, a waist-level finder is suitable. For panning action subjects, a pentaprism type is best. For critical close-up work, a magnifying finder is useful. Sometimes a 45° viewfinder is more comfort-able than either an eye-level pentaprism or a waist-level finder. With some cameras, some of the optional finders contain a through-the-lens metering system, when this feature isn't already built into the camera body.

Interchangeable Focusing Screens

Some single-lens reflex cameras offer inter-changeable focusing screens. The interchange-ability ranges from a 30-second do-it-yourself operation to a qualified-camera-repairman op-eration, with most falling in the do-it-yourself category.

The usual central split-image surrounded by a microprism collar in a matte field is fine for general use. Unfortunately, when using a lens with a small maximum aperture (f/5.6 or slower, usually) or shooting in dim light, half of the split-image blacks out, as does the microprism collar, rendering both useless. In this event, you have

to use the matte field for focusing. Technology is improving the situation a bit—Canon intro-duced a New Split/Microprism screen for its AE-1 Program camera that is usable even with f/8 lenses.

Built-In Metering

Virtually all 35mm SLR cameras produced to-day have built-in through-the-lens light meters (or have them available in optional viewfinders, as do several medium-format cameras). This means the meter reads the light coming in through the lens, the same light that forms the image on the film. This is especially handy for close-up work. Built-in light meters are averag-ing reflected-light meters, and are therefore subject to the same "laws" that govern this type of meter, as discussed in the section on meters.

Automatic Exposure Control

Many current cameras offer automatic expo-sure control via their built-in metering systems. This means that once you've selected either a shutter speed or an aperture you wish to use, the camera will automatically set the appropri-ate aperture or shutter speed to go with it under the existing lighting conditions. You don't have to match needles or LEDs; just set either the shutter speed or the aperture, then point and shoot. The meter will adjust the exposure to match the lighting conditions (within the limita-tions of built-in metering, which will be dis-cussed in the section on light meters).

There are several types of automatic-expo-sure systems:
APERTURE-PRIORITY: With an aperture-prior-ity system, you set the lens aperture you want

Almost all automatic-exposure 35mm SLR cameras also offer a manual mode, which is important when you want to exercise creative control over exposure. On some auto cameras, the meter works in the manual mode; on others it doesn't.

Programmed auto exposure means the camera selects both shutter speed and f-stop, leaving you free to concentrate on composition. No. 1 and No. 2.

Most automatic-exposure cameras offer exposure-compensation dials that are used to compensate for strong backlighting and other "abnormal" lighting situations. The compensation ring is set for normal operation in photo No. 3; it's set for 1½ stops additional exposure in photo No. 4.

to use (to provide the desired amount of depth of field), and the camera will automatically select the appropriate shutter speed for that aperture under the existing lighting conditions. Since the auto system sets the shutter speed, which is inside the camera body, it will work with most lenses that can be attached to the camera, and with close-up gear such as auto bellows units as well.

SHUTTER-PRIORITY: With a shutter-priority system, you set the shutter speed you want to use, and the camera will automatically set the appropriate aperture to provide correct exposure. Since the auto system sets the lens aperture, which is in the lens, it will work only with lenses especially designed to operate with the system; lenses that will fit the camera but are lacking the linkage cannot be used in auto mode.

Critics of aperture-priority automatic exposure claim that the camera might select a shutter speed that is too slow to stop an action subject, while critics of shutter-priority systems claim that the camera might select an aperture that is too large to provide the necessary amount of depth of field. While this is true, it is a fact that in a given light level, with a given film speed, a given aperture will require a specific shutter speed to provide proper exposure. This holds true no matter what system you use. If the film speed and light level call for an exposure of 1/125 at f/8, and you want to shoot at f/16 for increased depth of field, you're going to have to shoot at 1/30 second. Likewise, if you want to shoot at 1/500 to stop action, you'll have to do it at f/4. Most automatic-exposure cameras show the shutter speed and aperture in the viewfinder; if you don't like one of them, just change the other until you get one you do like. For example, if you have an aperture-priority

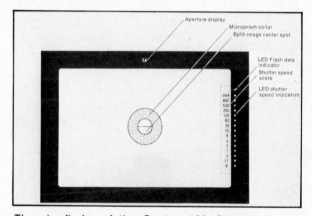

The viewfinder of the Contax 139 Quartz camera shows everything you'd like to know: aperture, shutter speed, flash status. A central split-image surrounded by a microprism collar is a good focusing system for general photography.

system and find that when you set the aperture to f/16, the camera selects a shutter speed of 1/30, and you decide you have to shoot at 1/250 to stop the action, open the aperture to f/5.6, and the camera will select 1/250 second.

Some cameras offer both shutter-priority and aperture-priority operation (the Minolta XD-11 and the Canon A-1).

PROGRAMMED: With a programmed automatic-exposure system, the camera selects both the shutter speed and the aperture. Depending upon the light level and speed of the film you're using, the camera is programmed to start with its fastest shutter speed and smallest aperture, and adjust both as the light grows dimmer: 1/1000 at f/16, 1/750 at f/13.5, 1/500 at f/11, etc., until the lens is wide open, at which point

only the shutter speed will change (since the lens can't open any wider). This mode is handy when you want to concentrate on your subject, and don't want to worry about exposure at all.

STOPPED-DOWN: Stopped-down automatic exposure permits auto exposure control when the automatic linkage between camera and lens is disconnected or absent. Auto lenses allow metering at maximum aperture, because linkage between the camera and the lens tells the meter what aperture the lens is set for, even though the lens diaphragm itself remains fully open until the picture is snapped. If you use a non-automatic lens, or if a bellows or other accessory disconnects this linkage, the meter won't be told where the aperture ring is set, and underexposure will result if the lens is set at any aperture but its maximum. With stopped-down automatic exposure, you stop the lens down manually (generally using the depth-of-field preview stop-down lever), and the meter actually reads the light transmitted at the aperture to which the lens is set and adjusts the shutter speed accordingly.

FLASH AUTO EXPOSURE: When an automatic-exposure camera is used with a dedicated flash unit (i.e., a flash unit made specifically for that camera), several nice things happen. First, attaching the dedicated flash unit to the camera automatically sets the proper flash-sync shutter speed, so there's no more partial-frame pictures caused by forgetting to set the right shutter speed. Second, you don't have to set the film's ASA speed on the flash unit, because the camera takes care of that. Third, there is no need to set the aperture to be used on the flash unit, because the camera also takes care of that, once you've set the lens to the desired aperture. Fourth, since the exposure is calculated by the camera, based on the light coming in through the lens (with single-lens reflex cameras), it doesn't matter what focal length lens you use, or how close you get for close-up work—the camera will cut off the flash when the correct exposure is achieved.

MANUAL OPERATION: Most automatic-exposure cameras offer some form of manual operation along with the auto operation. Manual operation comes in two varieties: metered manual, and just plain manual. Metered manual means the camera can be used as a fully adjustable match-needle (or match-LED) camera, using the built-in metering system. Just plain manual mode means you can set any shutter speed and aperture combinations you want, but the meter doesn't operate; you have to determine exposure on your own. What you can do with a just plain manual camera is set it on auto and see what shutter-speed/f-stop combination it suggests, then use your experience to modify the exposure from there using manual operation. Many serious photographers believe that some form of manual mode is essential to enable a photographer to exercise creative or corrective control over exposure.

EXPOSURE COMPENSATION: All single-lens reflex automatic-exposure cameras have exposure compensation settings that allow you to provide (generally) up to two stops more or less exposure than the meter provides. This is because auto cameras, like manual cameras with built-in meters, can be fooled by certain conditions. When the subject is especially light, or the background is a lot brighter than the main subject, you'll have to give the film more exposure than the meter calls for; and if the subject is particularly dark, or the background is a lot darker than the subject, you'll have to give less exposure than the meter calls for. (The reasons for this will be explained in the section on light meters.) That's where the exposure-compensation feature comes in handy. The exposure-compensation feature generally is a ring around the camera's rewind knob. If the camera doesn't have such a control, you can still compensate—

Self-timers on 35mm SLRs frequently operate like this: The lever on the front of the camera (1) is moved to the down position (2) to set the timer. The activator lever is pushed (3) to start the timer; about 10 seconds later, the timer will fire the camera.

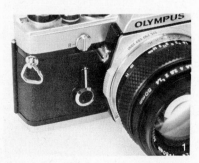

just use the ASA index dial. Setting it to the next lower film speed (than the speed of the film you're using) will cause a ⅓-stop increase in exposure; setting it another number lower will increase exposure another ⅓ stop. Likewise, setting it to higher film-speed numbers will decrease exposure in ⅓-stop increments. Don't forget to return the ASA index to the film's actual speed before going back to "normal" shooting conditions.

MEMORY LOCK: Some automatic-exposure cameras have an exposure memory lock, which allows you to move in close to meter the important portion of a scene, then lock-in the reading so when you move back to shoot the whole scene, the reading isn't changed by the rest of the scene.

Open-Aperture Metering

Open-aperture (also called full-aperture) metering allows you to make a meter reading with an automatic lens wide-open for viewing. Linkage between the camera and lens "tells" the meter to which aperture the lens is set, even though the lens aperture itself stays wide open until you push the shutter release to make an exposure (at which point an automatic lens stops down to the aperture set on the aperture ring automatically). This feature is convenient because it permits you to meter and view the scene at the same time, without having to stop the lens aperture down to its set stop. Almost all of today's 35mm SLR cameras offer open-aperture metering with at least some of their lenses.

Stop-Down Metering

As you might have guessed from the foregoing, stop-down metering is used when the open-aperture linkage between the camera and lens (which tells the meter to which f-stop the lens aperture ring is set) is absent or disconnected, such as when using a non-automatic lens or a

Another version of the self-timer utilizes the camera's main switch (1). After setting the switch to the self-timer position, push the shutter release, and the timer will trip the shutter about 10 seconds later. The self-timer indicator on the front of the camera (2) has a light that blinks while the timer is operating, and emits beeps for audible indication as well.

Both front and rear camera standards tilt forward and back and swing sideways. It's best to use the front standard to control depth of field, because tilting the rear standard will affect the shape of the subject.

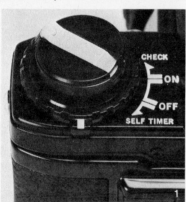
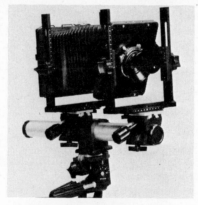
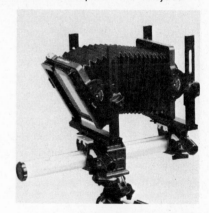

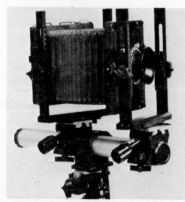
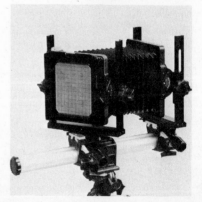

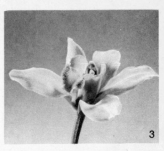

If you point the camera down at a subject (A), depth of field might not be great enough to cover the nearest and farthest points of the subject (2). If you tilt the lens board to make it more parallel to the plane of the subject (B), depth of field will be increased, and the whole subject will be sharp (3).

bellows unit. For stop-down metering, you use the depth-of-field lever to stop the lens aperture down to the stop set on the aperture ring, then the camera meter actually reads the light transmitted at that aperture to determine the exposure.

Viewfinder Displays

There was a time, (even recently) when all you saw in the viewfinder of a 35mm SLR or medium-format camera was the scene you were photographing. Now, you'll also see numbers, letters, and colored lights that glow steadily or blink. Exactly how information is presented in the viewfinder display varies from camera to camera, but here are a few of the things you'll find:

1. Mode of operation: If it's an auto-exposure camera, there is generally an indicator that tells you whether the camera is in automatic or manual mode.

2. Shutter speed: The viewfinder display often includes the shutter speed selected by you (if manual) or by the camera (if an aperture-priority auto-exposure camera).

3. Lens aperture: The viewfinder display often shows the aperture to which the lens is set (or the aperture selected by the camera, if a shutter-priority auto-exposure camera).

4. Correct exposure: There is always some indication of the meter's choice of correct exposure. This can be a match-needle system, in which you just adjust the f-stop or shutter speed until one needle in the display overlaps another, or it can be an LED system, in which an LED lights next to the proper shutter speed or f-stop on the display's scale. There are many varieties of these two basic systems.

5. Flash ready light: If the camera has a dedicated flash unit, the viewfinder display generally includes a light that tells you when the unit is ready to fire. Some cameras also have a light that blinks after exposure to indicate that the exposure was within the flash unit's range.

It's hard to say which display is best; they all take a little getting used to, and once you've used one for a while, it will become second-nature. One thing to consider, if you do a lot of night or available-light work in dim interiors, is whether or not the viewfinder display is illuminated. By this, we mean the whole display. A lit LED next to a shutter speed reading doesn't do you much good if the shutter speed readout isn't illuminated too when you're working in the dark. If you use a hand-held meter, or exposure tables, for your low-light work, then the viewfinder display needn't be illuminated.

Self-Timer

The self-timer is a device that trips the camera's shutter after a short time interval. Self-timers are built into many 35mm SLR cameras and some other cameras, and inexpensive add-on self-timers that attach to the camera's cable-release socket are also available.

Most photographers use the self-timer to enable them to put themselves into a picture. They set up and compose the scene, noting where they want to be, then cock the shutter, set the self-timer, and dive into position before the timer trips the shutter. Most self-timers have a delay of about ten seconds before tripping the shutter, and some can be set for shorter delays as well.

Another use for the self-timer is to trip the shutter when minimum camera shake is essential. Rather than trip the shutter by pushing the shutter button, which can cause perceptible camera shake, even with the camera mounted on a tripod, just set the self-timer and let it trip the shutter. This technique is useful for still-life subjects, but not very good when precise timing of the decisive moment is important. Using the self-timer to trip the shutter with the camera's mirror locked in the up position will minimize

camera shake and produce the sharpest possible pictures.

If you have a camera whose longest shutter speed is one-half or one second, you can obtain a consistent camera-timed shutter speed of around two seconds by setting the camera shutter speed on B, cocking the camera, then using the self-timer to release the shutter. This can be handy if you need an exposure time of a little more than two seconds and your camera's shutter only goes to one second or faster. This method works with most mechanical 35mm SLRs and with some auto-exposure electronic cameras, but with other auto cameras, the shutter trips at the mechanical X-sync auto speed. Try it with your camera and see what happens.

As mentioned earlier, relatively inexpensive add-on self-timers are available for cameras that don't have a built-in self-timer. If you don't foresee much use for a self-timer, you can save a bit of money by buying a camera that doesn't have a self-timer, and either doing without, or buying the add-on accessory.

The View Camera

The view camera provides the photographer with several advantages. First, it uses large-format sheet film, which itself provides two advantages: better image quality from a given film, because the image will not have to be enlarged as much as a smaller image would to produce a given size print; and the opportunity to process each shot individually, to provide the optimum range of tones for a given scene in black-and-white work. A second advantage of the view camera is its ability to produce great depth of field, through its swings and tilts (to be explained shortly) and its lenses, which often stop down to f/45 or f/64. A third advantage of the view camera is its ability to eliminate converging lines in shots of buildings, through its rises, falls and shifts (also to be discussed shortly). The aforementioned view camera movements give the photographer more control over the image he places on his film than is possible with any other camera type.

Of course, the view camera also has its disadvantages. It is heavy and large, and cannot be hand-held, limitations that effectively rule out its use for candid and action photography. The image you see on the ground-glass is upside down, which takes some getting used to, and cannot be seen in daylight, so you have to use some kind of darkening device (usually a cloth you drape over yourself and the back of the

The depth of field is greatest when imaginary lines drawn through the film plane, lens plane and subject plane all intersect at the same point. *Below left*

A view camera lens contains a shutter. The shutter is locked open for focusing and composing (focusing is best done with a rear standard, because moving a front standard changes image size); remember to close it before removing the dark slide from the film holder. *Above right*

If the camera is pointed up to get the top of a tall building in the picture, the film plane won't be parallel to the building, and vertical lines on the building will converge near the top of the picture. The same thing happens if you photograph a building at a horizontal angle; horizontal lines will converge in the distance. *Below*

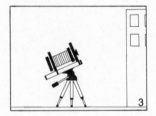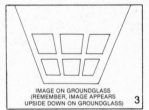

If you use the view camera's rising front to get the top of the building in the frame, while keeping the film plane (camera back) parallel to the building, there will be no convergence. *Above*

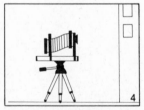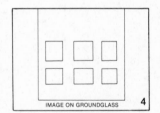

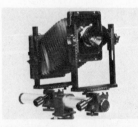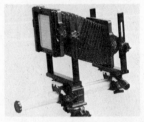

Both the front and back of a view camera rise and fall to control convergence. *Above*

If the maximum travel of the rising front still won't bring the top of the building into the frame with the camera back parallel to the building (A and B), then point the camera up, and tilt the camera's back and front so that they are parallel to building (C). This should bring the top of the building into the frame, and since the film plane is parallel to the building, there will be no convergence. *Below*

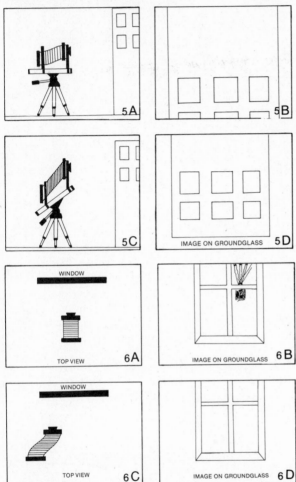

If you shoot from directly in front of the reflecting surface like a window, a reflection of the camera will appear in the picture (A and B). By moving the camera to one side, then shifting the lens back toward the subject (C), you can get a shot of the window with no reflection and no convergence (D). *Above*

Both front and rear standards of a view camera shift sideways to control image placement. *Below*

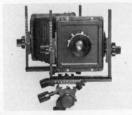

camera) in order to be able to see it. You get only two shots per film holder, as discussed earlier, meaning you must either carry many film holders with you, or carry a changing bag so you can reload in the field.

The view camera is definitely a still-subject camera, but it can handle these subjects better than any other camera type can. If you want to shoot hand-held candids or action shots, use a 35mm or medium-format camera; if you want to shoot landscapes or architecture, use a view camera.

DEPTH-OF-FIELD CONTROL: You can increase depth of field by swinging or tilting the camera lens so that the lens board is more parallel to the plane of the subject (see drawing No. 1). Maximum depth of field is achieved when lines drawn through the film plane, the lens plane and the subject plane all intersect at the same point (see drawing No. 2).

CONVERGENCE CONTROL: Whenever the film plane is not parallel to the subject plane (such as when pointing the camera up to get a tall building's top in the frame), parallel lines of the subject appear to converge toward the far end of the subject (see drawing No. 3). The view camera's rises, falls and shifts permit you to get the whole subject in the frame while keeping the film plane parallel to the subject, thus eliminating convergence (within the limits of the camera's movements and the lens' covering power). See drawing No. 4, and the photos in the section on perspective-control lenses. (Perspective-control lenses rise, fall and shift, and so can eliminate some convergence, although they usually are more limited than view cameras in this respect).

View camera movements can be combined to handle all sorts of situations. For example, if the front of the camera won't rise enough to get the top of a building in the frame in the example in drawing No. 4, you can combine tilts with the rise, as shown in drawing No. 5.

ELIMINATING REFLECTIONS: If you are taking a picture of a window or other reflecting surface straight-on, the reflection of you and the camera will appear in the window. But by using the view camera's shifting movements, you can move the camera to one side slightly, then shift the lens back toward the subject, and get a picture without a reflection and without convergence (see drawing No. 6).

For a complete discussion of using the view camera, see one of the books available on the subject, such as *The View Camera* by Harvey Shaman (Amphoto).

Camera Body Accessories

Auto winders cock the shutter and advance the film, either one frame at a time for individual shots or continuously at up to two frames per second for action sequences. Some winders will also rewind the film when the roll has been exposed. Auto winders are generally powered by four AA batteries (always use alkaline rather than regular batteries, for best performance).

Winders are handy for action sequences, obviously, but don't overlook their usefulness in portrait work. How often have you found a portrait subject relaxing just after you've made an exposure, producing that perfect expression, only to return to the before-the-camera stiffness by the time you've taken the camera away from your eye, recocked it, then raised it back into viewing position and recomposed your picture? With an auto winder, as soon as you make an exposure, the camera is recocked automatically while you hold it ready for that "decisive moment." Another good use for a winder is extreme close-up work, when the mere physical

An auto winder is a great convenience in awkward shooting situations. Here, the photographer rolled the aerobatic airplane upside down, then held the Contax 139 Quartz camera with a Contax 139 winder and a prefocused 28mm wide-angle lens against the top of the instrument panel and fired off a whole roll of Tri-X while making a 360-degree turn. If he'd had to manually recock the camera after each shot, one frame would have been all he'd have been able to get comfortably.

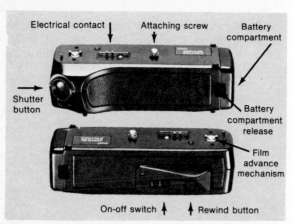

Front and back views of Contax 139 winder show how simple and compact the device is. The battery compartment holds four AA batteries (always use alkaline batteries, never regular ones, or they'll run down very quickly in winders and motor drives). The rewind button pushes the rewind button on the camera baseplate, since you can't reach it with the winder attached. The shutter button on the winder is convenient when holding the camera for vertical-format shots; pushing the camera's shutter release will also operate the winder. For single shots with this winder, push and release the button; for continuous shooting, just hold the button down.

The Canon winder for the AE-1 Program camera has a three-position switch. "C" position is for continuous shooting; with the switch set here, the camera will fire repeatedly at the rate of about two frames per second as long as you hold the camera shutter button down (this winder has no shutter button—some do and some don't). "S" position is for single-frame shooting; with a switch at this position, the camera will fire only once each time you push the button, no matter how long you hold it down. The three-position setup is nice because it keeps you from accidentally firing off two or three frames when you mean to shoot only one.

act of cocking the shutter manually may jiggle the camera sufficiently to throw the subject out of focus and require refocusing. The winder eliminates this problem by eliminating the need to manually cock the camera. With the winder, you'll never miss that great shot because you forgot to wind the camera, either (if, of course, you remember to turn the winder on).

Not all cameras will accept an auto winder, although most major manufacturers make at least one model that will, and a few (such as the Konica FS-1 and the Contax 137 Quartz) have winders built in.

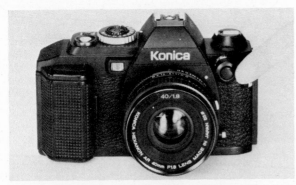

Konica FS-1 has a built-in auto winder. The left-handed shutter-release button is an option that makes shooting more natural for left-handers.

The winder's ability to advance the film rapidly while you keep your eye at the viewfinder can help to catch those nice expressions you miss when you take the camera away from your eye to cock it by hand.

Motor Drives

Motor drives serve the same function as auto winders—they advance the film and cock the shutter automatically after each exposure—but they are generally capable of doing it at a faster rate in a continuous mode, with rates of three to five frames per second being customary. Motor drives need more power to be able to achieve such rapid rates and offer a variety of power sources: AA batteries (usually eight, 10 or 12), rechargeable nickel-cadmium batteries, and AC current.

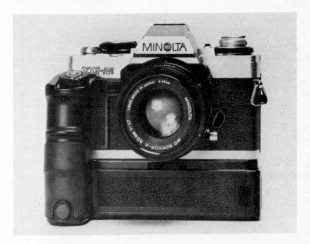

The motor drive attaches to the bottom of the camera like a winder, but generally has a hand grip that comes up in front of the camera as well.

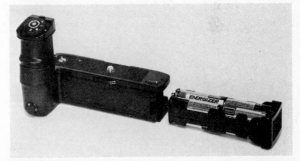

Motor drives offer more versatility than auto winders, and in return, require more battery power. This motor drive for Minolta XG-M camera uses eight AA batteries, and offers three winding modes: single-frame, low continuous (about the same two-frames-per-second rate as a winder), and high continuous (3.5 frames per second).

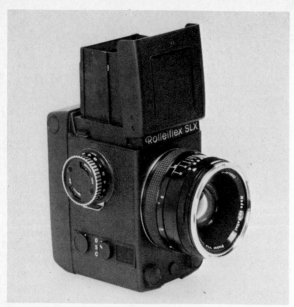

The Rolleiflex SLX 6 x 6cm camera has a built-in motor that advances the film to the first frame, rewinds the film at the end of the roll, and offers single-frame or continuous (at .7 frames per second) operation.

(pole vaulter sequence): Motor drive can be used to film motion studies. Many athletes have been aided by such studies of their techniques.

One thing to keep in mind when using a motor drive at its fastest setting is the shutter speed chosen. Obviously, you can't advance the film at a rate of five frames per second (one frame every 1/20 second) and expose each frame for 1/15 second. The operating manual for each motor drive will indicate the slowest shutter speed you can use. This is really not a great problem, because if you're shooting something that requires five frames per second, a fast shutter is generally a necessity due to the nature of the subject matter.

You really can't shop around for the right motor drive or auto winder because only the one made by the camera maker for a specific camera will fit a specific camera model. However, there are a few niceties that some units offer and others don't. If you haven't yet bought a camera, and think you'll have a lot of use for a winder or motor drive, they're worth considering. First, some units have two shutter-release buttons, one in the usual place for normal horizontal shooting, and another positioned for vertical shooting, thus making vertical-format shots more comfortable. Second, some units offer motorized film rewind, which is a convenient feature (although under conditions of high static electricity, it's a good idea to rewind the film manually, slowly, because the motor does it so fast static electricity marks could be produced on the film). Third, some motor drives have a

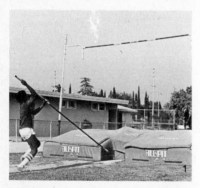
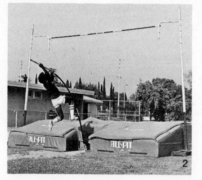
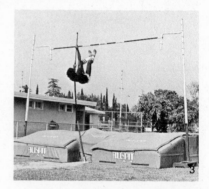
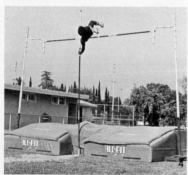
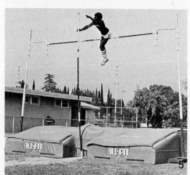
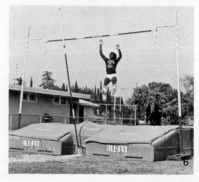

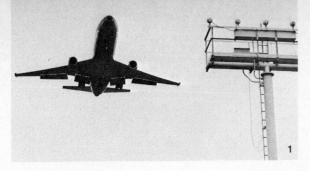

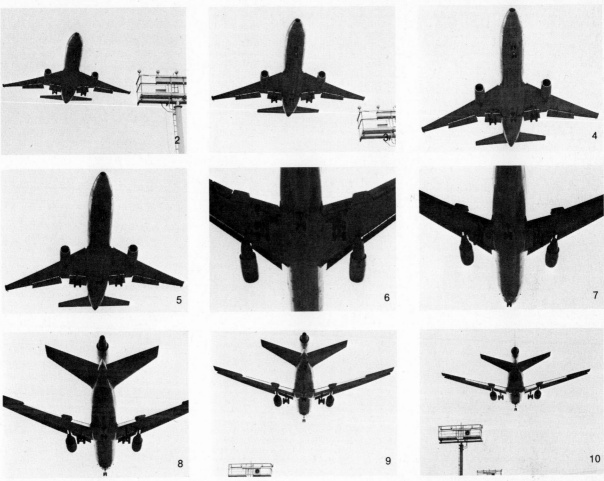

(jet sequence): Motor drive can also be used just to produce interesting results. Here, the photographer spun around as the approaching jet passed overhead, and caught it coming and going.

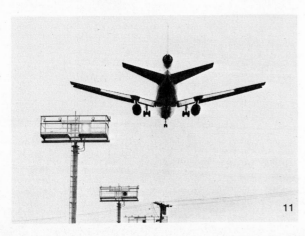

built-in clutch that keeps the unit from tearing the film off its spool when it gets to the end of the roll in either advance or rewind mode, another nice feature. Fourth, some motor drives offer more accessories than others (these will be discussed next), and if you have use for these accessories, you'd do well to get a motor drive that offers them.

Most manufacturers of single-lens reflex cameras offer auto winders or motor drives for at least one of their cameras. However, some cameras won't take either, some will take only a winder or only a motor drive, and some will take both. Winders are less expensive; motor drives,

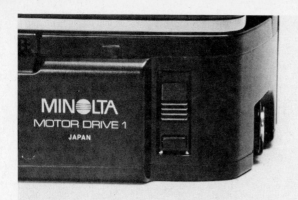

This switch on the Minolta motor drive pushes the rewind button on camera baseplate. Some motor drives offer motorized rewinding of film.

The shutter button is located atop the handgrip, surrounded by the winder rate selector dial.

The Minolta XG-M motor drive has a second shutter button at the base of the unit, handy for use when the camera is held for vertical-format shots. The button has a locking mechanism, so that you don't accidentally press it with your hand while holding the camera in a horizontal position.

due to their faster operating rates and systems of accessories, are more versatile.

Probably the biggest problem with motor-driven photography is that you can use up a lot of film very quickly. At five frames per second, a 20-exposure roll is gone in just four seconds! If you're not too discriminating about what you shoot, you can waste an incredible amount of film in an amazingly short time. So it's a good idea to think about what you intend to shoot, and whether using a motor drive in a continuous high-speed mode is a good idea for a given task. If you're shooting a racing car crash or a

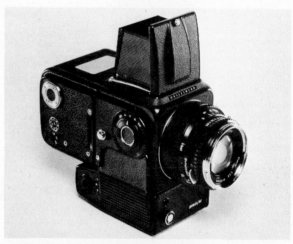

Medium-format cameras have motor drives, too. Hasselblad EL/M will fire off more than one frame per second, quite a feat considering the amount of film the motor has to move.

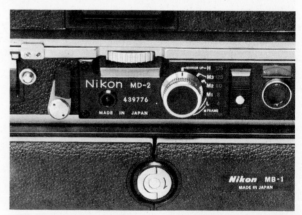

This Nikon motor drive offers low-speed continuous operation, three medium speeds, and a high speed. Marked next to these settings are the slowest usable shutter speeds with each of them. Mirror must be locked in up position at highest speed. This unit also offers motorized rewind, and interchangeable power sources.

motion study of a steeplechase horse, fine; if you're shooting portraits or nonmoving subjects or slow-breaking action, perhaps using the single-frame mode will be more productive. Another good reason for using single-frame mode unless you really need high-speed continuous operation is battery life: You'll get several times more exposures per set of batteries in single-frame mode than in maximum-speed operation.

Bulk-Film Backs

Realizing that it is a drag to run out of film just as the image you want to record appears before your lens, the motor-drive manufacturers generally offer a bulk-film back that holds 250 exposures' worth of film for use with their motor-driven 35mm cameras.

The bulk-film back simply attaches to the camera in place of the normal camera back. It accepts up to 10 meters of 35mm film (which must be loaded into special bulk-film magazines in a darkroom, since such great lengths of film don't come preloaded in cassettes as the 36-exposure lengths do). Some manufacturers also

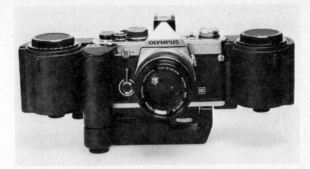

1. Bulk-film backs for 35mm SLR cameras hold enough film for 250 exposures, so you don't have to reload every few seconds when using a motor drive at maximum speed.

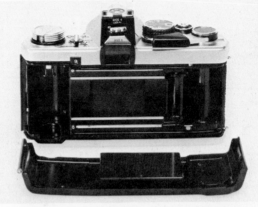

2. The first step in installing a bulk-film back is to remove the normal camera back.

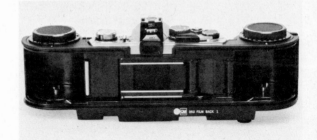

3. The bulk-film back frame is then attached to the camera body.

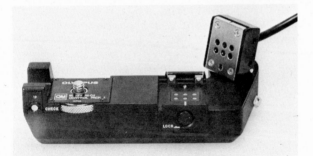

Some motor drives, like this Olympus unit, offer rechargeable power packs. The charging unit plugs into a power pack and into the wall socket. Make sure the wall outlet is the proper voltage for the charging unit (see instruction manual for unit).

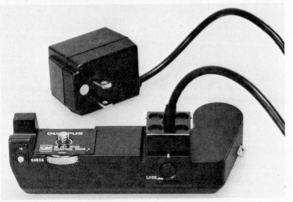

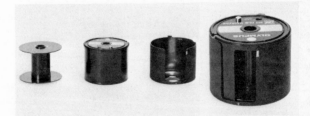

4,5. Three-piece supply and take-up magazines are used to hold 33-foot lengths of 35mm film.

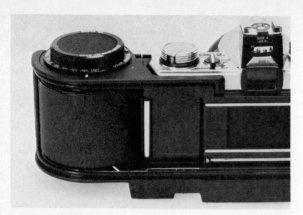

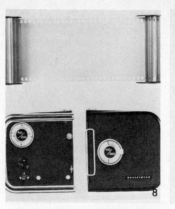

6. Film magazines fit in spaces at each end of the frame. As when using normal cassettes, the loaded magazine goes on the left, the take-up magazine on the right.

8,9. Bulk-film magazines are one area where medium-format cameras have it over 35mm SLRs in convenience. This Hasselblad magazine (8) holds 100-200 exposures of medium-format film, and all you need do to use it is remove the normal magazine and attach this one, a procedure that takes just a few seconds. Hasselblad also offers a 500-exposure magazine for its cameras (9).

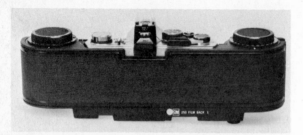

7. Once the film is threaded into the take-up magazine, the back plate is attached.

offer a special bulk-film loader that can be used in the darkroom to load preset lengths of film into the bulk loader from 100-foot bulk film rolls, thus making the job somewhat easier.

Intervalometer

An intervalometer is just a timer that can be used in conjunction with a motor-driven camera to automatically make exposures at preset intervals. Just what the range of intervals is depends on the particular unit. Most can be set for intervals from two frames every second to one frame every minute. Intervalometers are useful for time-lapse studies, both for hobbyists and for industrial and scientific users.

Be sure to take into consideration the amount of film in the camera when using an intervalometer. If you want to photograph a flower opening, and it takes two hours for it to progress from closed to completely open, you're not going to get the whole opening on a 36-exposure roll of film at a rate of one exposure per minute. Here, you'd have to set a rate of one exposure every four minutes (if your intervalometer has that capability), or use a bulk-film back on the

camera. Naturally, you'll want to fasten the camera securely to a tripod or other support, protected from both the elements and passers-by, and you'll want to consider changing lighting conditions' effect on exposure (here's where an automatic-exposure camera can really come in handy).

Another consideration in intervalometer work is the power source. Some intervalometers operate only on AC current, and so cannot be taken into the field. Others are battery-operated, and therefore can be taken anywhere, but with these units you have to consider battery

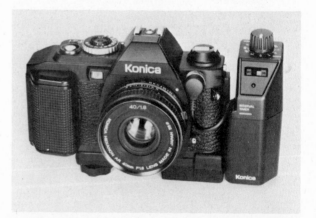

An intervalometer attaches to the camera with an auto winder or a motor drive, and fires frames at preselected intervals. This one for Konica FS-1 with a built-in winder can be set for rates from one frame every two seconds to one frame every 60 minutes.

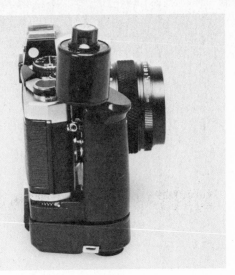

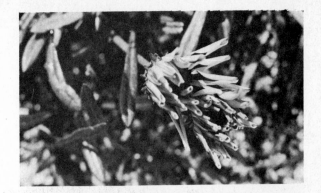

If you're on a budget, this inexpensive interval timer from Kalt Corporation offers settings from one frame every ½ second to one every 50 seconds. Don't count on the rate being exactly as set on the dial, but if you just need a frame shot every so often automatically, this unit will do it for a very low price. (Note: Check with the manufacturer of your camera before using this unit.)

life. Sometimes the operating manual will list an expected battery life, but don't count on it. It's best to put in new alkaline (or freshly charged rechargeable) batteries before undertaking a shooting session that involves many exposures or a long period of time.

It's a good idea to observe the event you wish to record to see how long it takes, so you can figure out what a good interval will be, considering the event's duration and the amount of film you have.

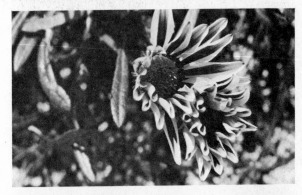

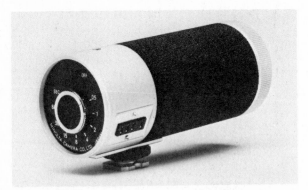

Intervalometers come in various shapes and sizes. This one, for Minolta XK motor, attaches to the accessory shoe of the camera and can be set for rates from one frame every ½ second to one frame every 60 seconds.

Gary Schuster shot this sequence using an intervalometer with his Olympus OM-2. Once he set up the shot and turned the system on, he was free to go about his duties, while the intervalometer saw to it that the opening of the flower was duly recorded.

Remote Controls

Remote controls allow you to fire the camera whenever you want to, from some distance away. An intervalometer fires the camera at pre-set intervals, but some subjects require your presence if you want to catch that "decisive moment." With a remote control, you can set up the camera near a wild-animal feeding area, then lurk unseen some distance away, and fire the camera when an unsuspecting beast ambles into the camera's angle of view. You can also attach your camera to the wing of an airplane, point it at the cockpit, and use the remote control to fire it. Anytime you want to fire the camera without being right there, the remote control is the answer.

There are three basic types of remote controls. First, and simplest, is a long cable release. These are available in lengths of at least 30 feet. If you need to be farther away, or don't want a cable leading from the camera to your hideaway, there are infrared and radio remote controls available.

Infrared remote controls are usable up to about 60 feet from the camera, and consist of a receiver, which mounts onto the camera, and a transmitter, which stays with you. Just point

the transmitter at the camera and push the button when you want to make an exposure. Naturally, you will want to have a winder or motor drive on the camera, so you won't have to run over and re-cock it after each shot.

Some infrared controls offer more than one channel, so you can use more than one camera at once, to get different angles on the subject.

Radio remote controls are the best for long-distance work, since they'll function up to 900 or more feet away. Like infrared remote controls, radio remote controls consist of two

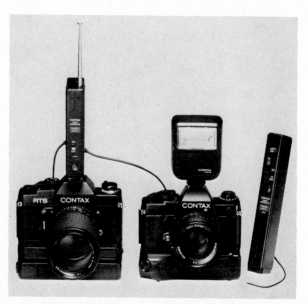

A Contax radio controller set can be used to fire a second camera with a flash by using a connecting cord. A radio transmitter has much greater range than the infrared type, and need not be pointed at the receiver to function.

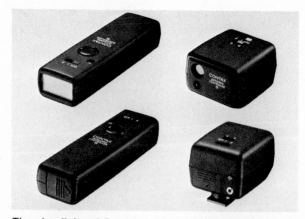

The simplicity of Contax Infrared Controller S can be seen in detail shots. Make sure the "eye" of the receiver is pointed toward where you'll be hiding.

Contax Infrared Controller S consists of a receiver that attaches to the camera's flash shoe, and a transmitter unit that the photographer uses to fire the camera from distances up to 20 meters.

Data backs let you imprint information on the film. This one, for Olympus OM-2, permits imprinting the date or time, and is quartz-controlled for extra precision.

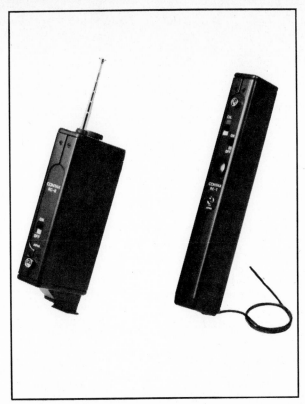

The Contax transmitter (right) and receiver are compact and efficient, letting you fire the camera from as far as 300 meters away (depending upon terrain).

Pentax offers two data backs for its top-of-the-line LX model. One imprints the date or the exposure data used to make the shot; the other (shown) imprints the clock face or other data in top left corner.

pieces: a receiver, which attaches to the camera, and a transmitter, which stays with you. Unlike infrared transmitters, the radio transmitter doesn't have to be pointed at the camera to fire it. You can use radio receivers on several cameras and fire them simultaneously with the radio transmitter, or you can use separate channels to fire the cameras independently of one another.

Data Backs

A data back imprints data directly onto the film each time a frame is exposed. The data back simply replaces the normal camera back (except on the Olympus OM-10 Quartz, with which a data back is standard).

All data backs allow you to imprint the date, and some let you imprint other information such as the time, shutter speed, aperture, or alphanumeric code of your own.

Using a data back is pretty simple. First, remove the camera's standard back, and replace it with the data back. Second, set the data back for the film in use (color or black-and-white, and

the ASA speed) so the data imprint will be properly exposed on the film. Third, use the back's battery check to confirm that the batteries are functioning properly. Fourth, set the data you wish to imprint, using the dials on the data back. Finally, make your exposure as you would in the normal manner.

The data will appear in one corner of the frame; which corner varies with manufacturer. One thing to keep in mind when using a data back is the color of the background in the corner where the data will be imprinted. If the imprint is white, and the background is very light, you won't be able to read the data; likewise, if the background is red and the data imprint is

red, you won't be able to read the data. So try to compose each data shot so that the background in the corner on which the data is imprinted contrasts with the data imprint (if the imprint is white, use a dark background; if the imprint is dark, use a light background).

Some data backs require use of a special film blind to block out the corner on which the data will be recorded; if yours is one of these, be sure to set the blind before trying to record data. If the film blind is required, the corner of the frame will be blocked out whether or not you record data there; with other data backs, you can turn the back off and shoot normal pictures with no data or block-off in the corner.

Only the manufacturer of a given camera produces a data back for that camera, so there isn't a whole lot of choice as to which data back to get—unless you are also looking for a camera, in which case you might want to take the available data back's features into consideration when evaluating a potential camera purchase (if you'll have use for a data back, of course; otherwise it doesn't matter).

As with all electrical photographic devices, be sure to use the proper batteries and install them properly, as detailed in the owner's manual.

Angle Finders

An angle finder is an L-shaped accessory that attaches to the eyepiece of an eye-level viewfinder to permit you to comfortably make shots with the camera on the ground. It would be very hard to get your eye into viewing position with an eye-level viewfinder for such shots; the angle finder is a convenience item.

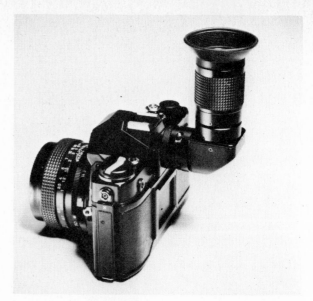

Konica offers this combination angle-finder-magnifier for its 35mm SLR cameras.

Eyepiece Correction Lenses

Many single-lens reflex camera manufacturers offer diopter correction lenses for their cameras' viewfinders. These enable near- or far-sighted photographers to use the camera without wearing eyeglasses, which is nice because you can't get quite close enough to the viewfinder to see everything that's in it while wearing eyeglasses. The range of correction available varies from manufacturer to manufacturer, but most cover a fairly good range.

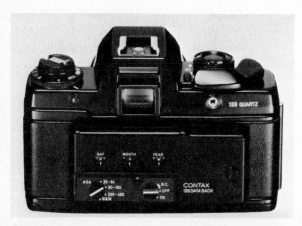

Data backs must be set for the film in the camera to get a good, clear imprint. This Contax back can be set for black-and-white film, or for low-, medium-, or high-speed color film.

While eyepiece correction lenses clip onto the viewfinder eyepiece with most cameras, the Pentax LX offers an adjustable built-in correction. Just look through the viewfinder and turn the adjusting screw until the focusing spot looks sharp.

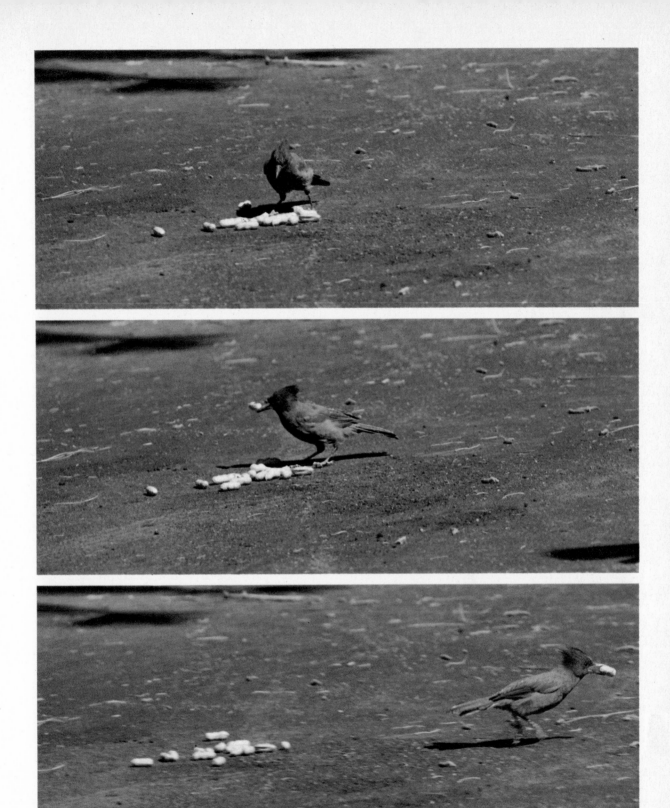

Remote control made it easy to photograph this blue jay without being noticed and scaring it away.

Lenses

Lenses focus the light rays from a scene sharply on the film in the camera, and, except for mirror lenses, they contain diaphragms that control the amount of light that reaches the film.

The focal length of the lens (the distance from the film plane to the optical center of the lens) controls the size of the image that will be recorded on the film, and concurrently, the angle of view. Short-focal-length lenses take in a wide angle of view and produce small images of a subject from a given distance. Long-focal-length lenses take in a narrower angle of view and produce large images of the subject from the same distance away.

Contrary to popular belief, the focal length of the lens does not alter perspective (the apparent relative sizes of and distances between subjects in a scene). Changing the camera-to-subject distance alters perspective. If you shoot a scene with a 24mm lens, then put a 200mm lens on the same camera and shoot the same scene from the same spot, the 24mm shot will show more of the scene, and everything in the scene will appear smaller on the film, but the perspective will not change because the camera position did not change. If the center section of the 24mm shot is blown up so that it covers the same area of view as the 200mm shot, aside from the fuzziness caused by the extreme degree of enlargement, the two prints will be identical; the perspective is the same.

In brief: If you change only the camera-to-subject distance, perspective will change. If you change only the focal length of the lens and keep the camera position the same, perspective will not change. If you change both lens focal length and camera position, perspective will, of course, change because of the change in camera position.

The reason photographers commonly believe that changing the focal length changes perspective is that they generally change camera position when they change focal length. If they switch to a shorter-focal-length lens, they move closer to the subject to maintain a desired image size, and this change in camera position does change the perspective.

Except on the simplest cameras, the lens has a focusing ring that is rotated to sharply focus the image in the viewfinder (and therefore, on the film). And, except for mirror lenses and lenses on the simplest cameras, the lens has an aperture ring, marked in f-numbers, which is used to control the amount of light transmitted to the film. The aperture ring also controls the depth of field, which is the depth of the area in front of and beyond the point focused upon that appears sharp in a photograph. Using smaller apertures (setting the aperture ring to larger f-numbers) provides more depth of field; using larger apertures (setting the aperture ring to smaller f-numbers) provides less depth of field. If your scene includes an important subject in the foreground and another in the distance, you'd want to shoot at a small aperture so that you'll have enough depth of field to reproduce both subjects sharply. On the other hand, if you are shooting a portrait against a busy, distracting background, you'd want to shoot at a large aperture, so the resulting limited depth of field will throw the distracting background so far out of focus that it is no longer distracting.

Other things you might find on lenses are a depth-of-field scale, which shows you how far before and beyond the point focused upon will be within the depth-of-field limits, and a depth-of-field preview, which stops an automatic lens down to the set aperture, so that you can actually see in the viewfinder just how much depth of field there is. (This, of course, is applicable only to single-lens reflex cameras, which allow

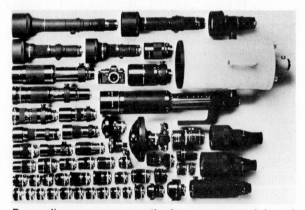

Depending upon your particular camera model, various interchangeable lenses are available. Nikon's F3 35mm SLR accepts 70 different Nikkor lenses, providing the photographer with great versatility in controlling the images he puts on his film.

At night, fast normal lens can be used wide open to permit relatively short exposure times and "freeze" slow-moving vehicles and other subjects.

Telephoto lenses help to zero in on your subject from afar.

When you're photographing an event such as a fair, where you aren't really sure what might pop up, a zoom lens can be a great asset, enabling you to crop the scene immediately while trying to maneuver a better vantage point.

Above
Bill Hurter shot this sunset with 1000mm mirror lens. Sunsets are one good subject for long-focal-length lenses, but remember that you should never look at the sun through the camera; severe eye damage can result. Instead, hold a white card a few inches behind the viewfinder eyepiece, and compose the shot on that.

Left
Mirror lenses turn out-of-focus highlights into rings or "doughnuts" of light. Photo by Bill Hurter.

Above
Inherent in wide-angle lenses is great depth of field, enabling you to hold good sharpness from fore-ground to background.

Right
Soft-focus lenses give a soft glow to subjects, ideal for nature subjects and portraits. This shot was made with a very inexpensive Sima SF 100mm f/2 soft-fo-cus lens. Photo courtesy of Sima Corporation.

Changing focal lengths changes image size, but not perspective (how big one object in the scene appears to be relative to another, and how much distance there appears to be between them). Photo No. 1 was made with a 200mm lens. Photo No. 2 was made from the same spot with a 24mm lens. Everything in the scene appears much smaller, and you probably think the perspective has changed too. Look at photo No. 3, which is a blowup of the center section of photo No. 2, enlarged so that it covers the same area of the scene as the 200mm shot (No. 1). Aside from the fuzziness caused by the extreme degree of enlargement, photo No. 3 is the same as photo No. 1. The relationship among the various elements in the scene is the same in both pictures; the perspective is the same.

you to view through the lens.) With the depth-of-field preview, the image gets darker when the lens stops down, and at small apertures in dim light, you won't be able to see much in the viewfinder, but the depth-of-field preview is quite handy in many situations.

Automatic Lenses

Automatic lenses permit you to compose and focus your scene with the lens wide open, regardless of the aperture set on the aperture ring. Then, when you push the shutter release, the lens automatically stops down to the set aperture. The advantage is that you get the brightest possible image for viewing and focusing, and don't have to worry about stopping the lens down to the shooting aperture once you've focused and are ready to shoot.

Preset Lenses

Preset lenses will not automatically stop down to the set aperture when you push the shutter release; they must always be stopped down to the set aperture. With a preset lens, you select your shooting aperture, set the preset ring at

that aperture, then open the lens to its maximum aperture for focusing. When you're ready to shoot, twist the aperture ring until the preset ring stops it at the preset aperture, and shoot.

Nonautomatic Lenses

Manual lenses are like preset lenses, only without the preset lock. You open the lens to maximum aperture for viewing and focusing, then stop it down to the desired shooting aperture (you have to look at the aperture ring to see when you've got it), then shoot.

Lens Speed

Lens speed refers to the size of the lens' maximum aperture. Lenses with large maximum apertures (f/1.2, f/1.4) let in a lot of light and are considered "fast" lenses. Lenses with small maximum apertures (f/5.6, f/6.3) let in less light and are considered "slow" lenses. (Actually, these numbers are relative. While an f/2.8 50mm lens would be considered quite slow for a 50mm lens, f/2.8 would be considered quite fast for a 300mm lens.)

The advantages of a fast lens are that you can

shoot in dimmer light than with a slower lens, or use a faster shutter speed in the same light; and that you get a brighter image on the focusing screen, making focusing easier, since the lens transmits more light. The disadvantages are cost (it costs more to make a fast lens) and sharpness (a fast lens of a given focal length generally isn't quite as sharp at maximum aperture as a slower lens of the same focal length).

Lens Mounts

Most camera manufacturers today use their own form of bayonet mount to attach lenses to their cameras. With this type of mount, a red dot or mark on the lens is aligned with a similar mark on the camera body, then the lens is rotated about ⅛ turn to lock it in place. To remove the lens, the lens release button (usually on the camera body, but located on the lens in some cases) is pressed, and the lens is rotated ⅛ turn until the two red marks align, then the lens is detached. Each camera manufacturer has its own bayonet mount, and with few exceptions, one manufacturer's lenses won't mount on another manufacturer's cameras.

Accessory lens manufacturers (those who

What changes perspective is changing the camera position—moving it closer to or farther from the subject. Photo No. 1 was made with a 24mm lens. Note the size of the background relative to the size of the subject. Photo No. 2 was made with a 50mm lens, and the camera was moved twice as far away from the subject in order to maintain the same subject size. Note that the background has grown in relationship to the subject, and appears to be closer to the subject. The perspective has changed because we moved the camera. Photo No. 3 was made with a 100mm lens, from twice as far away as the 50mm shot, to maintain the same subject size, and the background has grown again; again the perspective has changed because the camera was moved. Photo No. 4 was made with a 200mm lens, again moving the camera twice as far away to maintain the same subject size, and again the perspective has changed because the camera was moved.

make lenses but not cameras) make lenses that come with mounts to fit the more popular cameras, and they also make lenses with "universal" mounts that fit "universal" adapters. With these lenses, all you do is buy an adapter for each camera you have, and you can use a given lens with all your cameras, rather than having to buy a lens for each camera.

Depth of field is the area in front of and behind the point focused upon in which objects appear sharp. It is controlled by the lens aperture. Photo 5 was shot with the lens at maximum aperture f/1.4, and shows little depth of field. Photo No. 6 was shot at minimum aperture f/16, and shows great depth of field.

Doing Your Own Testing

The state of the art in lens design is that no current lens is inherently inferior, and in most cases, the quality of manufacture lives up to the quality of design. However, it is possible to get a ''lemon'' in any lens line, and it is best to actually shoot a few pictures with any lens before buying it, just to make sure that you don't get stuck with that rare bad one. Just take your camera and a tripod into your local camera shop and shoot a few frames with each lens you're contemplating buying (noting the serial numbers of the lenses you try, so you can be sure to get the same one you tested), and compare the results. If you can't detect any difference, buy the least expensive lens tested; if you can detect a difference, buy the sharpest one. Bear in mind that with any lens, the focusing, aperture, and (if applicable) zoom rings should operate smoothly and precisely, with no binding or excess play, and if you gently shake the lens, you should hear no clunks or rattles. If the lens fails in these respects, you can't count on it to remain sharp, even if it tests out okay. A lesser consideration is which way the focusing ring rotates. Some rotate clockwise, and some rotate

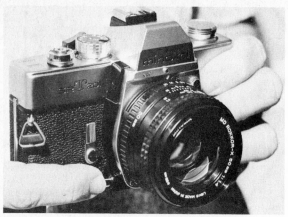

How do you know how much depth of field you will have at a given aperture? You can consult depth-of-field tables, if available, but a simpler and more direct way is to use the camera's depth-of-field preview. Pushing the button on the lower right and side of the lens mount stops the lens down to the set aperture, so you can see in the viewfinder just how much depth of field you have, assuming the lighting is bright enough. When you stop the lens down with the depth-of-field preview, the image gets darker, since the lens is transmitting less light.

If it's too hard to see the image in the viewfinder with the lens stopped down, you can refer to the depth-of-field scale on the lens barrel. With this lens set at f/16, everything from infinity to about eight or nine feet will be within the depth-of-field limits.

Lens speed is relative; the Canon FD 300mm f/2.8 (1) is extremely fast for a 300mm lens, but f/2.8 would be very slow for a 50mm lens. The Nikon 85mm f/1.4 (2) is fast for any focal length, extremely so for 85mm.

counterclockwise, and you might want to have all your lenses rotate the same way, to avoid missing a grab shot because you initially turned the ring the wrong way. Don't buy an unsharp or sloppy lens for this reason only, though.

Lens Coatings

Lens coatings help prevent light loss, as the incoming light passes through the several glass elements of the lens, and lens flare. Virtually all lenses made today have some kind of coating. Some coatings, and multi-coatings, are more efficient than others, but all seem to do a pretty good job of maintaining contrast and preventing flare. If you stick with a major brand (camera manufacturer or accessory lens maker), you'll get a pretty efficient lens coating.

Color Correction

When light is transmitted through the glass elements of a lens, different wavelengths (color) focus at slightly different points. Most lenses are corrected so that the short (blue) and long (red) wavelengths come to focus at the film plane, while intermediate (green) wavelengths focus slightly ahead of or behind the film plane. With most lenses this doesn't make too much difference, but with long lenses it is a bit more noticeable; so there are available (for a higher price, naturally) apochromatic telephoto lenses, which bring all three colors of light in focus at the film plane, and produce sharper results.

Normal lenses are good for general photography.

Lens Accessory Size

One thing you might want to consider when trying to decide which lens to buy is the size of the accessories it takes. For instance, if you have a large number of 55mm diameter filters, it might be wise to buy a lens that takes 55mm accessories, so you can use all of your filters with it. If you get a lens that takes smaller filters, you can get a step-up ring that screws into the new smaller lens and accepts your filters, but if the new lens takes a larger filter size, you might run into vignetting (having the filter black out the edges of the image) when you attach the smaller filters. This is certainly not so great a consideration as things like sharpness, quality, and price, but it is something to think about if two potential lens purchases seem to compare evenly otherwise.

Interchangeable Lenses

Interchangeable lenses allow you to change lens focal lengths to increase or decrease the size of the image you will record, and they allow you to use special-purpose lenses that produce effects you can achieve no other way. Top-line 35mm rangefinder cameras (the Leicas and the Minolta CLE), 35mm single-lens reflex cameras, medium-format cameras, and large-format cameras accept interchangeable lenses (as does the Pentax A110 110-format camera). The ability to switch lenses on his camera is invaluable to the serious photographer.

Normal Lenses

Normal lenses take in about the same angle of view as that in which the human eye can see usefully. (The human eye can see an angle of view of about 140 degrees, but it can see well enough to identify subjects at an angle of only about 50 degrees, which is about the angle of view of normal camera lenses. The focal length of a normal lens is approximately equal to the diagonal measurement of the image produced by the camera. For example, the diagonal measurement of the 24x36mm image produced by a 35mm camera is 43mm; normal lenses for 35mm cameras run in the 40-55mm range. Normal focal lengths are fine for general snapshooting, group shoots, and some scenic and architecture work.

For many years, cameras were sold with a normal lens as standard equipment, but now, photographers have finally gotten through to the manufacturers that "normal" focal length might not be what they want to use most of the time, so cameras are often sold with a moderate wide-angle, a short-range (35-70mm or so) zoom, or even no lens.

Historically, a big advantage of the normal lens has been speed. Normal lenses had apertures ranging from f/2.8 to f/0.95, with most falling in the f/1.4 to f/2 range, while wide-angle

Wide-angle lenses let you take in a lot of the scene before you.

One problem that is particularly noticeable with wide-angle lenses, even though it occurs with all lenses, is that of converging verticals when you point the camera upward or downward (1). This can be corrected by keeping the camera pointed straight ahead, but this might not produce the composition you want (2). Another solution is the perspective-control wide-angle lens, to be discussed.

and telephoto lenses rarely had apertures larger than f/3.5 or f/4. However, in the last few years, many lens makers have introduced much faster wide-angles and telephotos so that today you can find several moderate wide-angle and short telephoto lenses that are as fast as most normal lenses. Zoom lenses are still slower, but even these are appearing in the f/2.8-f/3.5 range.

The main thing to remember about normal

The Pentax 35mm f/1.4 wide-angle lens is an example of the trend toward faster wide-angles. Many photographers prefer the wider angle of view with a 35mm lens to that of the 50mm normal lens; a fast 35mm lens like this one lets these photographers use what they want with no speed penalty.

lenses is that they are only an option. Don't feel that you should have one *because* it is "normal." If a normal lens achieves your objective, then use it. But don't feel constrained; experiment with other lenses.

Wide-Angle Lenses

Wide-angle lenses are those that take in a wider angle of view than the camera's normal lens. These are often broken down into two groups: super-wide-angle lenses and moderate-wide-angle lenses; the only difference is the super-wides take in a wider angle of view than the others. They all follow the same rules (unlike the fisheye lenses).

Obviously, wide-angle lenses are useful when you want to make a picture that includes a lot of the scene. When you want to emphasize the size of a nearby object or the vastness of a landscape, these are the lenses to use. Another good use for wide-angles is to get the whole subject in the picture when you are unable to move far enough away to do it with a normal lens. A wide-angle lens might let you get the whole room, or whole group of people, into the shot when the normal lens won't.

While wide-angle lenses won't curve the hori-

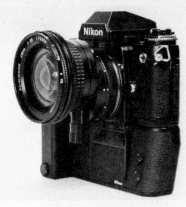

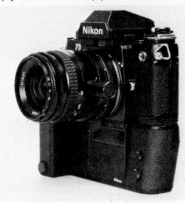

Perspective-control lenses allow you to eliminate converging verticals by permitting you to shift the lens to get the whole subject in the frame instead of tilting the camera. Nikon offers two PC lenses: a 28mm (1) and a 35mm (2).

zon even if the camera is tilted up or down, they will cause vertical lines to converge when the camera is tilted up or down. (Actually, normal and telephoto lenses do this too; it's just more obvious with wide-angles.) If you have to tilt the camera up to get a whole building in the shot, the sides of the building will converge toward the top of the picture, and the building will appear to be falling over backward. If you don't like this effect, there are several things you can do to avoid tilting the camera. First, you can move farther away from the building (if possible). Second, you can switch to a wider-angle lens. Third, you can try to find an elevated shooting location. For example, shoot the building from a window halfway up another tall building across the street. Also, you can use a perspective-control wide-angle lens, which will be discussed. Or, you can correct convergence (within limits) when making a print by tilting the easel so that the bottom of the building is projected on the portion of the easel that is closest

to the enlarger lens. Finally, you can use a view camera, which has movements that can correct the convergence (see section on view cameras).

Perspective-Control Lenses

Perspective-control lenses give the 35mm photographer some of the versatility of the view camera. These lenses can be shifted about 11 degrees vertically and horizontally (or diagonally — most rotate, so you can shift them in any direction parallel to the film plane).

One good use for perspective-control (also called shift) lenses is to eliminate converging vertical lines in building shots. Instead of tilting the camera up to get the whole building in the picture (which places the film plane at an angle to the building and causes the convergence), you can shift the lens up so that the whole building appears in the frame without pointing the camera up. In this way, the film plane stays parallel to the building, and there is no convergence. With cameras that offer interchangeable focusing screens, the grid-pattern screen is ideal for use with a perspective-control lens, because its grid lines let you see exactly when the vertical lines are properly aligned.

Another good use for perspective-control lenses is to shoot around unwanted foreground objects. If there is an obstruction to a clear shot of your subject from the desired camera position, you can shift the lens sideways to shoot around it. You can also photograph reflective surfaces without reflections. Just set up the camera a bit to one side of the reflecting subject, then shift the lens sideways to center the subject in the viewfinder.

Perspective-control lenses come in either

28mm and 35mm focal length and are offered by most major 35mm SLR camera manufacturers. The lenses are quite expensive, but if you do a lot of architectural photography with a 35mm SLR, or frequently require the perspective-control lens' capabilities, they're invaluable.

Fisheye Lenses

Fisheye lenses are the widest-angle lenses, normally covering a 180-degree field of view (at least one covers 220 degrees). They come in two varieties: circular fisheyes, which produce a circular image on the film, and full-frame fisheyes, which "crop" a rectangular image out of the circle so that the rectangular frame is filled.

Making one exposure (5), then shifting perspective-control lens left (4) and right (6) permits you to produce a mini-panorama. Sideways shift can also be used to shoot around obstructions and to eliminate your image from a straight-on shot of a reflective surface such as a window.

2

3

When shooting a tall building, if you keep the film plane parallel to the building, you can't get the whole building in the picture (1). If you tilt the camera up to get the whole building in, the film plane will no longer be parallel to the building, so converging verticals will result. (2). By shifting perspective-control lens up, you can get the whole building in the picture without tilting the camera up, so there are no converging vertical lines on the building (3).

Circular fisheye lenses are quite expensive, but produce startling and unique effects. A few good subjects are a partly cloudy sky, with the camera pointed straight up; the earth from an airplane (the circular fisheye lens will make the earth look round) and round objects.

Some circular fisheye lenses protrude so far into the camera body that the mirror must be locked in the up position before attaching the lens, while other circular fisheyes don't require locking the mirror up. It is a good idea to read the instructions to see whether locking the mirror up is required before attempting to mount the lens on the camera.

Full-frame fisheye lenses come in focal lengths about twice those of circular fisheyes (16-18mm, as opposed to 6-8mm, for 35mm cameras). There are also non-fisheye super-wide-angle lenses in this focal-length range (15-18mm), but these are different from full-

frame fisheyes. First, full-frame fisheyes have an angle of view of 180 degrees, while the super-wides have angles of view of 100 degrees (18mm) to 111 degrees (15mm). You'd think that one 18mm lens would have the same angle of view as another, and that's true for normal lens formulas, like the super-wides, but fisheye lenses have a different set of rules. This different set of rules is also the reason for another difference between full-frame fisheyes and super-wides. If you point the camera straight ahead, with the lens parallel to the ground, the

Circular-image fisheye lenses have an unmistakable fisheye appearance.

horizon line will appear straight with either type of lens. But if you tilt the camera up or down, the horizon line will curve with a full-frame fisheye, while it will remain straight with the super-wide. Even if you keep the lens parallel to the ground, objects at the edges of the frame will appear curved with the fisheye, while they won't with the super-wide. Just remember that fisheye lenses curve things and regular lenses usually don't.

Fisheyes can produce a variety of effects with a single subject, but they're all curved.

Good subjects for full-frame fisheyes include cityscapes, landscapes, and street scenes when you want the curved effect at the edges or the horizon.

When using a fisheye lens, you have to watch your feet and tripod legs; with that 180-degree angle of view, they could appear in the picture. This isn't so great a problem with the full-frame versions, because they cut off the top and bottom of the round image, but check the bottom of the frame for intruding feet before shooting with a circular fisheye.

One more caution for fisheye use: When you look through the viewfinder with a fisheye on the camera, you seem to be a lot farther away from subjects than you really are. Make sure you don't accidentally smash the front element of the lens into a nearby object because of this. When composing your image, make sure you take your eye away from the viewfinder and check your distance from anything you might bump into. (This isn't as much a problem with fisheyes that require the mirror to be locked up. Because you can't see anything through the viewfinder with the mirror locked up, an auxiliary finder comes with the lens and makes it easier to keep tabs on distances.)

There are fisheye adapters on the market that attach to your normal camera lens and produce a curved fisheye effect. These don't produce quite as sharp results as real fisheyes do, but they cost far less and are a good choice if you want the effect but don't want to spend much money.

Telephoto Lenses

Telephoto lenses have greater focal length than the camera's normal lens. Actually, the

The fisheye's 180-degree angle of view can take in an entire office from the doorway.

Fisheyes originally enabled scientists to photograph the whole sky in a single shot, and that's still a good use for the lens.

It's easy to put a lot of yourself into your work when you use a fisheye lens. Be careful unless you want to be in the picture.

term "telephoto" refers to a particular design in which the physical length of the lens is shorter than its focal length. But today all lenses longer than normal ones are called telephotos by most photographers (with the exception of mirror lenses, which will be discussed next).

Telephoto lenses are used to bring the subject to you when you can't get close enough to it to produce the desired size image. They are often classified as short, medium, and super-telephotos, but all that separates these classifications is focal length.

Short telephotos (those up to twice the focal length of the camera's normal lens, or perhaps a little longer) are ideal for portraits, because they produce the right image size at a subject-to-camera distance that provides a pleasing perspective. Short telephotos are also useful for action photography when you can get fairly close to the action.

Medium telephotos (those up to perhaps eight or 10 times the normal lens' focal length) are useful for wildlife photography, sports and action subjects, and photographing subjects without their knowledge.

Super-telephotos (those longer than about 10X the normal lens' focal length) are useful when your subject is very far away, for sunsets with a huge sun-ball, and for a compression effect with near and far objects.

The longer the lens, generally, the farther its minimum focusing distance, and the slower it is.

Bending the horizon when the camera is tilted up or down is a fisheye characteristic. If the camera is pointed straight ahead, the horizon line will be straight (1). If you tilt the camera up, the horizon line will arc downward (2), and if you tilt the camera down, the horizon will arc up (3).

You wouldn't want to shoot a 600mm lens at f/1.4 anyway, due to the extremely limited depth of field, but the faster the lens the better for focusing purposes, because with a faster lens, you'll get a brighter image in the focusing screen. Slow long lenses generally black out half of a split-image focusing screen or a microprism screen, so you have to focus the dim image on the matte ground-glass part of the screen.

There is a rule of thumb that says you shouldn't try to hand-hold a lens at a shutter

speed slower than the lens' focal length, e.g., not below 1/125 second for a 125mm lens, but unless you are exceptionally efficient at hand-holding the camera, use a tripod with any lens longer than 200-250mm, no matter what the shutter speed. Long lenses magnify not only the image, but also any camera movement.

Most lenses from about 300mm on up come with tripod mounts on the lens, so you can attach the lens rather than the camera body to the tripod. The reason for this is simply that these lenses generally are heavier than the camera body, and so mounting the lens rather than the camera body minimizes strain on the camera's lens mount.

With really long lenses, you should lock the camera's mirror up and use a small sandbag to help absorb vibrations, because at such high magnifications, even slight vibration can destroy image sharpness.

Mirror Lenses

Mirror lenses employ mirrors to "fold" the light so that they produce the effect of a long-focal-length lens from a much shorter distance. A mirror lens of a given focal length is much shorter and generally has a somewhat greater diameter than a telephoto lens of the same focal length.

Mirror lenses offer the advantages of smaller shooting distances, much closer minimum focusing distances than telephoto lenses and

Short telephoto lenses are ideal for portraits, because they produce the right image size at a distance that produces a pleasing perspective.

Full-frame fisheye lenses "crop" a rectangle out of the circular fisheye image, so the image fills the frame. Things are still curved, but the picture is rectangular.

Since they're still fisheyes, full-frame fisheye lenses will curve the horizon line unless they are pointed straight ahead. **Above and Right**

Medium telephoto lenses are good for bringing the action to you when you can't get close enough to produce the image you want.

generally lower cost. Mirror lenses have the disadvantages of being even more fragile than telephoto lenses, and having no diaphragm, so exposure can be adjusted only by changing the shutter speed or by using neutral density filters to control the amount of light transmitted by the lens. Also, you cannot control depth-of-field.

One quirk of mirror lenses is that they turn out-of-focus highlights into little rings or "doughnuts," an effect that can be put to good use in scenes with lots of spectacular highlights, such as sunlit water at the beach.

Zoom Lenses

Zoom lenses provide a number of different focal lengths in one lens. By operating the lens' zoom control, you can change its focal length throughout its range. A popular zoom lens is the 80-200mm, which can be set for any focal

length from 80mm to 200mm just by operating the zoom control.

There are two kinds of zoom controls. The first is a twist ring, similar to a focusing ring. This ring is turned until the desired focal length is set. (You can set the lens for a specific focal length by referring to the scale on the lens, or you can just look through the lens at the scene as you zoom the lens, stopping when you see an attractive cropping.) The second type of zoom control is a push-pull mechanism in conjunction with the focusing ring. This one-touch zoom control lets you focus and zoom with the same control. Turn the ring to focus; push or pull it to zoom. About the only concern with this type of control is that, with some zoom lenses, if you point them downward, the weight of the lens can cause the zoom ring to creep forward, changing the focal length of the lens. A small piece of tape can hold the control in place for downward shots if this is a problem.

The obvious advantage of a zoom lens is that it can take the place of several fixed-focal-

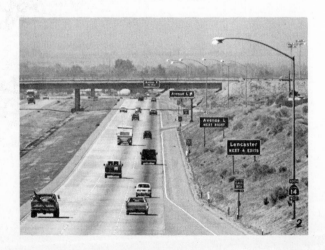

Super-telephoto lenses really close up distances. Photo No. 1 was made with a normal 50mm lens; shot No. 2 was made from the same spot with a 650 lens.

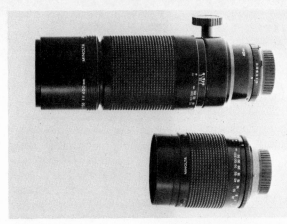

Mirror lenses use mirrors to reflect the light back and forth, in effect "folding" a long focal length into a compact package. The lower lens shown here is a 500mm mirror lens; the much longer lens above it is the same manufacturer's 400mm telephoto lens.

Here's a Nikon 1000mm mirror lens. Note the absence of an aperture ring. The circular thing protruding from the side of the lens near the lens mount is the control for built-in filters. Can you imagine what a set of filters large enough to cover the front of this beast would cost?

Lenses this big weigh more than the camera body, so the lens instead of the camera body is attached to the tripod to minimize stress on the lens mount. A cable release is a good idea when using long lenses because they magnify vibration of the camera as well as the image.

length lenses, thus saving you both money and weight in your camera bag. Another great advantage is the ability to crop the scene from one camera position, especially useful when you must shoot from your seat at a concert or sporting event, at the flick of your wrist. Zoom lenses can also produce unique special effects by zooming the lens during a long exposure.

The disadvantages of zoom lenses include cost (they cost more than a fixed-focal-length lens in the same focal-length range), size (they're naturally larger and heavier than a single-focal-length lens), speed (they're generally slower than a fixed-focal-length lens in the same focal-length range), and to some degree, image quality. (A fixed-focal-length lens will produce a sharper image than a zoom lens, because it can be corrected for its specific focal length, while a zoom's corrections have to be a compromise to incorporate all its focal lengths, but today's zoom lenses still produce excellent image quality.)

Zoom lenses come in many focal-length ranges, which vary from manufacturer to manufacturer, but some of the more popular ranges include 35-70mm, 75-150mm, and 80-200mm. One of the longest zooms is the 360-1200mm Nikkor (which lists for more than $10,000!).

Many zoom lenses incorporate a "macro" mode, particularly those made by accessory lens manufacturers, thus adding close-up capability to the multiple focal lengths.

Some zoom lenses have a different maximum aperture at the shortest focal length than at the longest, a concession that enables manufactur-

ers to produce better-performing zooms more economically.

Zoom lenses operate just like fixed-focal-length lenses, except you can change the focal length at will by operating the zoom control. It is a good idea to focus with the lens set at its longest focal length, because this provides the largest image and the least depth of field, making focusing much easier. Once focused, just zoom the lens back until you have the cropping you want, and shoot. (Note: There are also variable-focal-length lenses, which are similar to zooms, but require focusing at the focal length you intend to use, because changing the focal length also changes the focus. True zoom lenses will retain focus as the focal length is changed.)

If you don't mind the weight and speed penalty, a zoom lens can save you money by serving

A zoom lens is ideal for situations where you can't move, such as at plays, concerts, and the like. Here, a 75-150mm zoom was used to frame actresses Kimberly Woodward and Duchess Dale in a scene from "The Miracle Worker."

A one-touch zoom (left) is zoomed by moving the focusing ring backward or forward. A two-control zoom (right) is zoomed by turning the bottom ring, focused by turning the top ring. Below left

Some zoom lenses have smaller maximum apertures at their longest focal length than at their shortest focal length. This one is an f/3.5 lens at the shortest length, and an f/4.5 lens at maximum length. Center

The Minolta Varisoft 85mm lens offers varying degrees of softness by rotating the soft-setting ring. The ring is marked, so you can repeat any effect you like. Below right

the purposes of several fixed-focal-length lenses, and give you the convenience of quickly cropping your scene.

Soft-Focus Lenses

Soft-focus lenses produce soft, glowing effects in photographs. Several methods are used to achieve this effect, such as the one that employs a disk with a large center opening surrounded by a series of smaller openings. This produces a sharp image and many lesser out-of-focus images which can be quite pleasing in portraits, softening highlight areas while retaining sharpness in darker areas. Stopping the lens down sharpens the overall image, while opening the lens aperture softens it.

Autofocus Lenses

There aren't many autofocus lenses available today, aside from the ones built into autofocus cameras. In fact, there are only two: the Canon

Sima's 100mm soft-focus lens creates its effect by producing two images on the film, a sharp one and a soft one. The lens focuses continuously from six inches to infinity and includes two aperture disks (which can be used to control the degree of softness, since aperture affects this) and two neutral density disks (which allow changing exposure without changing aperture and therefore altering the soft effect), and is compatible with all modern 35mm cameras. It should be in camera stores by the fall of 1981.

35-70mm f/4 autofocus zoom, and the Ricoh XR Rikenon AF 50mm f/2 normal lens. Autofocus lenses generally operate on the principle that subject contrast is highest when the subject is sharply focused, so they contain some kind of sensor that "reads" contrast as the lens motor focuses, stopping when the contrast is highest (and therefore the subject is in focus).

The Canon 35-70mm provides the user with moderate wide-angle to short telephoto focal lengths, all with autofocusing. The Ricoh 50mm fits Ricoh and all K-mount cameras; the Canon lens fits only Canon cameras. When installed on automatic-exposure cameras, these lenses turn them literally into point-and-shoot cameras.

Just as there are some limitations on automatic exposure devices, there are some on autofocusing, but point-and-shoot people won't worry about them, and more serious photographers will quickly learn what the limitations are and how to deal with them.

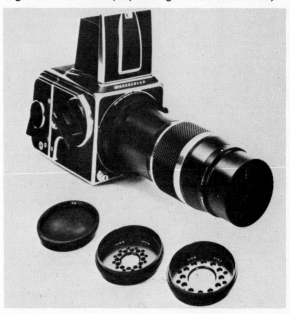

The Rodenstock Imagon 200mm soft-focus lens can be used with many medium-format cameras. It uses the same principle as view-camera soft-focus lenses: a large center opening that produces a sharp image, surrounded by small openings that introduce varying degrees of softness (depending on the disk used).

The Fujinon 180mm soft-focus for view cameras produces very pleasing portrait results. The large central opening produces a sharp image, while many smaller openings produce out-of-focus images to create a soft-focus effect.

Ricoh's AF 50mm f/2 autofocus lens combines with an autoexposure camera such as the Ricoh KR-10 so that all you need do is point the camera at your subject and push the shutter release, and you'll get properly exposed, sharply focused images in most situations. *Below left*

Ricoh XR Rikenon AF lens attaches to any K-mount camera and provides autofocusing from one meter to infinity. A switch disengages the autofocus and permits focusing down to 20 inches. Power is supplied by two AAA batteries. All lens attachments except close-up lenses can be used. Below center

Canon's autofocus 35-70mm zoom lens requires only 1.4 seconds to change from closest focusing distance to infinity. Below right

Filters

Photo filters are the photographer's "seasonings." The right filter can be just the touch needed to turn an otherwise ordinary photograph into a feast for the eyes. But like the chef's spices, filters must be used with discretion; overdoing it will spoil the entree.

Using Filters

Depending upon the type of filter, various methods are used to attach it to the camera lens. These methods are shown in the accompanying photos.

Colored filters absorb some of the light (they transmit mainly light of their own color, and little light of other colors), so you must give more exposure than you would if you weren't using a colored filter. Colored filters are assigned filter factors, which tell you how much more exposure you must give when using them. A filter factor of eight means you must give eight times as much exposure with the filter as you would without it. You could make this correction by using an exposure eight times as long as normal, or you could open the lens three f-stops (opening one stop would double the exposure, two stops would quadruple it, and three stops would increase it eight times—see the filter factor/f-stop increase table). Or you could divide

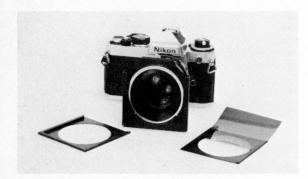

Screw-in filters just screw into the front of the lens. Also available are filters in rings without threads; these are attached to the camera using adapter rings.

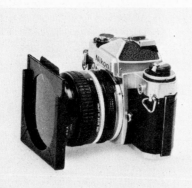

Gelatin filters are very fragile and easy to damage with fingerprints, so handle them carefully, only by the edges, and use a filter frame and holder to attach them to the camera. Shown are the Kodak gelatin filter frame and filter frame holder.

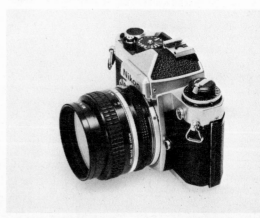

the ASA speed of the film you're using by the filter factor and set this number on your meter's ASA index, then expose as per the meter. If you use the camera's built-in through-the-lens meter, leave the ASA set at the real film speed; the meter will read the light transmitted through the filter and correct fairly accurately for the filter's absorption of light. It is more accurate to meter without the filter, then apply the filter factor, however, because meters don't "see" colors the same way film does.

For the most accuracy, you can do a simple test to determine the working filter factor for your filters. Just set up a Kodak Neutral Test Card (the "gray card," available at your local camera shop), and shoot one frame at the normal exposure, with no filter in place. Then put the filter over the lens, and shoot a series of exposures, starting with the normal exposure, and opening the lens in half-stop increments. Then examine the results. Find the filtered frame on which the density of the gray card is the same as it is on the unfiltered frame, and the amount of exposure correction used to produce that frame is the correct amount to use with that filter. The accompanying filter-factor table will give you filter factors for some of the more popular colored filters, so you'll know approximately how many stops of exposure increase to carry your test through.

Fog Filters

Fog filters make a scene look foggy—they soften the image, reduce contrast, mute colors, and produce halos around lights. Like diffusion filters, fog filters require no exposure compensation, but since exposure does play a role in the final effect you'll get, it's a good idea to bracket exposures each time you use a fog filter on a new subject, until you learn just what it will do. Also, like diffusion filters, fog filters come in various strengths. Start with a medium-strength filter; after you've used it for a while, you can decide if you could also use a stronger or weaker effect.

Star Filters

Star filters, also called cross-screens because of the crisscross pattern of lines they contain, turn point light sources in the picture into

If you have lenses that take different-size filters, you can get filters that fit the largest lens, and use step-up rings to attach them to smaller lenses. The step-up ring screws into the lens; the larger filter screws into the ring.

If you have to use a filter that is too small to screw into the lens, you can attach it with step-down rings. The ring screws into the lens; the smaller filter screws into the ring. Using a smaller filter can often cause vignetting (darkening of the corners of the picture), so this is not a good idea unless absolutely necessary.

"stars." These filters come in two-point, four-point, six-point, eight-point and 16-point varieties. There are also four-point variable star filters, with which the angle between the points can be varied by rotating one part of the filter.

These filters generally produce best results at medium lens apertures, because some produce a diffusion effect at large apertures, softening

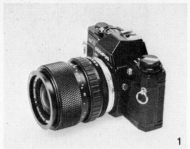

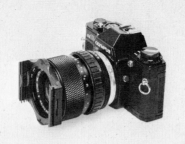

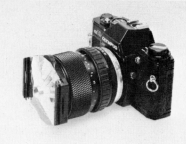

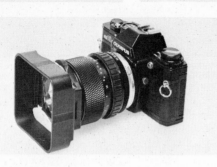

Another solution to the problem of mounting filters on different-size lenses is the filter system, such as this one from Cokin. Here, the adapter ring screws into the lens (1); it has a standard-size lip that holds the filter holder (2). Standard-size filters slip into slots in the holder (3). A lens hood can be attached to the holder (4). For multiple effects, several holders can be attached to one another (5).

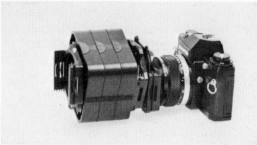

the image, and with some filters the star effect tends to fade away at small apertures. You can use the depth-of-field preview on a single-lens reflex camera to see what happens to the effect at various apertures with a given filter and lens combination. Star filters require no exposure compensation, but the effect does vary somewhat with exposure, the stars becoming more intense with more exposure, and less intense with less exposure, a fact you might want to experiment with, especially in night work.

Multiple-Image Filters

Multiple-image filters produce multiple images of a subject. They are quite sensitive to focal length, aperture, and subject distance.

Multiple-image filters produce multiple images of the subject. They're available in several varieties.

Using a long-focal-length lens will cause the main image to be large, and the secondary images to be mostly out of frame. Shooting with the lens aperture wide open produces a softer effect; shooting with the lens stopped down produces a sharper effect, and in some cases may actually show an out-of-focus image of the filter itself. Moving closer to the subject causes the images to merge together; moving farther back causes them to spread apart, and they may spread clear out of the frame.

Diffusion Filters

Diffusion filters spread bright areas of a scene into the shadow areas, producing a soft, glamorous look in portraits (and at the same time partially hiding wrinkles and skin blemishes), and a pleasant ethereal effect in scenics. The precise effects vary from one manufacturer to another, but the best diffusion filters only spread the highlights into the shadows; they don't make the image unsharp, severely reduce contrast, or severely mute colors in color shots. It's a good idea to shoot a couple of frames with a diffusion filter in the camera store, then have

A diffusion filter softens the image to various degrees, depending on the strength of the filter and sometimes on the lens aperture used. Photo No. 1 was made with no filter; photo No. 2 was made with PicTrol at a moderate setting with the lens wide open.

PicTrol has plastic teeth that can be opened and closed using the ring around the plastic case to control the amount of diffusion produced.

PicTrol is attached to the camera by epoxying the adapter ring onto the back of the filter. Adapted PicTrols are also available, with an adapter ring attached.

the film processed and examine the results to see if you like the effect before buying a diffusion filter.

Besides varying in degree of contrast reduction and image sharpness, diffusion filters come in various strengths. Generally, stronger filters work best with harsh, contrasty lighting, while weaker ones work well with softer lighting, but it really depends on what you want for a particular picture.

One unique diffusion filter is the Arkay Pic-Trol, which was originally produced as an enlarger diffuser, but has been successfully adapted to on-camera work. The PicTrol consists of a rather large circular plastic case with a hole in the center. Clear plastic teeth open and close this center hole in a diaphragm-like manner when the control ring is rotated. When the center hole is completely open, no diffusion occurs. As the teeth are closed, more and more diffusion occurs, until the teeth are completely closed, producing so much diffusion that you can't tell what you're photographing. So you can set any amount of diffusion you want.

The PicTrol can be attached to the camera lens by epoxying an appropriate-size adapter ring onto the filter, and at least one company offers adapted PicTrols ready for camera use. One thing to bear in mind is that the center hole in the PicTrol is only about 40mm in diameter, and so will cause vignetting with large-diameter lenses, but it works quite well on 100-135mm lenses for 35mm SLRs.

With most diffusion filters, and particularly with the PicTrol, the shooting aperture has an

FILTER FACTORS OF COMMON FILTERS

Filter	Daylight Factor	Tungsten Factor	Color
3	1.5	—	Yellow
4	1.5	1.5	Yellow
6 (K1)	1.5	1.5	Yellow
8 (K2)	2	1.5	Yellow
9 (K3)	2	1.5	Yellow-Green
11 (X1)	4	4	Yellow
12	2	1.5	Yellow
13 (X2)	5	4	Yellow-Green
15 (G)	2.5	1.5	Yellow
23A	6	3	Red
25 (A)	8	5	Red
29 (F)	16	8	Red
47 (C5)	6	12	Blue
47B	8	16	Blue
50	20	40	Blue
58 (B)	6	6	Green
61 (N)	12	12	Green

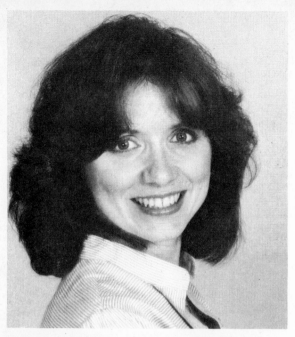

A diffusion filter from the Cokin system produces a soft effect without greatly affecting contrast.

Star filters can be used to soften image.

Variable-vignetters produce diffusion-like effect; extending the vignetter produces a more softening effect. *Above and Below*

effect on the result. At large apertures, the effect is greatest; with the lens stopped all the way down, the diffusion effect may completely disappear. So it's a good idea to use the camer's depth-of-field preview to see what the effect looks like at the shooting aperture before making the exposure. Diffusion filters require no exposure compensation, although varying the exposure can produce different diffusion effects with some filters.

Polarizers

Polarizers can reduce or eliminate reflections from nonmetallic surfaces, and can darken a blue sky in both color and black-and-white photographs. (If you used a red filter to darken the sky in a color photo the whole scene would take on a red cast.)

Polarizers work best when used at certain angles to the reflecting surface and to the light source, but all you have to do to use them is look through them. If you use a single-lens reflex camera, just put the filter over the lens and look through the viewfinder. Rotate the polarizer until you see an effect that you want. If you never see an effect that you want, then the angles are wrong, so try another angle.

Some through-the-lens metering systems don't work very well with polarizing filters, so it's best to just apply a filter factor of 2.5 (1 1/3

FILTER FACTOR/F-STOP INCREASE TABLE	
Filter Factor	Open Lens This Many Stops
1	0
1.25	⅓
1.5	⅔
2	1
2.5	1⅓
3	1⅔
4	2
5	2⅓
6	2⅔
8	3
10	3⅓
12	3⅔
16	4
20	4⅓
24	4⅔
32	5
40	5⅓
48	5⅔
64	6
80	6⅓
100	6⅔

For filter factors between the numbers shown, use the f-stop increase for the filter factor closest to the factor of your filter.

If you see a reflection from a nonmetallic object in your scene, and don't want to (1), just rotate the polarizing filter until you don't see it (2). Sometimes the reflection will add to your picture though; think about that before eliminating it.

stops) to a normal meter reading when using a polarizer. You also might want to bracket exposures, because the amount of exposure changes the effect produced to some degree.

Haze, Ultraviolet and Skylight Filters

Haze and ultraviolet filters absorb ultraviolet radiation, to which film is "overly" sensitive, relative to the human eye. These are "automatic" filters—if ultraviolet radiation is present, they absorb it; if it isn't, they do nothing. Some photographers like to keep a UV filter on the lens at all times as a protective measure (better the filter should be damaged by an accident than the front lens element).

Skylight filters absorb a little blue light along with the ultraviolet, and are used to reduce the bluish cast caused by shooting in the shade (which is illuminated mainly by blue light from the sky, hence the filter's name) or on overcast days.

Fluorescent-Light Filters

Fluorescent-light filters are used with color film to correct the off-color results produced when shooting under fluorescent lighting. There are two types of fluorescent-light filters: "D," for use with daylight-balanced color films, and "B," used for type B (tungsten-balanced) films. Both filters require about one stop of additional exposure.

The color corrections produced by fluorescent-light filters provide fairly good results, but won't be perfect, because fluorescent lighting produces a strange wavelength-emission spectrum, and there are many types of fluorescent light tubes, each of which has its own particular peculiarities. More precise corrections can be obtained by using various combinations of color compensating filters; exactly which combination to use for a specific film with a specific type of fluorescent tube can sometimes be obtained from the manufacturer of the film or fluorescent tube. When shooting under fluorescent lighting, it's a good idea to use color negative rather than slide film whenever possible, because further color correction can be made when printing the negatives, if needed.

Neutral Density Filters

Neutral density filters cut down the amount of light entering the lens without otherwise affecting it. They are useful in several situations. If your camera is loaded with fast film, and you have to shoot outdoors in bright sunlight, you can use a neutral density filter to cut down the amount of light entering the lens, thus making exposure possible when it wouldn't be otherwise. If you are shooting a portrait with a distracting background, you can use a neutral density filter to cut down on the light so you can shoot at a large aperture, thus throwing the distracting background so far out of focus that it is no longer distracting. If you are shooting moving subjects, and want to really emphasize the motion, use a neutral density filter to cut the light down so you can use a slow shutter speed to really blur the background as you pan the camera to keep the subject sharp. If you use fill-in flash outdoors with a focal-plane-shutter camera, you can use a neutral density filter to cut the light entering the lens down enough so that you can use the necessary 1/60-second shutter speed for flash pictures.

Colored Filters

Colored filters are used in black-and-white photography to alter tonal relationships among objects in a scene. A colored filter will lighten objects of its own and similar colors, and darken objects of its complementary color in a black-and-white photograph. Yellow, orange and red filters will darken blue skies to make white clouds really stand out. A light red filter will lighten red blemishes on a model's skin (but don't use a dark red filter, or the skin itself will be lightened to a chalky white in the print). If there are two important subjects in a scene that are similar in brightness but different in color, the contrast between them can be dramatically increased by using a filter of the same color as the object you want lightened.

A special colored filter, the Kodak Wratten No. 90 Monochromatic Viewing Filter (catalog No. 149 4871 in two-inch square gelatin form) will give you a good idea of how a scene will reproduce in a black-and-white photograph (i.e., how much difference or similarity there will be among the tones of the objects in the scene). To see what effect a colored filter will have on the scene, view the scene through a "sandwich" consisting of the colored filter and the viewing filter. The Kodak gel is quite delicate; Zone VI Studios (Newfane, Vermont 05345) offers viewing filters mounted in clear glass and plastic, with a handy neckstrap. Zone VI also offers viewing filters for color work, which take

Shutter speed of 1/1000 freezes the moving car, producing a static picture (1). Using a neutral density filter to cut light down allowed use of a 1/30 second shutter speed for more dynamic results (2).

Film is more sensitive to blue and ultraviolet radiation than our eyes are, so the sky appears lighter in a black-and-white photograph than we'd expect it to, and clouds blend into it (1). A yellow filter (2) will restore the sky to the way it looked to us when we shot the picture, and a red filter (3) will make the sky even darker for a dramatic effect.

Here's an unfiltered shot of some lit signs at night.

Here, a four-point star filter was used over the lens.

Here, a fog filter was used. Note the glow around the lights, the loss of contrast, and the overall foggy feeling.

Laser-produced diffraction grating produces colored slashes around lights.

Infrared red filter.

Infrared green filter.

Infrared yellow filter.

into consideration the higher contrast properties of color films.

In color photography, colored filters are used to produce proper color rendition when the lighting is not the sort the film is meant to be exposed by (see the accompanying table), and for special effects. For example, an orange or red filter can be used to add "punch" to a rather dullish sunset.

One great special-effect use for colored filters is the three-filter technique. This involves photographing a subject that contains both stationary and moving elements, making three exposures on one frame of film. One exposure is made with a red No. 25 filter over the lens; the next, with a green No. 61 filter; and the last with a blue No. 38A filter. (These are Kodak Wratten designations, and may vary with other manufacturers' filters.) Take a meter reading of the scene in the normal manner, then open the lens one stop from that setting, and make the three exposures with the camera thus set. Since red, green and blue are the basic components of white light, anything in the scene that is not moving will appear normal in the resulting picture. But anything that is moving will take on colors, depending on where it was on the film when each filter was used. Waves breaking on a beach, and clouds blowing through the sky are good subjects for this technique.

Diffraction Gratings

Diffraction gratings break up point sources of light into colors of the spectrum. Normal diffraction gratings produce a straight slash of spectral colors from a light source; laser-produced diffraction gratings produce swirls and stars of

In color photos, red berries against green leaves have plenty of color contrast to separate them. But since they both reflect the same amount of light, they appear the same shade of gray in a black-and-white photo. In order to produce contrast between them, you can use a red filter to lighten the red berries and darken the green leaves (1), or conversely, use a green filter to darken the red berries and lighten the green leaves (2).

spectral colors, and often multiple images as well.

Other Filters

There are many other types of special-effects filters. For a complete discussion of them and all filters, see Petersen's *Photo Filters and Lens Attachments.*

COLOR FILTERS FOR COLOR PHOTOGRAPHY			
If your film is balanced for:	And you want to expose it by:	Use this filter or its equivalent:	Or your pictures will look too:
Daylight	3200°K. light	80A	Orange
Daylight	3400°K. light	80B	Orange
Daylight	Clear flash bulbs	80C or 80D	Orange
3200°K. light (Type B film)	Daylight	85B	Blue
3400°K. light (Type A film)	Daylight	85	Blue
3200°K. light	3400°K. light	81A	Blue
3400°K. light	3200°K. light	82A	Orange

A red filter used with Kodak High Speed Infrared black-and-white film produces jet-black skies and water, and white foliage. (Usually, that is. Infrared film is a bit unpredictable, because you can't see infrared radiation, and your light meter can't accurately measure it.) Above

Monochromatic viewing filter from Zone VI Studios can be used to help visualize how colored objects in a scene will reproduce as tones of gray in a black-and-white photograph. Below right

Other Lens Accessories

Tele-extenders (also known as tele-converters) are short extension tubes that contain glass elements. They fit between the camera body and lens and virtually double the focal length of the lens. (There are a few 3X tele-extenders, which triple the focal length of the lens.)

This is the obvious advantage of a tele-extender. A 135mm lens becomes a 270mm, a 200mm becomes a 400mm, and so on. It's an inexpensive way to acquire that long focal length for sports, nature, and other subjects. But tele-extenders also offer a not-so-obvious advantage. While they double the focal length of the lens, the lens' minimum focusing distance remains the same. If you have a 50mm lens that focuses down to 18 inches, add a tele-extender and you now have a 100mm lens that focuses down to 18 inches. This enables you to produce larger images of small objects than would be

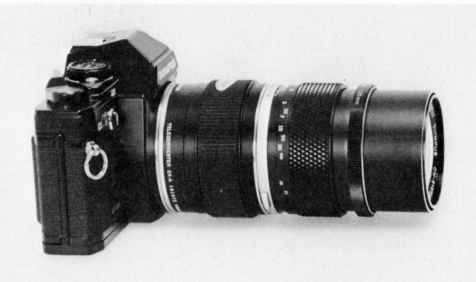

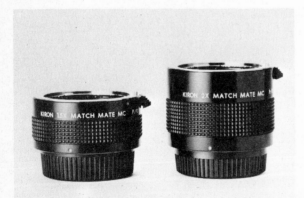

Kiron Match Mates are 1.5X and 2X tele-extenders designed especially for Kiron telephoto and zoom lenses. They provide excellent results at all focusing and aperture settings.

Matched tele-extenders are also available from some camera manufacturers, like this one from Olympus.

Soligor makes this 1.7X tele-extender for the subminiature Pentax A110 interchangeable-lens camera.

1-2. A matte box is attached to the lens via a screw-in adapter ring that has a lip for mounting onto the box.

3. Cards containing cutouts of various shapes can be placed in the rear slot of a matte box to turn out-of-focus highlights into the shape of the cutout. It's best to work with a 100-200mm lens and shoot with the aperture wide open, making out-of-focus highlights as large and unfocused as possible.

possible with a 50mm or 100mm lens alone (since a 100mm lens normally has a minimum focusing distance in the neighborhood of 39 inches). A normal 50mm lens on a 35mm SLR with a 2X tele-extender and a +4 and +1 close-up lens will allow you to produce almost life-size images on your film.

Of course, as with most photographic equipment that provides advantages, tele-extenders are not without their disadvantages. First, an image made with a tele-extender isn't going to be quite as sharp as one made with a prime lens of equivalent focal length, especially at large apertures. But the loss of sharpness caused by most tele-extenders isn't great enough to be noticeable unless you make huge blow-ups from your negatives or slides. Some companies are now making "matched" tele-extenders de-signed especially for a specific lens in their line, and these perform very well.

A second disadvantage of tele-extenders is that they cost lens speed. A 2X tele-extender causes a light loss of two stops, turning your 50mm f/1.4 lens into a 100mm f/2.8 lens. Through-the-lens metering systems will automatically compensate for this. The main problem occurs when you use your 2X tele-extender to turn your 200mm f/5.6 lens into a 400mm f/11 lens, and in the process may render your focusing screen's split-image microprism unusable. In this case, put as much light as you can on your subject, and use the plain matte part of the focusing screen to focus.

Matte Boxes

Matte boxes are large, bellows-type lens shades that permit you to produce a variety of special effects. By using the proper matte-box insert cards, you can put the same subject in several places in one photograph, put one subject in the center of another subject, create vignettes, and turn out-of-focus highlights into stars or other shapes. The accompanying photos will give you some idea of the effects available and how to produce them.

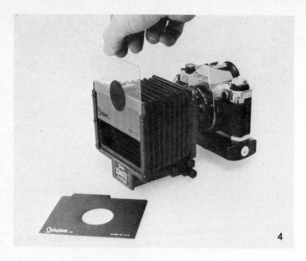

4

6

4-6. Positive/negative montage masks let you put one image in the center of another. First, put a center-spot mask in the front slot of the matte box (4) and shoot your background subject; then put an opaque mask with a center hole in the matte box and shoot your center subject (5). One result is shown in photo No. 6.

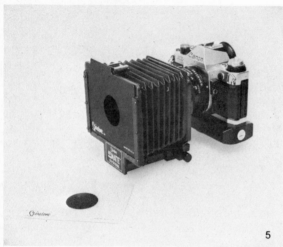

5

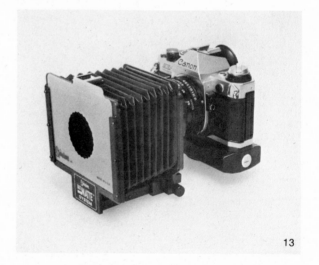

13

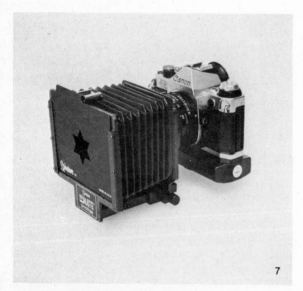

7

14

7. Opaque masks with shaped cutouts allow you to shoot a subject with a shaped vignette.

13-14. Translucent vignetting mask (13) produces a soft white vignette (14). Large apertures produce a soft transition between center and vignette; small apertures produce a harsh transition.

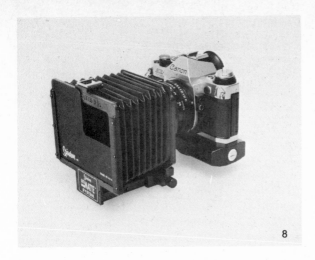

8

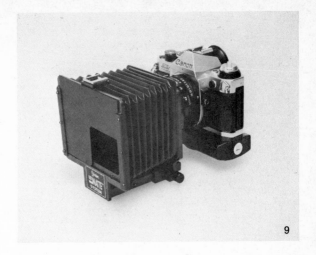

9

10

11

8-12. This mask permits you to put the same subject in up to four places in one photograph. First, it is positioned to expose the top left portion of the scene (8); subject is posed there and the exposure is made. (The camera must be mounted on a tripod if the background is to have continuity, and the camera must be capable of making in-register multiple exposures.) Next, the mask is positioned to expose the lower left portion of the scene (9), subject is situated there and exposure is made on the same frame of film. The process is repeated for the lower right (10) and upper right (11) portions of the scene, all on the same frame of the film. The final result (12) shows the subject in four different parts of the scene. Careful positioning of the subject is important; note that legs in the right rear portion of the scene overlap the lower-right portion of the scene. Therefore, legs appear in the segment of the scene that had already been exposed, so the background shows through them. (Another reason for overlap problems is that the matte box was left in the car on a hot day, and all of the masks warped, as phonograph records do under similar circumstances. Never store any photo equipment in a sealed car on a hot day!)

12

This lens hood (for a Contax Distagon 15mm lens) looks like this because of the extreme wide angle of view of the lens. If a standard circular lens hood were used, it would appear in the picture as a vignette.

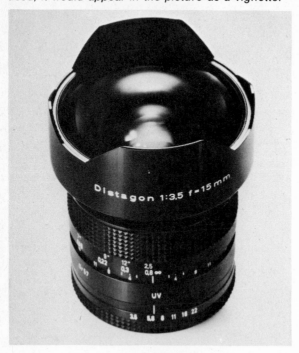

Lens Hoods

Lens hoods prevent non-image-forming light from striking the front element of the lens and causing lens flare. It's a good idea to use a lens hood for all shooting, and certainly any time you're shooting with light coming from anywhere but behind you. (Lens flare reduces contrast and sharpness of the image and produces "spots" of light in the scene.)

The main thing to know about lens hoods, other than prevention of lens flare, is to use the right length. If you use one that is too short, it won't be very efficient; if you use one that is too long, it will cause vignetting. Lens hoods provided by the lens manufacturer generally are about optimum for the lens with which they are provided. Accessory lens hoods should be "tested" for vignetting by shooting a frame wide open and a frame stopped down with the hood on the lens with which you intend to use it.

While modern multicoated lenses have pretty good anti-flare characteristics, flare can still occur if no lens hood is used. (It can happen even if a lens hood is used, but only if you're shooting almost straight into the light.)

Lens hoods help keep stray light from striking the front element of the lens and lessening image quality.

Right-Angle Adapter

A right-angle adapter, or mirror adapter, fits on the front of the camera lens and permits you to take a picture at a right angle to the direction in which you are pointing the camera. It contains a mirror at a 45-degree angle that reflects the image entering at a 90-degree angle to the lens to the film plane in the camera. These devices are best used with lenses in the 135-200mm range. The front of the device is a dummy lens element to "fool" subjects into thinking it's a normal lens and you are shooting straight ahead. The right-angle adapter causes the image to be reversed laterally (because of the mirror), although it does appear right side up, so you have to correct this when making a print by inserting the negative into the enlarger emulsion side up.

Stereo Adapter

A stereo adapter attaches to the front of the camera lens and produces two images on one frame of film. These images are made through two openings in the device, located about the same distance apart as are human eyes, and when the images on the film are viewed in the accessory stereo viewer, they appear to be in 3-D. These devices should be used only with normal-focal-length lenses, and at apertures in the f/5.6 - f/8 range.

Pentax 90-degree Mirror Adapter II permits you to photograph a subject unawares.

Pentax Stereo Adapter II (on camera) and viewer permit stereoscopic (3-D) photographs on single frames of 35mm slide film.

77

Close-Up Equipment

Close-up photographs are produced by getting close to the subject. Unfortunately, normal camera lenses won't focus closely enough to produce close-up photographs, so some means of making the lens focus closer than is normally possible is required. There are several such means.

Close-Up Lenses

The simplest means of making a lens focus closer than its usual minimum focusing distance (at least from the photographer's standpoint) is the close-up lens, or plus-diopter. A close-up lens looks like a colorless filter, and attaches to the front of the lens like a filter. It is similar to an eyeglass correction lens for farsightedness, and just as the eyeglasses allow the eye to focus on nearer objects than is otherwise possible, the close-up lens allows the camera lens to focus on nearer objects than would be otherwise possible.

Close-up lenses come in a variety of strengths, designated by diopter numbers such as $+1$, $+2$ and $+3$. The diopter number indicates how close the close-up lens will allow you to focus the camera lens, in fractions of a meter. For example, a $+1$ close-up lens will allow you to focus on objects one meter away; a $+3$ close-up lens will allow you to focus on objects ⅓ meter away (from the front of the lens). Close-up lenses can be combined, and when they are, their strengths are added: a $+1$ close-up lens and a $+3$ close-up lens equal a $+4$ close-up lens, allowing you to focus on objects ¼ meter away. (Always attach the higher-numbered close-up lens to the camera lens, and then attach the lower-powered close-up lens to the higher-powered one when using a combination of close-up lenses.)

It doesn't matter what the focal length of the camera lens is; a $+2$ close-up lens will always let you focus ½ meter away, a $+3$ will let you focus ⅓ meter away, and so on. (Assuming the camera lens is focused at infinity—more on this in a moment.) Naturally, the longer the focal length of the camera lens, the larger the image size it will produce at any given distance from the subject, so you'll get greater magnification with any given close-up lens when you use it with a longer-focal-length camera lens.

Using close-up lenses is simple. Just attach one to your camera lens, with the lens focused at infinity, and you can focus as closely as the diopter number indicates you can (one meter for a $+1$ lens, ½ meter for a $+2$ lens, etc.). If this isn't close enough, turning the camera lens' focusing ring toward its minimum focusing distance will allow you to get still closer. If you turn the camera lens' focusing ring to its minimum focusing distance, and still aren't close enough to your subject, then try a stronger close-up

Close-up lenses are handy for subjects that don't require a lot of magnification, those subjects which your normal lens won't focus quite closely enough photograph the way you want to.

Close-up lenses generally come in sets of three (either $+1$, $+2$ and $+3$, or $+1$, $+2$ and $+4$). This set is from Minolta.

The +10 close-up lens is the strongest that will still produce good results for most subjects.

lens (setting the camera lens' focus back to infinity). If you use a single-lens reflex camera, you can see exactly what the image looks like in the viewfinder, in terms of sharpness and size, and since problems of parallax and focus make close-up photography a matter of guesswork with non-SLR cameras, it is strongly recommended that an SLR be used for close-up work of any kind.

Since you can see through the viewfinder of an SLR camera how closely you can focus when using close-up lenses, there is really no reason to worry about any mathematical calculations. But for those of you who are into numbers, you can calculate how closely you can focus when the camera lens is not focused at infinity. Just multiply the distance set on the camera lens' focusing ring by the focal length of the close-up lens in use, then divide this number by the sum of the distance set on the camera lens focusing ring and the focal length of the close-up lens. (The focal length of the close-up lens is the same as the distance it lets you focus on with the camera lens set at infinity: one meter for a +1 close-up lens, ½ meter for a +2, etc.) For example, if you are using a +2 close-up lens and set the camera lens at three feet, the equation would be: 36 inches (or three feet) times 13 inches (⅓ meter) = 468 inches. Divide this by

36 inches plus 13 inches (49 inches), and you get 9½ inches, which is how closely you can focus with the +2 close-up lens and the camera lens focused at three feet. (Make sure you convert all measurements to the same units before doing the math; don't mix metric and feet-and-inches figures.)

While they are the simplest close-up devices to use, close-up lenses do have some limitations. First, they cause a loss of image quality (sharpness), particularly at the edges of the pic-

Extension tubes will let you get close enough to isolate and enlarge otherwise too-small-to-make-a-good-picture subjects, like small flowers. Photo No. 1 was made with a normal lens at the closest focusing distance; photo No. 2 was made with an extension tube inserted between the same lens and the camera.

Extension tubes are the in-between close-up gear, in more ways than one. They fit in-between the camera body and the lens physically, and in the close-up equipment pecking order, they rate in-between close-up lenses and bellows units, providing greater magnification and sharper results than the close-up lenses, but providing less magnification and versatility than bellows units.

Coins are another good subject for extension tubes. They'll let you record a large enough image on film so that you can really blow it up for study when you print the negative or project the slide.

ture. While this loss is barely noticeable with the lower-powered close-up lenses (+1, +2), it becomes worse as the diopter strength increases. The loss of image quality is especially noticeable when close-up lenses are combined. The second limitation of close-up lenses is magnification. Even the higher-numbered close-up lenses won't let you focus closely enough to produce 1:1 (life-size) magnification, whereas the devices to be discussed on the next few pages will take you from life-size to many times life-size. So close-up lenses are mainly for the casual close-up buff, the photographer who just wants to shoot an occasional flower and doesn't want to spend a lot of money on equipment.

Extension Tubes

If you are serious about close-up photography, and want magnifications greater than life-size on the film (remember, you can always blow-up the negative to almost whatever size you want), the equipment you need is either a set of extension tubes or a bellows unit. Both of

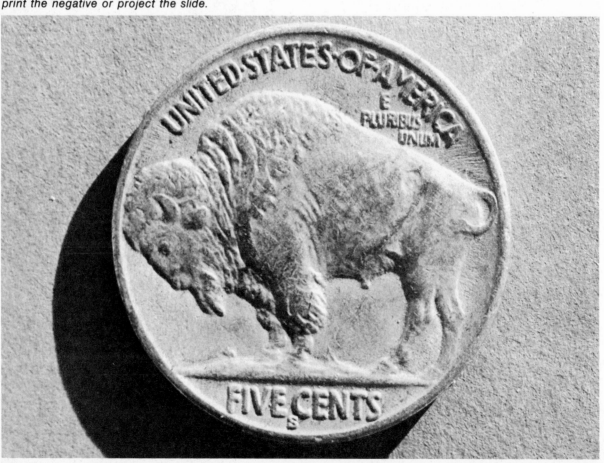

these will take you into the realm of greater-than-life-size magnification while using your camera's normal lens.

Extension tubes are just spacers that fit between the lens and camera body, thus increasing the distance between the optical center of the lens and the film, and thereby allowing you to focus closely enough to a subject to produce larger-than-life images on your film. They generally come in sets of three tubes of different lengths, and can be used alone or in combination to provide various degrees of magnification, generally from around one-half life-size to about twice life-size with a normal lens. (Shorter-than-normal focal lengths produce greater magnification with a given amount of extension, and longer-than-normal focal lengths produce less magnification.)

Since the increase in distance from the aperture ring of the lens to the film plane reduces the relative size of the lens opening, you must give additional exposure to compensate for this when using extension tubes. If your camera has a through-the-lens light meter, it will automatically do this (although stop-down metering will be required unless you're using automatic tubes—see the section on bellows units for a discussion of stop-down metering).

If you don't have a through-the-lens meter, you'll have to calculate the amount of compensation needed. The formula you need is:

$$f = FL/A$$

where f is the effective f-stop of your lens/extension-tube combination, FL is the effective focal length of the lens/extension-tube combination (the focal length of the lens plus the length

This is the Minolta Auto Bellows III.

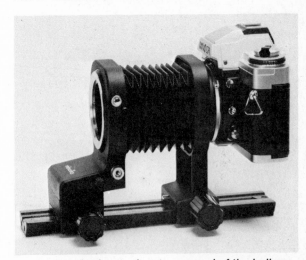

The camera body attaches to one end of the bellows.

For highly-enlarged close-ups the bellows is the way to go (unless you want to get into shooting with a microscope). This is a full-frame print from a 35mm negative made with 12.5mm micro bellows lens on Minolta Auto Bellows III, using partial extension of bellows.

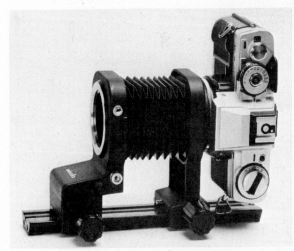

On the Minolta Auto Bellows III, the camera body can be rotated to a vertical position for vertical-format shots.

81

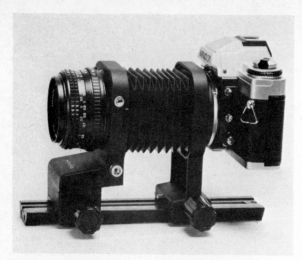

The lens attaches to the other end of the bellows.

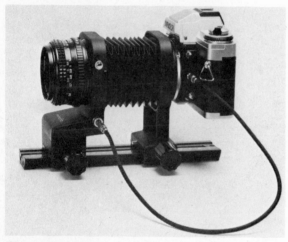

The cable release connects the camera cable-release socket and the bellows cable-release socket.

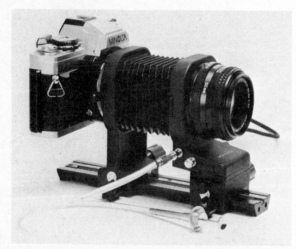

A second cable release attaches to the bellows shutter-release button.

of the extension tube being used), and A is the diameter of the aperture at which the lens aperture ring is set. To determine A, just divide the f-number to which the aperture ring is set into the focal length of the lens.

For example, let's say you're using a 50mm lens with 50mm of extension tubes, with the lens set at f/8. The effective focal length of the lens/extension-tube combination (FL) is 100mm (50mm for the lens plus 50mm for the extension tubes). The diameter of the aperture (A) is 6.25mm (50mm divided by f/8). Plugging these into the formula, you get:

$$f = FL/A$$
$$f = 100mm/6.25m = 16.$$

The effective aperture with the lens set at f/8 is f/16, a difference of two stops. This means two stops of light are lost with this lens/extension tube combination. (Whenever you use an extension equal to the focal length of the lens, you lose two stops.) So if our non-through-the-lens meter reading says to expose with 1/125 at f/8, for example, we have to give two stops more exposure to compensate for the light lost because of the extension. We must expose for 1/125 at f/4.

Obviously, a camera with a through-the-lens meter is very convenient for extension-tube and bellows work.

Other than determining exposure, using extension tubes is quite simple. Just attach them between the camera and lens, then move closer and closer to your subject until it is in focus. If you want a bigger image, use more extension tubes; if you want a smaller image, use less extension. A handy note: If you want a life-size

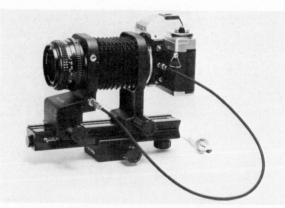

The entire bellows unit attaches to the focusing rail. The knob on the focusing rail gradually moves the whole bellows assembly forward or back for minute control of focusing. The focusing rail attaches to the tripod.

magnification, use an amount of extension equal to the focal length of the lens you're using—50mm for a 50mm lens, 100mm for a 100mm lens, etc.

The Bellows

The bellows functions as an infinitely variable extension tube. It is a very versatile tool for the serious close-up photographer, enabling him to produce magnifications up to about three times life-size on the film with a normal 50mm lens, and up to 20X life-size with special bellows lenses.

Using a bellows is pretty easy. Set it up (see the accompanying photos), and consult the tables in the bellows instruction manual to find a lens/bellows-extension combination that will produce the amount of magnification you want (if a specific magnification is important), or just attach a lens to the bellows to see how close to your subject it will bring you. Remember that the shorter the focal length of the lens you're using, the greater the magnification you'll get with a given amount of bellows extension.

Since changing the amount of extension also changes the magnification, it is normally best to set the bellows for the magnification you want and then focus by moving the whole bellows/camera unit closer to or farther from the subject. This is most easily and efficiently done by attaching the bellows to a focusing rail, and then attaching the focusing rail to a tripod. Use the tables in the instruction book to see how far

from the subject the lens must be, and set the tripod up that far from the subject, then use the knob on the focusing rail to gradually move the bellows closer to or farther from the subject until it is in sharp focus. Normally, you'll keep the lens focused at infinity; bellows lenses have no focusing mounts at all. A camera lens will not focus out to infinity when attached to a bellows; the bellows is for close work.

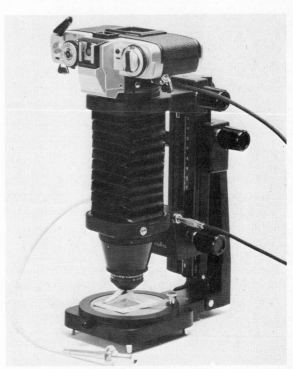

The macro stand holds both the subject and the bellows assembly for precise, sharp results. Even so, at great magnifications it is a good idea to lock the camera mirror up (if possible), because vibration is greatly magnified along with the image.

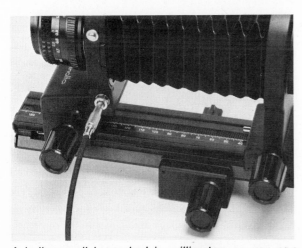

A bellows rail is marked in millimeters so you can readily figure out how much extension is used. The tables in the bellows instruction manual tell you how much extension to use with a given lens for a given magnification, and how much exposure compensation is necessary.

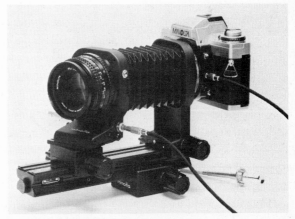

The lens standard swings and shifts for image and depth-of-field control, as does the view camera.

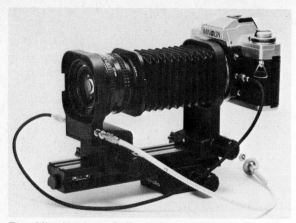

The Minolta Auto Bellows III lens standard rotates completely, so the lens can be reversed just by turning the standard instead of removing the lens and using the reversing ring.

If the camera is mounted on the focusing rail sideways, the focusing rail can be used to move the camera sideways for precise tracking. This is a good way to shoot several frames of a subject that is too large to cover in just one shot, while retaining precise magnification.

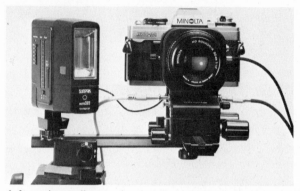

A focusing rail can also be used to hold the flash at an angle to the subject to provide modeling and bring out texture, which is not possible with flat on-camera flash.

One thing you'll notice when you look through the viewfinder with the bellows attached is that the greater the magnification, the less the light transmitted to the viewfinder—and to the film. This light loss ranges from about two stops at a 1X (life-size) magnification to almost nine stops at a 20X magnification. A through-the-lens meter will automatically compensate for this light loss, but that doesn't help you focus the dark image. When working at very great magnifications, try to provide as much light on the subject as possible.

Bellows units, like extension tubes, come in automatic and manual forms. Automatic means that you see the image in the viewfinder at maximum aperture no matter where the lens' aperture ring is set (this makes for easier focusing), and the cable release will automatically stop the lens down to the selected aperture just before it trips the shutter. With manual bellows units, you have to set the lens' aperture ring at its maximum aperture for focusing and composing, then set it for the desired f-stop before making the exposure.

Both types of bellows units require stop-down metering, because the bellows disconnects the open-aperture metering linkage between the camera body and lens. Stop-down metering is done by setting the lens aperture ring to the desired setting, and, with auto bellows, using the stop-down button on the bellows lens standard to actually stop the lens down to the set aperture. The meter is then turned on and the shutter speed set according to the match-needle indicator, or letting an aperture-priority automatic-exposure camera select a shutter speed.

(Note: Shutter-priority automatic cameras must be used in manual mode with bellows units, because the linkage that allows the camera to set an aperture in shutter-priority mode is disconnected by the bellows unit.)

Electronic flash is an ideal light source for close-up work with a bellows, because its brief duration minimizes subject movement and camera vibration effects, and it is sufficiently bright when used at close distances to permit stopping the lens down to maximize depth of field (which is about nil at high magnifications). To determine the proper exposure when using electronic flash for bellows work, measure the distance between the flash and the subject (in fractions of a foot) and divide this distance into the flash unit's guide number for the film you're

1. A bellows lens uses bellows and the physical movement of the camera toward and away from the subject for focusing; it has no focusing capability on its own. But it's optimized for close-up photography, and produces noticeably better results at high magnifications than normal camera lenses do.

2. This Minolta 25mm Bellows Micro Lens is actually a microscope lens that attaches to the bellows via an adapter. This lens will produce up to 9X magnification when attached to the Minolta Auto Bellows III, with fine results. A 12.5mm micro lens is also available for even greater magnification (up to 20.5X).

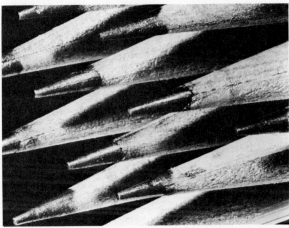

3. Here's a sample of what the 12.5mm Bellows Micro Lens can do, turning pencils into a graphic graphite composition. Photo courtesy of Minolta.

using. This will give you the uncorrected f-stop to use. Next, refer to the tables in the bellows instruction manual to find the number of stops the exposure must be increased to compensate for the amount of bellows extension being used. Open the lens this number of stops from the guide-number-calculated aperture (which was probably well beyond the range of your lens anyway), and you're ready to go. If this shooting aperture is not the one you wish to use, just move the flash unit closer to the subject (to permit using a smaller aperture) or farther away (to permit using a larger aperture), and recalculate the stop. It is a good idea to bracket exposures around the calculated figure, by opening and closing the lens in ½-stop increments, due to the variables involved (such as the reflectance of the surroundings).

Bellows Lenses

As you'd expect from the name, bellows lenses are designed both optically and mechanically to be used on a bellows unit. They are optically optimized for close-up photography, and have no focusing ring—focusing is done by using the focusing rail on the bellows.

Because they are especially designed for use on a bellows, bellows lenses produce better results than normal camera lenses for such work. The results are sharper, and the flat field of the bellows lens will produce much greater edge sharpness when using the bellows to shoot flat subjects such as postage stamps.

Bellows lenses generally come in 50mm and 100mm focal lengths, and produce the same size image with any given amount of bellows extension as a normal camera lens of the same focal length would. Some manufacturers also offer shorter focal length bellows lenses—for example, the Minolta 25mm and 12.5mm bellows micro lenses—which produce greater magnifications. The 12.5mm lens, when attached to the Minolta Auto Bellows III at maximum extension, using the M-2 adapter ring, produces a magnification of 20.5X—that's 20.5 times life-size, on the film.

Some bellows lenses, designated "auto," have automatic diaphragms, so that you can

view and focus at maximum aperture no matter where the aperture ring is set. Others have manual diaphragms, meaning you will view and focus at whatever aperture the lens is set for, so you have to set the lens for its maximum aperture for focusing, then stop it down to your chosen shooting aperture before making the exposure. If you're really serious about close-up work, you should get a bellows lens for your bellows. Which focal length depends on the magnification you want. With most bellows, a 100mm bellows lens will produce magnifications from 0.1X to 1.2X, depending on the amount of bellows extension used; a 50mm lens will produce magnifications from 0.8X to 3X; a 25mm lens, from 3X to 9X; and a 12.5mm lens from 8X to 20X (these are ballpark figures; exact figures will vary a bit depending upon the particular pieces of equipment employed). At minimum bellows extension, the 100mm bellows lens can focus out to infinity, but shorter focal lengths will not.

Macro Lenses

Macro lenses have extended focusing mounts so that they will focus much closer than ordinary lenses of the same focal length will—close enough to produce a half-life-size image on the film. Macro lenses generally come with a short extension tube that will permit focusing down to life-size magnification (but they won't focus out to infinity with the extension tube attached). A few macro lenses will focus down to 1:1 (life-size) magnification without an extension tube.

There was a time when macro lenses were decidedly inferior to ordinary lenses of the same focal length when used for normal photography, since macro lenses are designed to provide optimum results in close-up work, but today's macro lenses generally produce excellent results throughout their focusing range. In fact, some professional photographers use a 100mm macro lens as their "normal" lens, the one used most of the time. They like it because it is an ideal focal length for portraits, and it permits focusing down to half-life-size, making it ideal for product shots of all kinds of subjects. It isn't necessary to attach anything else to the camera or lens; simply focus on anything from infinity to close enough to produce a 1:2 reproduction ratio on the film just by turning the macro lens' focusing ring.

Macro lenses generally come in 50mm and 100mm focal lengths (Canon offers a 200mm macro lens). The advantage of a longer one is you can be farther away from your subject and still get the same image size on your film (with a 100mm lens, the camera can be twice as far from the subject as with a 50mm lens and still produce the same image size). This can be handy if the subject is something that is easily disturbed or somewhat dangerous.

Macro lenses do have some disadvantages, although none of them are a great problem. First, they are slower than an ordinary lens of the same focal length—a typical 100mm has a maximum aperture of f/3.5—but since portraits

Macro lenses generally come in 50mm and 100mm focal lengths, but Canon offers this 200mm macro lens too. The greater the focal length, the farther you can be from your subject at a given magnification (image size). *Above*

Macro lenses are good for magnifications up to life-size; beyond that, you'll need extension tubes or bellows units. *Left*

Today's macro lenses provide fine results even when focused at infinity; a 100mm macro lens can be used for portraits, aerial photography, small product photography and moderate-range action work as well as for close-ups.

1. The lens-reversing ring (shown is a Kiron Reverse Mate) has a mount for the camera body on one end . . .

2. . . . and a threaded ring into which the front of the lens can screw on the other.

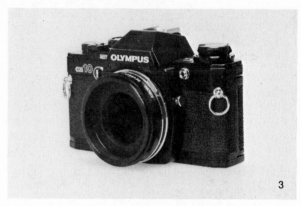

3. The camera-mount end attaches to the camera . . .

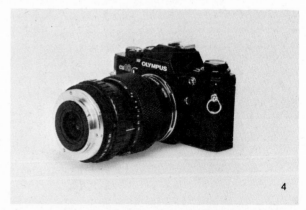

4. . . . and the front of the lens screws into the other end. Reversing the lens provides greater magnification with normal and wide-angle lenses, and it provides sharper results in close-up work.

are often shot at f/5.6 and macro subjects at f/16 or 22, that doesn't really matter. Despite the relatively small maximum aperture, focusing has presented no problem, even at night. The second disadvantage of macro lenses is weight. They are considerably heavier than an ordinary lens of the same focal length. If you generally work with the camera on a tripod, weight won't matter to you. You can even shoot night motorcycle races in existing light (three foot-candles) hand-held with the 100mm macro lens with reasonable success. The third disadvantage of macro lenses is cost. They are expensive. But if you intend to make use of the macro capability quite frequently, it will be worth it to you. You have to make that decision for yourself: will you use a macro lens' capabilities often enough to make one worthwhile, or will you be better off with less expensive but less convenient close-up diopters or extension tubes?

Lens Reversing Ring

Normal camera lenses are designed for use with subjects that are farther away from the camera than the focal length of the lens (for example, more than 50mm away with a 50mm lens). In addition, fast camera lenses, in order to provide their wide apertures, require front elements that are curved considerably. When used with a bellows for close-up work, such lenses produce less than optimum results. However, if the lens is mounted on the bellows reversed, these problems are greatly reduced. A lens reversing ring is just a small ring that screws into the front of the lens, and has a camera mount so that the lens can be mounted on the camera or bellows in the reversed position.

Additional Close-Up Devices

If you want to produce even greater magnifications than are possible with a bellows unit and a bellows lens, a microscope adapter is what you need (along with a microscope, of course). This is just a tube that attaches to the lensless camera at one end and to the microscope at the other, thereby allowing you to attach the camera to the microscope. Focusing is done by means of the microscope's focusing knob.

For scientific subjects that require close-up magnification and even lighting, there's the Medical-Nikkor lens with a built-in ringlight flash unit. This lens will focus from 1/11X to 1X magnification unaided, and from 0.8X to 2X magnification with a close-up attachment lens; the magnification is automatically imprinted in the lower right-hand corner of the film for reference. If no imprint is desired, the data imprinter can be turned off. The lens also features a built-in focusing lamp that automatically turns off when the exposure is made, and automatic flash exposure control.

Vivitar makes a handy accessory for some of its flash units: an auto flash sensor that clips onto the lens to read the light reflected from the subject for close-up flash work. This provides accurate automatic flash exposure at very close shooting distances.

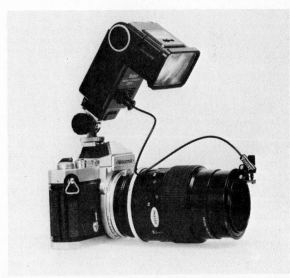

The microscope adapter (this one is from Minolta) provides means of attaching 35mm SLR camera to the microscope for extreme close-up work.

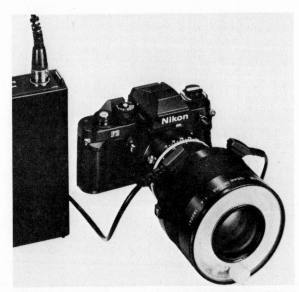

The Medical-Nikkor lens has a built-in ringlight flash unit for even lighting of close-up subjects. *Above*

The Vivitar close-up flash sensor permits use of an automatic flash unit with close-up subjects. *Right*

The Technal copy stand from Bogen holds the subject on a baseboard, lights on brackets, and the camera on a movable mounting plate on a vertical column.

A camera can be mounted alone (1) or with a bellows (2), depending on how close to the subject you want to get.

A simple slide duplicator is inexpensive and effective if all you want to do is duplicate slides in color, or make black-and-white copy negatives.

Copy Stands

Copy stands are useful for copying flat matter. They hold the camera, the subject, and the light sources. The camera can be mounted on the copy stand alone or with close-up equipment, depending on the magnification desired, and the camera-mounting plate can be lowered or raised to move the camera toward or away from the subject. The light brackets hold the lights at a 45-degree angle to the subject, to provide even, glare-free lighting. On some copy stands, the lights can be adjusted to other angles for special subject matter.

Slide Copiers

There are three basic types of slide copiers: Simple tubes that either replace or attach to the camera lens and hold the slide at a proper distance to keep it in sharp focus at a 1:1 reproduction ratio; bellows slide copiers, which attach to the lens attached to a bellows unit, and permit some cropping of the slide; and slide copying machines, which contain a bellows to which the camera and lens are attached, light source, and sometimes color-compensating filters to correct or enhance the color in copy slides.

The simple type is simple to use. Just attach it to the lens or camera body (as per the directions that accompany it), insert the slide to be copied in the slide slot, and point the copier at an appropriate light source (the sun for daylight color or black-and-white film; a tungsten lamp for Type B film), take a reading with the camera meter, and shoot. It's a good idea to bracket exposures until you see how your meter functions with the copier unit. You can also use an electronic flash as a light source, but you'll have to shoot a test roll to determine the proper expo-

A bellows slide copier permits cropping of the slide and requires a bellows unit.

The Bowens Illumitran is a versatile slide-copying machine that employs an electronic flash as its light source. The current model has a contrast-control unit that contains a separate flash unit and "flashes" film while exposure is made of the slide being copied, thus preventing contrast buildup so common to copy slides. *Above*

The Sickles ChromaPro utilizes a tungsten light source, and has built-in color compensating filtration to produce perfect color balance in copies. Shown on baseboard is special-effects slide compound that permits precisely rotating the slide to any desired angle(s), plus horizontal travel. *Right*

sure. Some of the simple slide copiers are a bit more complex and permit cropping the image through adjustments on the copier.

Bellows slide copiers are used like the simple copiers, but must be attached to a bellows unit. These copiers permit cropping the slide, and moving the slide up or down or sideways as desired to "zero-in" on the desired portion.

Colored filters can be held between the light source and the translucent glass of the slide copier to produce special effects or to correct an off-color original slide.

Slide-copying machines permit you to do all kinds of neat things as well as just copy slides straight. Just about any effect you might want for a slide show can be produced by following the directions that accompany the machine. Two basic types of machines are available: The Bowens Illumitran, which utilizes an electronic flash light source and has a facility for adjusting and calculating exposure; and the Sickles ChromaPro, which utilizes a tungsten light source and uses the camera's built-in meter to determine exposure. It's important to use daylight-balanced copy films with the Bowens unit, and tungsten-balanced films with the Sickles unit. Basic operation of both units is about the same: Attach the camera to the unit's bellows, attach a lens to the bellows, put a slide in the slide window, adjust the image size and focus with the bellows, determine the correct exposure, and shoot.

Meters

Incident-light meters measure the light incident (falling) upon the subject. Unless your subject is the light source itself, this is a simple way of obtaining good exposures. Just hold the incident-light meter right in front of your subject, point its translucent hemisphere at the camera, and expose according to the reading so obtained.

Naturally, this won't work if your subject is the source of light for the scene. In this case, point the translucent hemisphere at the light source, and bracket around the exposure so obtained.

Most professional movie cameramen use incident-light meters. One reason is that doing so assures that actors' skin tones will remain constant from scene to scene. Another reason is that incident-light meters make it easy to measure lighting ratios. Generally, a flat translucent disk is attached to the meter in place of the translucent hemisphere. Then the meter is held right in front of the subject and the translucent disk is pointed directly at the main light source,

and the reading noted (this reading is generally taken in foot-candles, rather than in terms of aperture and shutter speed). For example, if the reading is 64 foot-candles, and a lighting ratio of 4:1 is desired, simply point the translucent disk directly at the fill light, and have an assistant adjust its intensity (if possible) or move it toward (to increase its intensity) or away from (to decrease its intensity) the subject until the me-

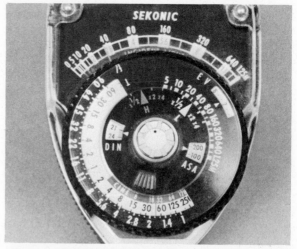

To use an incident-light meter, just hold it right in front of your subject and point the hemisphere directly at the camera.

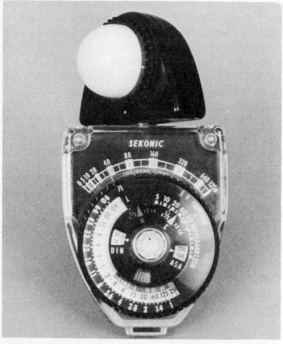

A large, white, translucent hemisphere is the distinguishing physical feature of incident-light meter. This hemisphere gathers the light as it falls on a three-dimensional subject.

Set the ASA speed of the film in the ASA window, then align the index mark on the dial with the foot-candle reading from the meter needle, and all the usable shutter-speed/f-stop combinations can be read from the calculator dial.

ter reads 16 foot-candles (¼ of the main-light reading of 64 foot-candles).

If you can't get to your subject to take an incident-light reading, you have some options. Most incident-light meters include a reflected-light attachment, so you can take a reflected-light reading. Or you can use the equivalent method for an incident-light reading: At camera position, hold the meter so that the light falls on it just as it falls on the subject. This works when the light at the camera position is the same as at the subject, but is not accurate if the lighting on the subject is different from the lighting at the camera position.

If you have one main subject, taking an incident-light reading right in front of the subject will result in a reasonable rendition of the subject. But if you have two important subjects, and each is in different lighting (such as might occur when shooting a landscape, part of which is in sunlight and part of which is in shadow), you'll have to take two incident-light readings, one in front of the sunlit subject and one in front of the shaded subject, then average the two readings and expose accordingly. (Movie cameramen use the incident-light meter to adjust the lighting so that all parts of the scene have the desired lighting on them relative to the lighting on the subject, so that when they expose for the subject, the whole scene will be properly reproduced.)

Reflected-Light Meters

Reflected-light meters measure the light reflected from whatever they are pointed at. This

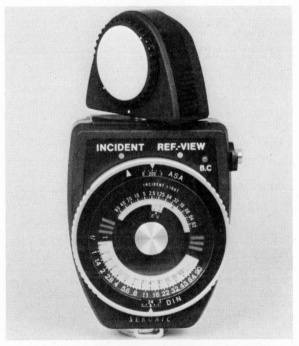

Most incident-light meters include a flat translucent disk, which is used for measuring lighting ratios. With the flat disk in place, the meter will read only that light from the light at which it is pointed, instead of all the light coming from that general direction. The meter head rotates for convenience when making such readings; you can point the disk at any light, while keeping the base of the meter facing you for reading. This Sekonic L-418 Auto Meter has a dial that automatically rotates when the button is pressed, to align itself at the right spot according to the light reading. The Sekonic L-398 Studio meter shown in the first photo uses a selenium metering cell and requires no batteries; this one uses a more sensitive cell and requires a battery.

This disk can be used to convert a meter for reflected-light readings, when they are desirable.

type of meter can provide the most accurate exposure information, but requires some thought in interpreting its readings, because it will "lie" to you under certain circumstances. If you just want to "point and shoot," an incident-light meter will give you good exposures more often than a reflected-light meter; if you're willing to learn to do a little interpreting, a reflected-light meter (especially a spot meter, to be discussed shortly) will produce the best results.

Averaging reflected-light meters (which includes all reflected meters except spot meters) are fine if what you point the meter at is the hypothetical "average" scene or subject, consisting of light, medium, and dark areas that average out to a medium tone. Unfortunately, the meter doesn't know what it is being pointed at; all it knows is how much light is reaching it. If it is pointed at a medium-toned subject (or at the "average" scene, whose range of brightness averages out to a medium tone), it will receive a certain amount of light, and call for a certain amount of exposure. If it is pointed at a

brighter subject or scene, more light will reach it, so it will call for less exposure. If it is pointed at a darker subject or scene, less light will reach it, so it will call for more exposure. The net result of all this is that the exposure recommended by a reflected-light meter will reproduce whatever you take the reading from as a medium tone in the photograph, even if what you read is a light or dark subject.

The circumstances under which a reflected-light meter will "lie" to you are basically these:

1. If you take a reading from a particularly light subject, the meter will call for too little exposure, resulting in an underexposed picture. When reading a light subject, you must give more exposure than the meter says, or the light subject will appear as a medium rather than a light tone in your photograph.

2. If you take a reading from a particularly dark subject, the meter will call for too much exposure, resulting in an overexposed picture. When reading a dark subject, you must give less exposure than the meter calls for, or the dark subject will appear as a medium rather than dark tone in your photograph.

A high-level slide is used when the light is too bright to read without it. Meters also offer ASA slides, which are used for direct f-stop readings in motion-picture work. (Since professional motion-picture cameras operate at a single shutter speed, all you need to know is what f-stop to use.)

Portraits are excellent subjects for incident-light metering, especially when backlighting is involved. Holding the meter directly in front of the subject and pointing the translucent hemisphere at the camera will result in a properly exposed face. A reflected-light reading from the camera position would be influenced by the bright background, and result in an underexposed (too-dark) face.

Above
This is an "average" scene, consisting of equal portions of bright and dark areas. Therefore an averaged reflected-light reading produced good results.

Left
This scene required a stop more exposure than the built-in camera meter called for, because the back-lighting made the meter "think" there was a lot of light everywhere, although there wasn't much light on the bear.

3. If you take a reading of a scene in which the background is much brighter than your main subject, the meter will be influenced by all that background brightness and call for too little exposure for your subject, resulting in underexposure of the subject. When the background is much brighter than your main subject (such as in backlighting situations), either move in close and meter only your subject, or give more exposure than the meter calls for; otherwise the bright background will be properly exposed, and your subject unfortunately will appear as a dark silhouette.

4. If you take a reading of a scene in which the background is much darker than your main subject, the meter will be influenced by all that background darkness and call for too much exposure for your subject, resulting in overexposure of the subject. When the background is much darker than your main subject (such as when shooting a spotlighted act on an otherwise dark stage from a back row seat), either move in close and meter only the subject (if possible), or give less exposure than the meter

calls for; otherwise the dark background will be almost properly exposed, and your subject will appear as a white, burned-out mass.

How much more or less exposure than the meter reading calls for do you give these subjects/scenes? That's where thinking, experience, and experimenting become important. It depends on how bright or dark the subject and background are, and on how you want them to appear in your photograph. As a very general rule, with unusually bright subjects or unusually bright backgrounds, give two stops more exposure than the meter calls for; and with unusually dark subjects, or unusually dark backgrounds, give two stops less exposure than the meter calls for. Your best option is to bracket exposures (shoot one frame at the exposure you think is right, then shoot another frame giving more exposure and another frame giving less

The Bild Expo-Sure is a translucent lens cap that converts built-in camera meters to incident-light meters for those who value incident-light readings but don't want to invest in an incident-light meter. Using the Expo-Sure involves carrying the camera up to the subject, pointing the lens at the spot where the camera will be to take the shot, taking a reading and setting the camera controls accordingly, then returning to the shooting position and making the exposure.

Left
Here's another "average" scene, with which an averaging spot meter works well. It has fairly even lighting, and consists almost entirely of medium tones.

An averaging reflected-light meter reads light reflected from a scene. Using this one is simple. Point it at the subject, and rotate the dial until the center light above the dial lights up. Then just read the usable shutter-speed/f-stop combinations from the top portion of the dial. This Gossen Luna-Lux SBC is part of a Gossen meter system that includes several useful accessories, such as an enlarging attachment to measure darkroom exposures, a fiber-optic probe to read directly off the groundglass of a view camera, and a microscope attachment. Note the small white hemisphere on top of the meter; this is an incident-light hemisphere, which is positioned over the meter cell when incident-light readings are desired.

While the selenium-cell Sekonic meter shown in the section on incident-light meters doesn't use a battery, most of today's meters use more efficient silicon blue cells and require batteries. Make sure you use the proper battery.

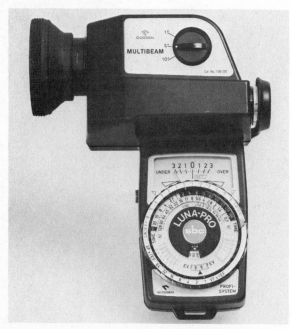

Gossen Luna-Pro SBC averaging reflected-light meter has optional spot attachment that narrows its angle of view down to 10, 5 and even 1 degree. Spot meters will be discussed shortly.

exposure). The first time you encounter one of these situations, keep notes for your future reference.

In practice, averaging reflected-light meters will provide adequate exposure information for most scenes you'll encounter without any compensation, but be aware of the aforementioned situations.

And yes, built-in camera meters are averaging reflected-light meters, subject to the same quirks we've just covered. Automatic-exposure cameras generally have exposure-compensation dials that are used specifically to make these corrections; if an auto camera has no exposure-compensation dial, you can make the corrections by setting the camera's ASA index to one-half the ASA speed of the film you're using (to increase exposure one stop), or to one-quarter the film's ASA speed (to increase exposure two stops); likewise, setting the ASA index for twice the film's ASA speed will reduce exposure by one stop, and setting the index for four times the film's ASA speed will reduce exposure by two stops. Don't forget to reset the ASA index to the proper film speed when you're through shooting the scene that requires compensation.

To use the gray card, just hold it right in front of your subject, and take a reading of it with your meter. Make sure you are close enough so that you read only the gray card and not a backlit background. Also, if the light is coming from behind you, don't cast your shadow on the gray card when metering it.

The Kodak Neutral Test Card comes packaged four to a kit, and is quite useful for determining exposure when you are working with an averaging reflected-light meter. It is also of great value in color work, as described in the text. Left

and color compensating (magenta and green
CC) filtration to make it match that for which the
film is balanced. In order to gain full benefit of
the color temperature meter, you also need a
complete set of light-balancing and color com-
pensating filters, so you can make any filter cor-
rection the meter might call for.

Color temperature meters come in two types:
two-color meters, and three-color meters. Two-
color meters are fine when dealing with black-
body radiator-type light sources, such as tung-
sten and photoflood lamps, because these emit
a continuous spectrum of light. Two-color me-
ters read only red and blue wavelengths, as-
suming that green ones fall in place according-
ly, which they do with blackbody-type light
sources. Unfortunately, many light sources are
not blackbody types that emit a continuous
spectrum. Fluorescent lights, arc lamps, and
sometimes daylight are examples that require
readings of the green wavelengths as well to
obtain accurate filtration information. Here is
where the three-color meters shine. Because
they read green as well as blue and red wave-
lengths, they provide filtration information that
provides the best possible color rendition under
any given light source. Minolta and Spectra cur-
rently make excellent three-color meters. Spec-
tra's was the first, and won an Academy Award;
Minolta's is easier to use and less costly. Both
provide excellent results.

*10. Press the CC (color compensating) button.
Another indication will appear. Make a note of it (+3
here).*

*11. Look at the table on the back of the meter, and
it will tell you what these readings mean. The -155
light-balancing indication means that you need even
more blue filtration than the table lists. That could be
anticipated, because the meter was set for daylight
film, and the color temperature of the light was lower
than that of even tungsten film. You can either use
both the No. 82C and 80B filters, whose corrections
add up to -157, or, even better, switch to tungsten-
balanced film and read the light again with the meter
set for that. The +3 CC indication means you need
to use either a CC05 (+2 correction) or a CC10 (+4
correction) magenta filter to take care of the
rest of the correction.*

*12. Opting for the better alternative, here the meter
has been set for Type B (3200°K. tungsten) film, and
the light can be metered again.*

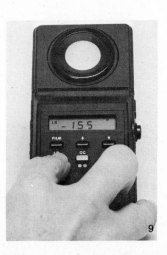
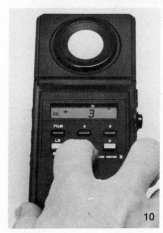
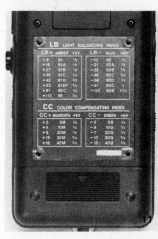

Lighting Equipment

There are two types of light sources that are used for photography: natural (daylight, moonlight) and artificial (man-made lights). Natural light sources are great for many types of photography, but not always ideally suited to the job at hand. Artificial light sources provide the photographer with complete control over his lighting, and provide sufficient light when there isn't enough for a picture otherwise.

While photographs can be made using just about any light source, four man-made light sources are by far the most commonly used. These are photoflood bulbs, tungsten-halogen tubes, flash bulbs, and electronic flash.

Photoflood bulbs and tungsten tubes are continuous light sources; their light is always there once they are turned on. Flash, on the other hand, is a momentary light source; it is there for only a moment, then gone. This difference between the two types of light sources gives each type its advantages and disadvantages.

Continuous light sources allow you to see just what the lighting looks like; the brief burst from a flash source doesn't last long enough to allow you to evaluate the lighting, although there are ways around this problem, as you'll soon see. But continuous light sources are hot, rapidly wilting perishable products and models, and they are hard on a model's eyes. Flash, on the other hand, because of its brief duration, doesn't get hot, and isn't so hard on the eyes.

Which type of lighting is best for you? That depends on your particular situation and needs. Obviously, flash is not suitable for movie work. Conversely, if you're trying to "freeze" a speeding motorcycle racer at night, the brief duration of an electronic flash is ideal. The next several pages will describe the four basic artificial light sources, and help you choose the best one for your particular need(s).

Photoflood bulbs look like large house-lamp bulbs.

You can screw a photoflood bulb into any house-lamp-type socket; this portable socket is handy for bare-bulb work.

For photographic use, photoflood bulbs are normally used in conjunction with a reflector like this one.

A tungsten tube contains a tungsten filament and halogen gas. Tungsten lights are often called quartz or quartz-iodine lights, because they were frequently made of quartz glass and filled with iodine gas, but now other glass and halogen gases are used, so the term tungsten-halogen lighting should be used.

Flash bulbs have all but disappeared except for flash-cube units made for snapshot cameras, but one notable exception is the Bowens Blaster from Bogen. This unit permits firing up to four large flash bulbs separately or simultaneously, and is battery powered with two nine-volt alkalines for portability.

camera lens, but this filter cuts out ⅓ f-stop of light, and the photoflood illumination is not very intense to begin with. There are 3200°K. photoflood bulbs, and these would be a better choice, because with them, you can use the faster Type B films without a filter.

The major disadvantage to photoflood bulbs, aside from their relatively low light output (especially when bounced off a reflector, which is the best way to use them for most work), is that as they age, they change both output (less) and color temperature (lower). While a photoflood bulb might produce perfect color balance on Type B film when new, after an hour or so of use, it might not. This is no great problem when working in black-and-white (although black-and-white films are less sensitive to 3200-3400°K. light than to daylight), but it can create serious problems if you work with color slide film.

In brief, if you are on a budget, and want to obtain a lighting system for minimum cost to learn with, and work primarily in black-and-white, photoflood lighting is the way to go. Otherwise, you will be better served by one of the other artificial light sources.

Tungsten Lighting

Actually, photoflood lamps are tungsten lamps; they contain a filament of tungsten, which is heated by electricity until it glows, giving off heat and light. But when photographers refer to tungsten lamps, what they mean is tungsten-halogen lamps. When any tungsten-filament lamp is used, more and more particles "evaporate" from its filament until finally the filament is so thin that it breaks. That's what happens when a bulb burns out. With a photoflood bulb, the particles that evaporate from the filament generally coat themselves on the inside of the bulb, and this cuts down both the intensity and the color temperature of the lamp.

Normal incandescent lamps, such as house light bulbs and photoflood lamps, are filled with a gaseous mixture that does not allow the tungsten filament to burn up at once, as it would if heated in air. By adding a halogen gas to this mixture, the tungsten-halogen lamp is produced. When the tungsten filament particles in this type of lamp "evaporate," they combine with the halogen instead of coating the walls of the tube. This tungsten-halogen combination then settles onto the filament, where the high temperature breaks it back down into tungsten, which recombines with the filament, and the halogen, which is then free to combine with more evaporated tungsten. In this manner, both the intensity and color temperature of the tungsten-halogen lamp are maintained throughout the life of the lamp.

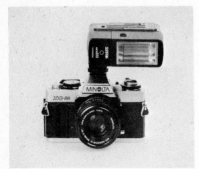

 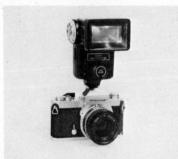 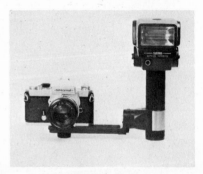

Electronic flash units come in various shapes and sizes. All are excellent portable light sources.

It's simple to test the guide number of your flash unit. Just set up a subject 10 feet away, and shoot a series of exposures at different apertures. Have the subject hold a card indicating the aperture used for each shot, so you'll know which f-stop was used for which frame. Then, evaluate the results. Multiply the f-number on the card in the best-looking frame by 10 (the flash-to-subject distance used for the test), and you'll have a working guide number for your flash unit. (Note: This guide number will be accurate for the surroundings used for the test. If you shoot in larger, darker surroundings, you'll have to give more exposure; if you shoot in smaller, brighter areas, you'll have to give less than the guide number calls for.)

109

Tungsten-halogen lamps have several advantages over photofloods: they maintain their rated intensity and color temperature fairly closely throughout their life, and they last longer. They are also more efficient, putting out more light per watt than photoflood bulbs. But they are also more expensive, and more delicate. Don't ever touch the tungsten tube with your fingers, even when it is cold; oils from your skin can weaken the bulb and cause it to shatter when it reaches operating temperature. (And always let any continuous light source cool down before putting it in a case.)

Tungsten-halogen lighting sees considerable use in motion picture and television photography, and it is quite useful for still photography as well. Its color temperature is 3200°K., ideal for Type B color films like Kodak Ektachrome 50 and Ektachrome 160.

The main disadvantages of tungsten-halogen lighting are heat output (your subject will get very hot very quickly if the lamps are used directly on it, less quickly if the light is bounced off a reflector) and intensity. Strangely enough, while the bulbs are so bright that it is very difficult to look toward them, they put out relatively little light compared to daylight. A 1000-watt or two 650-watt tungsten-halogen lamps used with umbrella reflectors for a portrait will call for exposures in the 1/30 second at f/5.6 range with fast color film.

In brief, if you feel uncomfortable with intermittent light sources (flash) and the resulting in-

There are two ways of connecting the flash unit to the camera. If both camera and flash unit have hot-shoe mounts, just slipping the flash unit into the camera's hot-shoe will provide the necessary electrical contact (1). If either lacks a hot-shoe, the flash is connected to the camera with a PC cord that plugs into the camera's PC socket (2). Above

Some cameras have both flash bulb synchronization (FP or M) and electronic flash synchronization (X). Make sure they are set for X sync for electronic flash shooting, or your film will come out blank. Right

ability to preview the lighting, tungsten-halogen lighting is the best approach for you. It's the best continuous artificial light source available for photography.

Several manufacturers offer tungsten lighting kits, which include several lamps, stands, barndoors and other accessories, and these are a good way to get started in using artificial lighting, since they have everything you'll need to start. (It's also a good idea to purchase some umbrella reflectors, too, if they aren't included in the lighting kit—see the discussion on studio accessories.)

Tungsten lighting is easy to operate. Just plug the lamps in, turn them on, and put them where you want them. It's a good idea to acquire a book on lighting techniques and keep it with you, so you'll have some idea of where to put the lights before you turn them on. Each shooting session, try a different setup from the book, and perhaps make a second attempt at a previous one that didn't seem to work, after re-reading the book, and soon you'll feel comfortable with your home studio.

This series of pictures shot with flash at 1/60 second (1), 1/125 (2), 1/250 (3), 1/500 (4) and 1/1000 (5) shows why it is necessary to use the proper flash shutter speed with focal-plane shutters. At speeds shorter than the flash sync speed, the focal-plane shutter doesn't completely uncover the film frame at any given time (it moves a slot across the film to expose it), so the whole frame isn't uncovered when the flash goes off.

If you use too long a shutter speed, and the ambient light level is strong enough, a ghost image of moving subjects will be formed by the ambient light, along with the sharp image produced by the flash. Unless you want a ghost image, use the fastest shutter speed permitted by your camera when shooting flash pictures.

Here's a tiny, simple manual electronic flash unit.

On the back is a simple exposure calculator table. It tells you what f-stop to use when the flash unit is a certain distance away from the subject, and you're using ASA 100 or 400 film. For example, if you are using ASA 100 film and are seven feet away, set the lens at f/5.6.

Here's the calculator on the back of an automatic flash unit that's set for manual operation. This one offers five different power settings; here it is set for full power. With ASA 100 film (the film speed is set on the ASA window), you'd use f/8 with a flash-to-subject distance of 12 feet.

Flash Bulbs

Flash bulbs were for years the only form of flash available to photographers, but today they have been all but outmoded by electronic flash, and are now used mainly on "simple" cameras for snapshooters (and even with these cameras, electronic flash is replacing the bulbs).

Flash bulbs are not really electronic light sources, because, although electric current triggers them, they produce their light through burning, not through electronic means. Flash bulbs are filled with oxygen and thin aluminum or zirconium wire. The ends of a filament are connected to electrical contacts, and the filament is covered with an explosive primer. When current is sent along the filament, the primer is set off. This in turn sets the wire afire, producing a bright flash of light.

Clear flash bulbs have a color temperature of around 3800°K. and are best used with black-and-white or color negative film, while blue-coated flash bulbs have a color temperature of around 6000°K. and are suited for most daylight-balanced color films.

Since each bulb is good for only one shot, if you do a lot of flash shooting, bulbs are a very expensive way to do it. This is one reason why electronic flash has taken over; the flashtube in an electronic flash unit is good for around 10,000 flashes.

With the same unit set for 1/8 power, and the same ASA 100 film, you'd have to use f/2.8 at 12 feet. Why variable power? So you can use the aperture you want to use, to control depth of field, and so you can shoot at closer range. Look at photo No. 3 again, and you'll see that at full power, you'd need to use f/32 to shoot at three feet from the subject. If your lens only stops down to f/16, you're out of luck, unless you switch to a partial-power setting.

Another disadvantage of flash bulbs is that, even though they are intermittent light sources, their flash lasts long enough to be temporarily blinding to the subject. You've no doubt been photographed by a flash bulb, and can recall seeing spots before your eyes for a couple of minutes afterward. Imagine what this could do to a motorcycle racer diving into a turn in traffic, or a circus acrobat flying through the air toward a waiting catcher. Electronic flash has a duration so brief that it doesn't have nearly so strong a blinding effect on your subjects.

Electronic Flash

Electronic flash is truly a wonderful source of light. It is economical; a flashtube is good for thousands of flashes; all you need do is periodically replace or recharge the batteries, and if you run the unit with AC current, it's even more economical. It is portable; a battery-powered unit with a fresh set of alkaline batteries will allow you to shoot up to a couple of hundred flash photos, yet will fit in a pocket. Its brief duration (usually 1/1000 second with manual units, and as short as 1/50,000 second with auto units used on nearby subjects) isn't blind-

ing like flash bulbs, isn't hot like incandescent lighting, and will freeze most moving subjects. And prices for electronic flash units start at less than the cost of a tank of gas for your car.

The sensor on an automatic flash unit measures the light reflected from the scene, and adjusts the flash duration to produce correct exposure at the selected aperture. At the far limit of the distance range for which the flash is set, the full flash duration will be used. At closer distances, which require less exposure, the flash duration will be shortened as needed to keep the exposure constant throughout the range.

Setting the automatic flash unit for a large aperture (f/2.8 here) provides the greatest range. With this unit set for f/2.8 (and the camera lens set for f/2.8), proper exposures will be produced at distances from 3.3 feet to 18 feet.

Selecting a smaller f-stop, for more depth of field, reduces the usable operating distance. Here, proper exposures will be produced only out to about nine feet.

Electronic Flash Basics

Before getting into the various types of electronic flash units, it is important to cover some information that applies to all of them.

GUIDE NUMBERS: Guide numbers are the most common way of rating the power of small electronic flash units. If you divide the flash-to-subject distance into the unit's guide number, the result is the proper f-stop to use; hence, the higher the guide number, the more powerful the unit.

There are two things to watch for when comparing guide numbers of flash units: First, that the guide numbers for both units are given for the same film speed (ASA 25 was generally used in the early 1970's; now ASA 100 is frequently used, and a flash unit will have a guide number twice as high with ASA 100 film as with ASA 25 film); and second, that the guide numbers for both units are given in the same distance units (feet were used for quite a while, but now many units have guide numbers based on meters). One more point to bear in mind about guide numbers: Sometimes the ones given by the flash manufacturer are a bit optimistic—if you base exposure on them, your pictures will be underexposed. Guide numbers should be

Dedicated flash units have special hot-shoe mounts that mate electronically with matched hot-shoe mounts on the cameras for which they are designed, so that the camera and flash unit "cooperate" to make flash exposure control and operation automatic and simple.

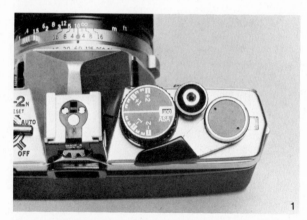

To use an Olympus OM-2 camera with the Olympus T32 dedicated automatic flash unit, first set the camera's ASA dial for the speed of film you're using.

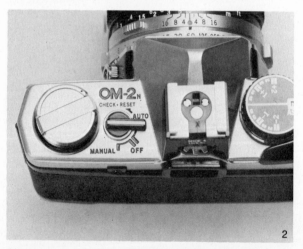

Next, set the camera for auto mode.

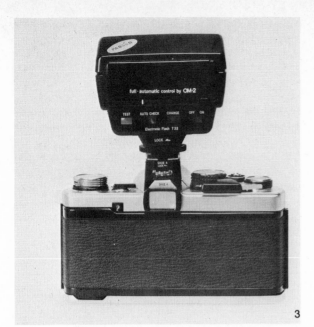

Attach the flash unit to the hot-shoe, and turn it on. The dedicated circuitry will automatically set the camera for the proper flash-sync shutter speed.
Note the absence of the usual aperture/distance exposure calculator on the back of the flash unit. That's because you won't need it. *Above*

Set whatever aperture you wish to use on the lens, and take the picture. The camera's circuitry will read the light of the flash plus the ambient light at the film plane and automatically adjust the flash duration to produce correct exposure.

The Konica X-36 dedicated flash for the Konica FS-1 and FC-1 cameras automatically sets proper shutter speeds, apertures and ASA speeds, but you must set the flash for one of two automatic modes, depending upon whether you desire a large aperture or a small one. *Below*

Olympus offers many accessories for its T-Series flash units. The multi-connector (bottom left) allows connecting up to nine flash units to the camera; cords of various lengths permit positioning units where desired. Also included are grip, various connectors, filters and accessory pouch.

Vivitar offers a number of accessories for its Model 285 flash unit. These include various power supplies and charger (top left), brackets (top right), umbrella reflector (bottom right), variable-power module and colored filters (bottom center), PC extension cord, slave and case (bottom left).

used to compare relative outputs of flash units, not as absolutes.

Before using any flash unit for serious work, you should test it to see what its real guide number is for you, keeping in mind the fact that flash-to-subject distance isn't the only determining factor. Obviously, if you're shooting in a small white room, a lot of light will be reflected from the walls, calling for less exposure than if you are shooting outdoors on a black night, when little light will be reflected. If you want to be sure about your exposure, you must do one of three things: First, shoot a test roll under the same conditions by which you intend to shoot; second, bracket exposures around the guide-number suggestion; or third (and best), use a flash meter (as discussed in the section on meters).

RECYCLING TIME: This is how long it takes the flash unit to get ready to go again once you've flashed it. Thyristor automatic flash units used at close range have very short (one or two seconds) recycling times; in manual mode, the recycling time will be much longer. Recycling time also depends upon the type of power supply (AC generally requires a bit longer than battery power) and the state of charge of the batteries (as they wear down, naturally the unit will take longer to recycle; if it takes more than 20 seconds or so, it's time to replace/recharge the batteries). Just as guide numbers given by the flash manufacturer shouldn't be taken too seriously, neither should recycling times, because they are based upon the time it takes the unit to reach a certain percentage of its full charge, not upon reaching full charge. If you take a pic-

One reason for removing the flash from the camera is to avoid red-eye, which is caused by having the flash unit too close to the lens axis.

ture as soon as the ready light comes on, the picture will be underexposed. Whenever possible, it's a good idea to wait several seconds after the appearance of the ready light before making an exposure to ensure that the flash unit will put out its rated power.

ANGLE OF COVERAGE: Here's another flash feature that isn't quite as simple as it would seem. The angle of coverage is based on the angle at which the light falls off to one-half its straight-ahead brightness (i.e., is one f-stop dimmer). In other words, if a flash unit has an angle of coverage of 60 degrees, that doesn't mean that a subject 30 degrees to one side will be properly exposed. Many flash units offer wide-angle attachments that spread the light out so that it will cover the field of view of a wide-angle lens. When using one of these, remember that subjects at the limits of the designated angle of coverage will be somewhat underexposed, and that these wide-angle attachments cut down the flash unit's light output. You will have to give the scene more exposure when using a wide-angle attachment than you would without it.

COLOR BALANCE: Electronic flash units generally have a color temperature of around 6000°K., and so are well-suited for daylight-balanced color films. Actually, 6000°K. is a bit higher (bluer) than daylight's 5500°K., but this is rarely a problem. Electronic flash units emit quite a bit of ultraviolet radiation, which is a greater problem than the extra 500°K. of color temperature, and some flash manufacturers offer gold-tinted flashtubes to offset this. Another problem occurs when using automatic flash units on nearby subjects, which results in extremely short flash durations. This can produce reciprocity failure and a resulting blue-cyan color shift in color slides. If you encounter this problem, just use a No. 81A filter over the camera lens, and increase the exposure one-third stop to compensate.

SYNCHRONIZATION: In order to make pictures using flash, there has to be some means of synchronizing the opening of the camera shutter with the firing of the flash. There are two types of synchronization in use today: X, and M or FP. X synchronization delays the firing of the flash unit until after the camera shutter has opened, and is used for electronic flash, which reaches

The PC extension cord lets you use the flash unit off-camera.

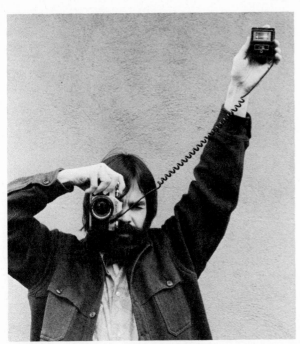

Holding a flash unit at arm's length, using a PC extension cord to connect it to the camera's PC socket, is a simple way to avoid red-eye.

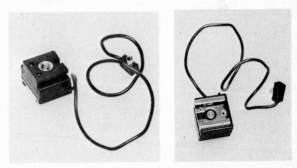

This flash shoe/cord from Kalt Corporation allows you to attach your flash unit to a tripod, then use a PC extension cord to connect it to the camera. This way, you can use a flash at any angle to the subject you choose, and have both hands free.

peak intensity almost instantaneously. M or FP synchronization fires the flash first, then opens the camera shutter, and is used for flash bulbs, which take a while (relatively speaking) to reach full intensity. It is important to have the camera set for the proper form of synchronization. If you use electronic flash with bulb synchronization, the flash will be over before the shutter opens, and you won't get a picture. If you use bulb flash with X synchronization, the shutter will close before the flash reaches peak intensity, and you'll get an underexposed picture. Also, be sure to use the proper flash-sync shutter speed if your camera has a focal-plane shutter.

POWER SOURCES: Portable electronic flash units can be powered by any of several sources; some offer a choice of all of them. AA alkaline batteries are the least expensive power source for electronic flash, in terms of initial outlay. Rechargeable nickel-cadmium batteries cost more, but can be recharged. The AA alkaline batteries will provide a lot more flashes than one charge on a set of nickel cadmiums, but when the AA's fade, you have to buy new ones. Heavy-duty 510-volt batteries (some are rechargeable) provide the most efficient power in terms of short recycling times and number of flashes per battery or per charge. AC house current provides an infinite number of flashes and never needs recharging, but isn't always available in the field.

If you do relatively little electronic flash work, the AA batteries are the best power source for you; if you do a moderate amount, use the rechargeable nickel cadmiums. If you do a lot of serious flash work, a 510-volt battery might be a good idea. And the ability to use the unit on AC current is always a good idea. Not all flash units will take all of these sources, so you might want to take power source(s) into consideration when selecting a unit to purchase.

Manual Flash Units

Manual flash units require you to calculate what f-stop to use to produce correct exposure each time you change the flash-to-subject distance. You can do this by means of guide numbers, as discussed earlier, or by means of the exposure calculator on the flash unit, as described in this section.

To use a manual flash unit, attach it to the camera. If the camera and flash unit both have hot-shoe mounts, you won't need a PC cord; otherwise, you must plug the flash unit's PC cord into the camera's PC socket. Set the camera for the proper flash-sync shutter speed

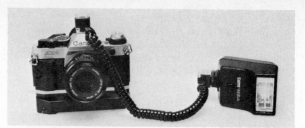

Duo-Sync cord from New Ideas lets you mount a single flash unit off-camera, and add another unit on-camera if you wish.

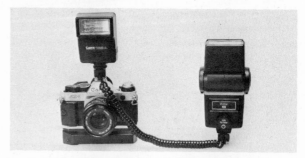

Some flash units accept a wall-type plug instead of the usual PC-type plug; PC extension cords are made for these, too. *Above*

Aside from slaves that attach to flash units, like the one shown with the Vivitar system on page 116, there are also flash units with built-in slaves, such as these Osram units. Just position these units where you want them (making sure their "eyes" can see the camera-controlled flash unit), and when you flash the camera-controlled unit, its flash will trigger these. Slaves do away with the need for extension cords.

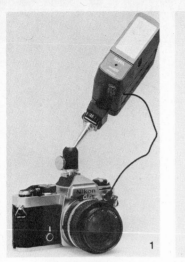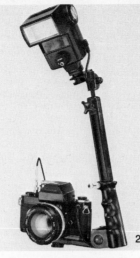

The Kalt flash bracket (1) allows you to tilt the flash unit for bounce effects, which is especially useful if the flash doesn't have a tilting head. The Siegelite bracket (2) holds the flash unit high above the camera to prevent red-eye and flat lighting effects.

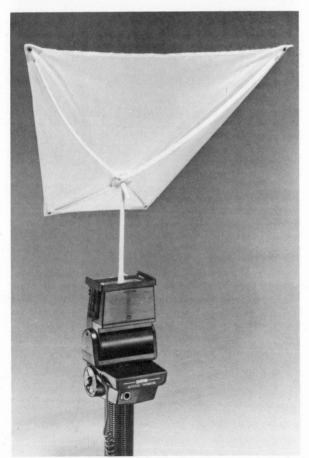

The portable bounce umbrella from Sunpak features a clear mounting plate that fits on the face of the flash, producing attractive, soft lighting.

(usually 1/60 second for cameras with focal-plane shutters—see your camera's instruction manual). Turn the flash unit on. Focus on your subject. Set the calculator on the flash unit for the ASA speed of the film you're using, and read the proper f-stop to use on the calculator opposite the distance focused on. Set that f-stop on your lens, and fire.

Automatic Flash Units

Automatic flash units save you the time and trouble of referring to the calculator on the flash unit to determine the proper f-stop for each flash-to-subject distance. Set the flash unit for the ASA speed of the film you're using, determine from the calculator an f-stop appropriate for the flash-to-subject distance range you will be shooting within (some automatic flash units offer a variety of f-stops so you can control depth of field), set this f-stop on the lens, then just focus and shoot. A sensor on the flash unit will measure the amount of light reflected from the scene, and cut the flash duration as short as necessary to provide correct exposure, automatically.

As with guide numbers, and automatic cameras, automatic flash units are geared for the "average" scene. If you are shooting in a small white room, which reflects a lot of light onto the subject, you might have to set the automatic flash unit's calculator for a faster ASA speed to avoid overexposure; conversely, if you are shooting in a large dark area, you might have to set the calculator for a lower ASA speed to avoid underexposure. A bit of experience shooting under various conditions will teach you when to override the automation.

With the first automatic flash units, the energy that wasn't used when the flash duration was cut short was just wasted, but most newer units employ thyristor circuits, which return the unused energy to the condensers in the flash unit, so that it can be reused. This results in faster recycling times when the flash is used at short distances that don't require full flash duration.

Some automatic flash units offer variable power settings. These offer several advantages. First, they allow you to use the aperture you want to use; just adjust the power to get the one you want. Second, they let you shoot closer to subjects than is possible with only a full-power setting. Third, when used in conjunction with thyristor circuitry, they permit very short recycling times at the lowest power settings, short enough in some units to keep up with an auto winder.

The basic component of a studio flash system is the power pack. Various flash heads can be plugged into it. Make sure that everything is turned off before plugging anything into the power pack, due to the very high voltage involved.

Once everything is plugged in, you can attach the power cord to the power pack and the AC wall socket, and turn on the power pack. Note that the ready light has come on.

Plug the flash heads into the desired channels. This power pack has two channels, labeled "A" and "B." The round knob at top left selects the amount of power to be sent through each channel. Here it is set to send 600 watt-seconds to channel A and 200 watt-seconds to channel B, meaning the main light plugged into channel A will put out three times as much light as the fill light plugged into channel B. If you plug two lamp heads into the same channel, the set power will be divided among them: If a second head were plugged into channel B, each head would receive 100 watt-seconds.

Now the two round modeling-light controls (one for each channel) at top right center are set to match the outputs selected for each channel, here 600 for channel A and 200 for channel B.

The sync cord that attaches to the camera (and flash meter) plugs into the sync cord receptacle.

Now the flash heads can be fired by the camera or by using the flash button on the power pack (being pushed here).

Here is a standard flash head for the power pack. It has a circular flashtube and in the center a tungsten tube that serves as the modeling light. Note the hole for an umbrella reflector just under the head.

This is a spotlight head for the power pack. It throws a narrow, sharp beam of light on a subject.

Here's a portrait made using two lamp heads, one with an umbrella reflector as a fill light and one with a Larson Soff Box (to be discussed shortly) as a key light. Note the crisp look to the photo; this is a characteristic of studio flash lighting.

Dedicated Flash

Dedicated flash units are produced by camera manufacturers specifically for certain automatic-exposure cameras in their line, and some accessory manufacturers make flash units with interchangeable dedicated modules for the various cameras that will accept dedicated flash units. These are automatic flash units that mate electronically with the camera's circuitry to make automatic flash photography really easy. (Note: Because each dedicated flash unit is specifically designed to mate with the circuitry of a specific camera, don't use a dedicated flash made for one camera with another camera of different manufacture, or you might damage the electronic circuitry of the flash unit or camera or both.)

When you attach a dedicated flash unit's hot-shoe to the hot-shoe mount of the camera for which it was designed, the special hot-shoe interaction causes things to happen. Exactly what will happen depends upon the particular units involved (see the owner's manual for a particular model to see which features it offers). Here is a typical sequence of events:

First, when you attach a dedicated flash unit to the camera for which it was designed and turn it on, it will automatically set the camera's shutter for the proper flash-sync shutter speed, so you won't have to worry about forgetting to do this and suffering the partial-frame pictures produced by using the wrong shutter speed.

Second, when the dedicated flash unit is cycled and ready to fire, a ready light in the camera's viewfinder will indicate this, so you don't have to take your eye away from the viewfinder to see when the flash unit is ready to go.

Third, after you've made the exposure, the ready light in the viewfinder will blink to indicate the flash exposure was sufficient for a good photograph.

Fourth, the camera/flash circuitry will automatically read the light and adjust the flash duration to produce proper exposure.

Fifth, the camera's automatic exposure control will make the exposure by existing light if

Here is an "economy" studio flash system, the Bo/Lite from Bogen. Each lamp head is self-contained, including its own power pack. A standard 100-watt light bulb is used as the modeling light.

Bo/Lite uses a straight flashtube rather than the curved type used in most studio heads. Above right

Barndoors clip on the head and are used to block light from reaching portions of the scene where it is not wanted. Above and below right

the flash isn't recycled and ready to go when you push the shutter button, so its nearly impossible to make a poorly exposed picture.

With some dedicated systems (Olympus OM-2 and Pentax LX, for example), the camera's meter reads the light at the film and controls the exposure, whether flash is used or not. With these systems, you can use any lens aperture. With some other systems, the lens must be set at a specific aperture (or at one of several apertures) as indicated by the flash unit's directions for a given distance range.

Accessories for Portable Flash Units

There are several accessories available for portable electronic flash units that can improve photographic results and/or make it easier to use the units.

PC EXTENSION CORD: The PC extension cord lets you move your flash unit off the camera. This is advantageous because 1) it will prevent red-eye in pictures of people and pets, and 2) off-camera lighting is generally more effective than the flat lighting produced by the shoe-mounted flash.

One end of the PC extension cord plugs into the camera's PC terminal, and the other plugs into the flash unit's PC cord. The flash unit is then positioned wherever you want it (within the length of the cord). It can be held at arm's length and overhead, held by an assistant, mounted on a light stand, or attached to any handy support with gaffer's tape. Note: If the flash unit has a hot-shoe mount, make sure that you don't touch the mount, and make sure that

A slave unit mounts atop the head and will fire it when it is struck by a flash from another head. In this way, several heads can be fired without being connected to the camera (since each head has its own power supply, each must be connected to the camera or it won't fire, unless the slave is used). Left

the mount doesn't touch anything metal.

It's a good idea to tape (with electrical tape) the junction of the flash unit's PC cord and the PC extension cord, so they don't become detached. This happens especially frequently with the coil-type extension cords, which have a spring effect. Also, be careful that the PC extension cord doesn't snap out of the camera's PC socket. You might want to keep a finger on it, or tape it in place with electrical tape.

One handy use for a PC extension cord is to fire a second off-camera flash unit, with the first unit mounted in the camera's hot-shoe. This way, you can use the corded unit above and to one side of your subject as a main light, and the shoe-mounted flash as a fill light.

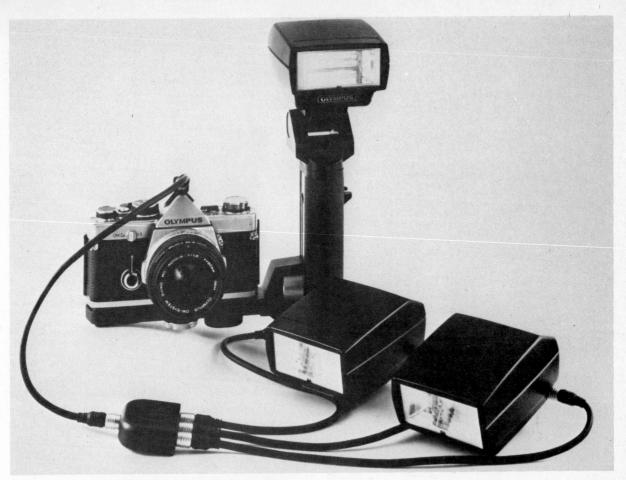

Don't overlook using portable flash units for multiple-light work. The sophisticated multiple-cord system for Olympus dedicated flash units allows synching as many as nine flash units, while providing direct off-the-film exposure control when used with the Olympus OM-2 camera.

The Bo/Lite has a receptacle for an umbrella for easy mounting.

BRACKETS: Brackets are used to move the flash away from the camera while still keeping it fastened to the camera. This keeps you from having to hold the flash unit in one hand and the camera in the other, while providing the advantages of off-camera flash (no red-eye, no flat lighting).

SLAVES: Slave units are an alternative to using a long PC extension cord to fire additional off-camera flash units. Slaves attach to the flash unit (depending upon the unit, they plug in like a lamp cord, attach to the flash unit's hot-shoe, or attach to the flash unit's PC cord), and trigger the units to which they are attached when light from the camera-mounted unit strikes them. The important thing to remember when using slave units is to make sure each slave has a clear "view" of the on-camera flash—if the slave can't "see" the flash from the on-camera unit, it won't trigger its unit.

Also available are slave flash units, with built-in slaves. These are ideal as the "other" lights in a multiple lighting setup.

123

Bounce umbrellas are umbrella-shaped reflectors that "bounce" light from a lamp head back onto the subject, providing softer, more pleasant results than direct lighting. They are almost essential for any serious studio work.

Light shines through the Larson Starfish's umbrella instead of being bounced from it, providing a softer effect than umbrella lighting. Above and Right

Square umbrellas are less expensive and a bit less efficient than hexagonal ones.

UMBRELLAS: Umbrella reflectors produce soft, directional lighting that is probably the most pleasing lighting a flash unit can produce. They are often used with professional studio flash systems (to be discussed soon), but they are also available for small portable flash units, so every photographer can have the pleasing results they produce.

Umbrellas mount on the flash head. The flash is pointed into the umbrella, and the umbrella is aimed at the subject, casting a pleasant and soft light on the subject when the flash unit is triggered.

When using umbrellas with automatic flash units that have sensors that stay attached to the camera and pointed at the subject, the automatic mode can be used, although bracketing exposures might be advisable. When using auto units with sensors that point wherever the flash is pointed, you must switch to manual mode (give about one stop more exposure than the flash-to-umbrella-to-subject distance calls for), unless they're dedicated units used with a camera that reads the flash at the film plane. If the camera's off-the-film-plane meter controls flash

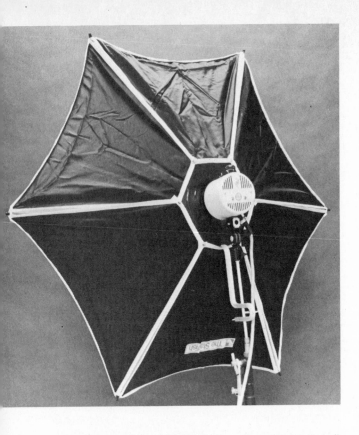

A Soff Box provides the same basic effect as the Starfish, but in a square format. This can be used as the main light for product photography, with a large hexagonal umbrella on the fill light.

exposures, these dedicated units can be used with umbrellas in the normal auto-flash manner.

COLORED FILTERS: Several flash manufacturers offer colored filters that fit over the flash head to produce special effects. One such effect involves using three flash units. One is to the left of the subject, with one colored filter. A second unit is to the right of the subject, with a different colored filter. The third unit is either above and behind, or in front of the subject, with a third colored filter. All are fired at once, using extension cords or slaves, and the result will be a multicolored subject that can be quite striking.

You can use any transparent colored material to produce similar effects; just tape it over the flash. (Don't do this with flash units that incorporate modeling lights, because the modeling lights produce heat, which can ignite some materials.)

Studio Flash Systems

Studio flash systems consist of a power supply, which plugs into a wall outlet, and a number of flash heads, which plug into the power supply. These systems are quite expensive, starting at approximately $500 for a fairly simple and relatively low-powered two-head system, and

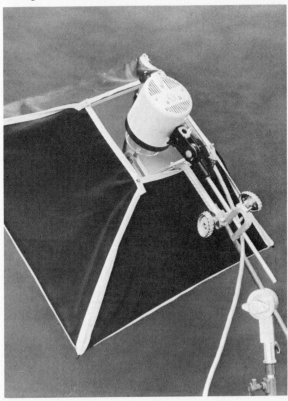

Air-Brella from New Ideas is a small, inflatable umbrella for smaller portable flash units. It provides softer lighting than direct flash. *Left and Above*

ranging into the thousands of dollars, for "what the pros use."

Naturally, you do get some advantages for all that money, which is why the pros use these systems. First, you get a lot of power. The system shown in the illustrations provides exposures of approximately f/16 with three-light setups covering a nine-foot square area, using umbrellas with all heads and medium-speed film. Couple this with the action-stopping short duration of the flash, and compare it with exposures of around 1/30 at f/5.6 for three umbrella'd tungsten lamps, or having to shoot wide open with three portable flash units with umbrellas covering the same area, and you can see that studio flash systems give you a lot of versatility.

A second great advantage of these setups is modeling lamps. Each flash head incorporates a tungsten modeling light, so that you can see the effect of your lighting setup. And not only do they have modeling lights, but they have variable-ratio modeling lights, which means if you are running twice as much light from your key head as from a fill head, you can adjust the modeling lamps so that the key modeling light is twice as bright as the fill modeling lamp.

Another wonderful feature of studio flash systems is their almost instantaneous recycling times. It's very frustrating to have to wait seven or ten seconds after an exposure to be able to make another one, when you've finally got your model to express just the feeling you want to capture.

Air-Diffuser, another New Ideas product, fits over the flash and diffuses the light for a soft, pleasant effect.

126

A sheet of white posterboard clipped to a light stand or any handy object makes an efficient and cheap reflector. It can be placed to reflect some of the main light into the shadow areas of a subject, instead of a fill light, if you have only one flash unit.

A gobo is a piece of dark cardboard that is positioned to keep light off areas of the scene where no light is desired.

A lesser but still important advantage of studio units is that they have built-in receptacles for umbrella reflectors, barndoors, and the like. Attaching these to portable flash units can be a bit of a pain, although with the proper clamps it can be done.

Aside from the cost, the main disadvantage of studio flash systems is that they are not portable. They're bulky, heavy, and require AC current for operation—but, then, that's why they're *studio* flash systems.

The Petersen book, *Electronic Flash* by Jim Cornfield, will tell you all you need to know about studio lighting techniques, and the accompanying photos will show you what's involved in operating a typical studio electronic flash system.

"Economy" Studio Flash Systems

If you want most of the benefits of studio flash, but don't want to spend the kind of money it takes to get a top professional system, there are relatively inexpensive (under $1000) systems available. These don't offer all of the features of the big systems, but they'll produce fine results in many situations. You'll get less power, fewer power settings, fewer flash heads capacity, and often, fixed-level modeling lights, but

Diffusers are translucent flats that are placed between the light source and the subject to soften the light. This is a homemade one; commercially built diffusers are also available.

Here's a detail shot showing how translucent material is stapled to a wood frame, and how corner brackets are installed.

you'll still get a pretty efficient system. It is very likely to contain receptacles to accept umbrellas and other accessories, motion-stopping short duration flash, modeling lights, and more light output than most tungsten lighting can provide.

As a minimum you'd want a system with two flash heads, umbrellas for each, modeling lights in each head, stands for each head, and a flash meter. A third head will give you more versatility in controlling the background (use it as a background light or a hair light or rim light), and at least 100 watt-seconds per head. Such a system will give you a wide range of versatility in your studio lighting.

Studio Accessories

Whatever light source you use, shining it directly on your subject will result in harsh lighting. There will be a sharp transition from glaring highlights to black shadows. Pointing the light source at the ceiling or a nearby wall will soften the effect, but then your lighting's direction will be vague and nebulous, and not terribly good

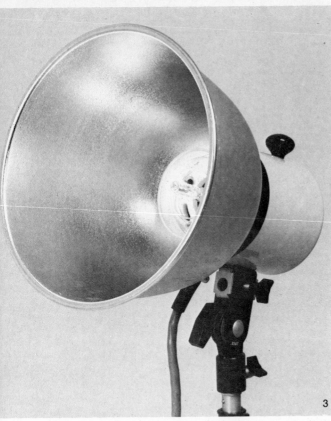

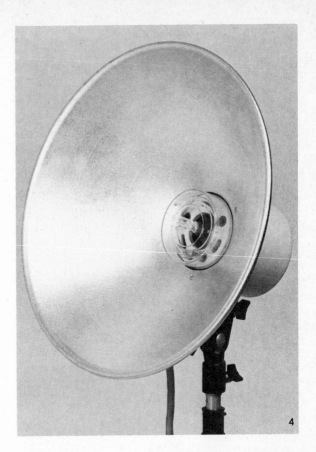

3

4

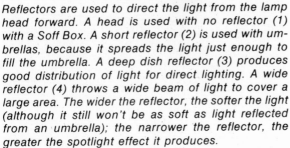

Reflectors are used to direct the light from the lamp head forward. A head is used with no reflector (1) with a Soff Box. A short reflector (2) is used with umbrellas, because it spreads the light just enough to fill the umbrella. A deep dish reflector (3) produces good distribution of light for direct lighting. A wide reflector (4) throws a wide beam of light to cover a large area. The wider the reflector, the softer the light (although it still won't be as soft as light reflected from an umbrella); the narrower the reflector, the greater the spotlight effect it produces.

unless that is the effect you want in your photographs.

Fortunately, there are several simple ways to produce soft and directional lighting for your photographs. One is the umbrella reflector. This is an umbrella-shaped device that is covered with a reflective material. You attach your light source to the umbrella so that the light shines directly into the umbrella, and then point the umbrella at your subject. The result is lovely soft lighting that comes from a definite direction. Umbrella coverings come in various colors. White provides the softest effect. Silver is a more efficient reflector, so it provides more light output, but also a somewhat harsher effect (but still a lot softer than direct lighting). Gold cover-

ings warm the color of the light when that is desirable. Blue coverings cool the color temperature of tungsten lamps so they can be used with daylight-balanced color films. Some manufacturers also make available various colored coverings for their umbrellas; these are used for special color effects.

Umbrellas come in various sizes. The larger ones produce a softer light, and cast it over a larger area; the smaller ones produce a harsher light, and cover a smaller area.

One additional advantage of umbrellas over walls and ceilings as reflectors (aside from being more directional) is that they are more efficient; more of the light reflected from them reaches the subject. Therefore, you need open the lens only about one-half stop with silver coverings, and 1-1½ stops with white coverings, over the aperture based upon the distance from the light unit to the umbrella to the subject. This is done in order to compensate for the light lost by the reflecting process. Still, the most efficient way to determine exposure when using any kind of reflected lighting is with an incident light meter (for continuous light sources) or a flash meter (with electronic flash).

There are also square umbrellas, which are

129

Light stands come in many varieties. Casters make it easy to move about (1), but be careful not to tip it over if you bump the casters into a cord. A lightweight stand (3) is good for all but heavy professional movie lights. A mini-stand (2) is handy when you need to mount a light in a low position.

AutoPole from Bogen lets you mount a light in a window frame or doorway.

All kinds of clamps are available to help you attach equipment to other objects in the studio.

generally smaller, less expensive and less efficient than "round" ones, but still produce much nicer lighting than direct lighting.

Even softer lighting is provided by "umbrellas" that enclose the light unit, so that the light shines through the covering, rather than bouncing off it. These are best used with flash units; continuous light sources could get too hot for them. Again, an appropriate light meter is by far the best way to determine exposure with such devices.

Barndoors are flaps that attach to the light unit and adjust to keep light from going where it isn't wanted. Gobos are larger dark surfaces that attach to light stands and serve the same purpose as barndoors—they keep light off portions of the scene. It's advisable to use commercially produced barndoors, especially with continuous light sources, since they attach directly to the light unit and must be able to withstand a lot of heat. You can make your own gobos, though, simply by cutting a piece of cardboard to an appropriate size and clipping it onto a light stand or other holder. Just watch your scene, and position the barndoors or gobo(s) until the light falls only where you want it to.

Fill reflectors are used in place of fill lights, to lighten shadow areas on your subject. These can be simple large sheets of white posterboard clamped to a light stand and positioned so that they reflect some of the light from your

main light source onto the shadow side of the subject.

Diffusers are used between the light source and the subject to soften the light when the light unit is pointed directly at the subject. There are many commercially available diffusers offered by makers of light sources, or you can make your own. Just make sure that your homemade diffuser doesn't get too close to a continuous light source and catch fire. (And avoid asbestos diffusers—asbestos can be harmful to your health.)

Lamp reflectors come in various shapes and sizes. The wider ones produce broader areas of coverage, and slightly softer light. The narrower reflectors produce a narrower area of coverage, and harsher light. When using a bounce umbrella, the smallest reflector is the best choice (that is, the one that extends the least length in front of the light source).

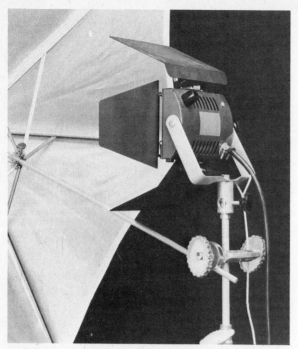

Here, a Larson clamp is used to attach an umbrella to a light stand holding a tungsten lamp.

A translucent light table (this is the Technal Transi-Table from Bogen) is used to photograph small objects when you don't want a "seam" between floor and wall to show.

If you add a light under the translucent light table, the subject will appear to be hovering in white nothingness, handy for product shots.

All kinds of light stands are available. Make sure the ones you get are sturdy enough to hold whatever you intend to attach to them. Some have wheels so they can roll—be careful not to inadvertently roll one into a cord and tip it over. If you attach something to an arm on a light stand, so that it sticks out to one side, make sure one of the light stand's legs is aligned with the arm to keep the whole thing from tipping over. If you attach anything heavy to a light stand, it's a good idea to weight the base of the stand down with a sandbag or any other heavy weight that's available.

Naturally, you'll need clamps to attach things to your light stands, and a great variety of these are available. Once you know what kind of light

Here's a good way to hang small widths of seamless background paper. Make sure one leg of the stand runs under the roll of paper, or the stand will tip over from the weight of the paper.

If you've wondered how "they" make those neat shots that seem to have been shot in a room with no floor or walls, the answer is the seamless background. These are rolls of heavy paper that come in various widths and many colors and textures. They are hung from various devices, and curve gradually from vertical to horizontal, so that no "seam" appears between floor and wall.

This type of clamp attaches to the top of the light stand and allows mounting a cross bar at any desired angle.

Here's a full-size studio seamless background paper roll, held by a bar-and-bracket setup attached to the wall. If you don't want to permanently attach a background holder in your living-room home studio, portable background holders are available from Bogen and from Brewster/Polecats, Old Saybrook, Connecticut 06475.

stand you are going to use, and what you are going to attach to it, a close look at the various clamps available will help you decide which will be best for each application.

Specialized Light Sources

There are several rather specialized light sources that are worthy of note:

RINGLIGHTS: Ringlights fit around the camera lens and produce flat, shadowless lighting that is useful any time shadowless lighting is advantageous. This includes industrial, technical, scientific, close-up, and some fashion work. Unlike normal on-camera electronic flash units, electronic-flash ringlights are not self-contained; they consist of the ring head and a separate power supply. While most ringlights are electronic flash units, Spiratone offers one that uses a flashcube, and Aristo Grid Lamp Products offers a cold (fluorescent) light version called the Mic-O-Lite.

BARE-BULB FLASH: Bare-bulb flash (without a reflector to direct the light forward) produces an overall even lighting that is useful when you want to give the impression of shooting by existing light, but there isn't enough of it to make your shot. Many flash-bulb units can be used without the reflector to produce bare-bulb results, and there exists a bare-bulb electronic unit by Rolleiflex.

TRUE STROBES: Electronic flash units are often called "strobes," but this term really applies to rapidly flashing units such as those found at discotheques. Wein Products and Balcar both offer photographic electronic flash units that do function as strobes, producing many flashes per second. This effect can be used to produce action montages. Set up the camera on a tripod,

A ringlight, such as this Olympus unit, encircles the lens to provide flat, shadowless lighting.

set up the strobe, have a subject rehearse a movement past the camera, then darken the room (making sure it is clear of obstructions that your model might bump into in the dark), open the camera shutter on T or B setting, turn on the strobe, and have the model perform the motion through the frame (it can be a dancing movement, or a golf swing, or anything else you can think of). You can use a short exposure time (up to the maximum permitted for flash sync with your camera) to record fewer "steps" of the movement, or a longer time to record more. You can also adjust the rate of the strobe to best suit the movement of your subject.

UNDERWATER FLASH: Many manufacturers offer underwater electronic flash units for underwater photography. (When you get more than a few feet below the surface, everything takes on a blue-green cast unless you shoot with flash.) Don't ever use anything underwater but a flash specifically designed and built for underwater work, because there's a lot of voltage involved. If you're serious about underwater photography, you should get an underwater flash, because it will really make a difference, especially in color work.

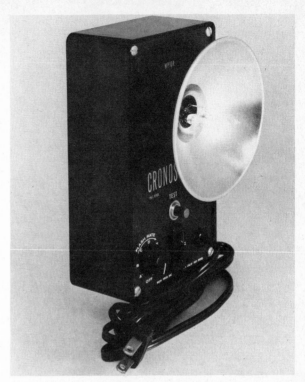

The Wein Cronoscope is a relatively inexpensive strobe for special-effects photography.

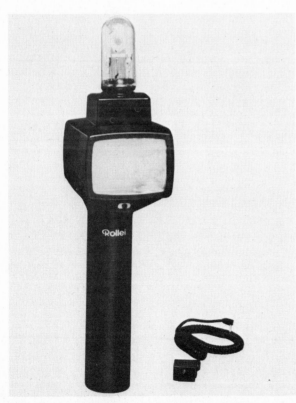

This bare-bulb electronic flash from Rollei can be used as a bare-bulb unit or as a normal flash unit.

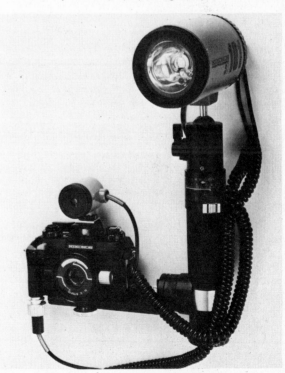

The Nikonos SB-101 underwater flash (shown attached to the Nikonos IV-A underwater camera) is ideal for producing those striking underwater color photographs you see in diving publications.

Camera Supports

The primary purpose of a camera support is to do a better job of holding the camera motionless than you can. If it won't do that, it's of little value.

A secondary function of camera supports is to mount the camera where you want it mounted. Sometimes a standard tripod won't permit this, so there are all sorts of clamps available to do it, and with a little ingenuity you can devise your own mounting device, again bearing in mind that it must hold the camera securely.

Before getting into the basic types of commercially available camera supports, here are a couple of often-overlooked methods of steadying the camera. The first is a handy nearby wall or fence. If you have to make a long exposure, and don't have a commercial camera support, just rest your camera on a nearby fence, wall or whatever else is handy (taking care not to rest the camera on something it could damage). While not as steady as a good tripod, such a camera support will help produce sharper results than simply hand-holding the camera will.

A second often overlooked means of steadying the camera is the camera strap. It can be used as shown in the accompanying photo to help brace the camera, with noticeably improved results over just hand-holding the camera in the usual manner.

Grips

Many camera manufacturers, and some accessory manufacturers, make hand grips for cameras. These make holding the camera much more comfortable than just holding the stock camera, and they provide some additional steadiness while shooting. Using them is simple: Just attach the grip to the camera, then hold the grip in one hand while cradling the camera in the other hand. Sometimes the grip is part of a motor drive or auto winder, and sometimes the grip will include a flash shoe, but the primary purpose of the grip is to make hand-holding the camera more comfortable.

Tripods

Tripods are the most popular and useful camera support for general photography. These three-legged camera stands serve two very useful functions. First, they prevent camera move-

Bracing a camera against a handy solid object will help to steady it when you don't have a tripod or other commercial support handy.

You can gain some steadiness just by cinching the camera strap tightly as shown. The slack is taken up and held in the right hand.

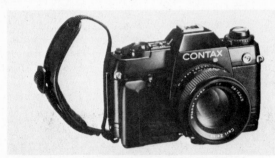

The Contax 137 Grip Adapter provides steadier hand-holding of the camera, and balances the camera when a flash unit is used.

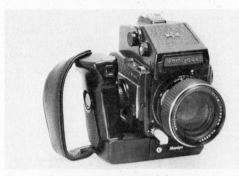

The motor drive for the Mamiya 645 includes a hand-grip. The camera is actually more comfortable to hand-hold with a motor drive/grip than without.

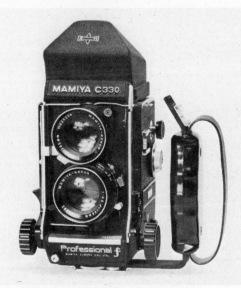

The grip for the Mamiya C330 twin-lens reflex facilitates holding the camera steadier and more comfortably, and includes a handy bracket for the flash unit.

ment from occurring during exposure and blurring your picture. Second, they lock in your composition, so you can carefully examine it before making an exposure, and maintain it during exposure.

A tripod can hold the camera more steadily than a human being can (if you don't believe this, just attach a page of a newspaper on a wall and photograph it at various shutter speeds hand-holding the camera, then photograph it at the same shutter speeds with the camera on a tripod, and examine the resulting pictures). If maximum sharpness is desired, all photos should be made with the camera attached to a tripod. There are the photojournalistic and grab-shot types of pictures that require the freedom of the hand-held camera, but whenever it is possible, the camera should be attached to a tripod.

If you do much still-life, scenic, or architectural photography, or work in the studio a lot, the tripod's ability to hold the camera in position to maintain a composition is invaluable. Trying to maintain a precise composition with the camera hand-held, especially if you have to physically move elements in the picture or use a perspective-control lens or view camera movements, is highly impractical, if not impossible. Put the camera on a tripod, and you can arrange scenic elements to your heart's content, knowing the camera will be pointed right where you left it when you go back to view the scene. And you'll

The Pentax 6 x 7 offers an attractive grip with a flash shoe.

know that you won't accidentally move the camera slightly as you squeeze off the shot, thus both varying the composition and blurring the photographic image.

What constitutes a good tripod? Sturdiness is the first requirement. If the tripod is too flimsy to steadily hold the camera(s) you intend to attach to it, it's not going to serve its purpose. When evaluating a potential tripod purchase, partially extend the tripod's legs and center column, lock them in place, mark their positions with pencil lines on the legs and column, then press down on the camera mount with the palm

If you want to record shadow detail in night scenes, you have to make long exposures. These shots were exposed for 10 seconds at f/5.6, using a 24mm lens on a 35mm SLR camera, and Tri-X film. A good tripod is essential to hold the camera steady during such long exposures. (In order to retain highlight detail along with shadow detail, the film was developed in a Perfection XR-1 extended-range developer, which prevented highlights from becoming too dense on the negative to print.)

of your hand. There should be no slipping (the pencil lines will indicate this) or bowing of the legs or center column. If there is, find another tripod. Extend the legs and center column to maximum height, and check the tripod for stability by pushing on the camera mount.

The next most important considerations in a tripod are range of movements, convenience, and smoothness of operation. The tripod's legs should extend far enough to mount the camera at eye level without using the rising center column. (The center column should be used for fine-tuning camera height only; extending it pro-

vides less stability than extending the tripod legs.) The legs and center column should extend and retract smoothly and easily, and they should lock positively. A center column that cranks up and down instead of having to be manually pulled up and pushed down is great.

The tripod head should permit using the camera in both horizontal and vertical positions. It should allow the camera to be panned horizontally 360 degrees, and tilted up and down as far as you'd ever want to tilt it for a shot. All locks and handles should operate easily, smoothly, and positively. Levels on the tripod and the

This tripod has three-section legs, a crank-up center column, a three-way pan-tilt head and holds a 35mm camera rock-steady for long exposures (and for short ones whenever you don't need the freedom of the hand-held camera). Above left

Two nice things about this tripod: If the leg locks should start to slip after a lot of use, they can be re-tightened by using the nuts; and the rubber feet can be screwed down for indoor use (so the tripod won't damage floors or carpets) and screwed up to reveal sharp points for good grip outdoors. Some tripods have these features and others don't; you might want to take them into consideration when evaluating tripods. Above center

A three-way pan-tilt head allows panning the camera 360 degrees by loosening lock-handle A, tilting the camera up or down by loosening lock/handle B, and moving the camera to a vertical position by loosening lock/handle C. This setup is more convenient than those that have separate handles and locks; compare tripod features and decide for yourself.

Above right

The ability to tilt a camera to a vertical position is invaluable for portrait work. Some photographers prefer a three-way pan-tilt head to a universal ball-and-socket head (which can be moved any direction by loosening one lock) because they prefer to make one adjustment at a time. Others may prefer the ball-and-socket head, which allows for quicker positioning once you get used to it.

head are especially handy if you shoot architecture or landscapes.

You'd think that using a tripod is pretty straightforward: attach the camera, point the camera, and shoot. Well, it is, and it isn't. There are some tips that can make life with the tripod easier and more effective. First, as already mentioned, don't use the extending center column as your primary camera-height control. Use the extending tripod legs to set the height; use the center column to fine-position the camera. Second, extend the thicker portions of the legs before the thinner ones. Since the thicker leg sections are sturdier than the thinner ones, you'll gain maximum stability this way. Third, for even more stability, especially in a windy environment, suspend a weight from the center of the tripod. This will help stabilize the tripod and keep it from being knocked over. Fourth, have one of the tripod legs pointed the same direction as the camera lens, especially with heavy cameras and lenses. This will provide a bit more stability, and will give you more room behind the camera. However, if you are shooting a tabletop scene, you might not be able to do this, because the leg would hit the table before you could get close enough to your subject. In this case, rotate the camera on the tripod 180 degrees, so that one leg points the opposite direction from the lens, and you can get closer to the

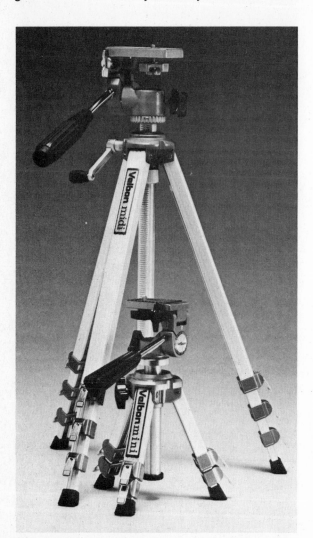

One disadvantage to some tripods is that they won't permit mounting the camera low enough for some close-up subjects. If you do a lot of such work, you might want to consider a mini-tripod, like this Velbon model.

This tripod head features a quick-release camera mounting plate, so if you want to remove the camera for hand-held work, you can do it quickly with a twist of a lock, instead of having to unscrew the tripod mounting screw.

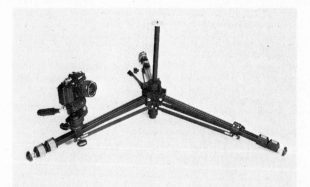

The Slik U212 tripod offers another solution to the problem of getting the camera low enough for those difficult shots. The tripod head detaches from the center column and attaches to the spread leg.

table with the camera.

On those occasions when you must extend the tripod's leg(s) only part-way, it is often a problem extending each leg the same amount as the others just by "eyeballing" it. There are two ways to solve this problem. First, extend all legs to the desired height before spreading them; that way it is easy to see when they're all extended the same amount. The second way to handle the situation is to mark lines on the legs, starting from the bottom of each leg, in one-inch intervals. Then you can just extend each leg the desired number of inches. If you don't want to do all that inscribing, at least one company offers marked tape that you can apply to the tripod legs for the same purpose.

What if you want to mount two cameras on the same tripod? This Gitzo Twin Heads bracket will do just that.

Bogen's Master Benbo tripod offers still more solutions to difficult camera positioning problems.

For studio work with large-format cameras, a studio stand such as this Cambo model from Calumet is a good choice. It will hold the heaviest of cameras solidly, and features casters for easy moving, and locks so it won't move when you want it to stay put.

Another Slik solution to a tripod problem is provided by the leg mount on the model U212, which permits vertical mounting of the camera for copy work.

Before carrying the tripod from one location to another with the camera attached, make sure that all of the locks are securely locked. This will keep you from being struck by a swinging camera or lens, and will keep you from experiencing the painful sound and sight of your camera dropping to the ground.

This handy little item from Vivitar serves as a small tripod and shoulder pad. *Above and Left*

Panorama Head

The panorama head is a handy device that mounts between the tripod and the camera, and permits making a series of exposures that encompasses 360 degrees of horizon.

You can just unlock the pan lock on a normal tripod head and make the same series of exposures, but the camera won't be precisely positioned for each exposure, and the results won't be precise. The panorama head produces precise horizontal tracking, and has click stops that provide precise positioning for each exposure. The resulting series of prints can be mounted end to end to produce a single, long print that encompasses 360 degrees of horizon. Or, you can tilt the camera 90 degrees to a vertical position, and make a series of exposures that covers 360 degrees vertically, for an unusual effect.

Wooden-legged tripods from Zone VI Studios (Newfane, Vermont 05345) will hold anything from a 35mm to a view camera solidly. The legs spread flat for low-angle shots. The lightweight model (left) will support up to a 5 x 7-inch view camera; the standard model (right) will support up to an 11 x 14-inch camera.

The Minolta Panorama Head II attaches to the tripod; the camera attaches to the panorama head. The numbers on the ring are focal lengths; set the focal length of the lens in use opposite the white dot, level the head using the built-in level, and the click stops will automatically stop the camera at proper intervals for a panoramic sequence.

A cable release screws into the camera's cable-release socket, and permits you to trip the shutter without applying direct pressure to the shutter button, thus minimizing camera movement due to that pressure. Never pull the cable release taut; keep a bend in it as shown, or you might accidentally jerk the camera and/or cause the cable release to bind.

Below
Here's part of sequence made using 100mm lens.

143

The accompanying sequence was made with the Minolta Panorama Head II, using a 100mm lens on a Minolta SR-T 202. The panorama head was set for the 100mm focal length (so the click stops provide the correct interval between exposures), then one exposure was made, the camera was rotated until the first click stop was reached and another exposure was made, then the panorama head was rotated to the next click stop and the next exposure was made, and so on until the original position was reached. The procedure is simple, and the results are accurate.

Cable Releases

A cable release allows you to trip the shutter without jiggling the camera. Even when the camera is mounted on a tripod, the pressure of your finger pushing the release button can jar the camera slightly, thus reducing image sharpness. With a cable release, the finger pressure is applied to the cable release button, and far

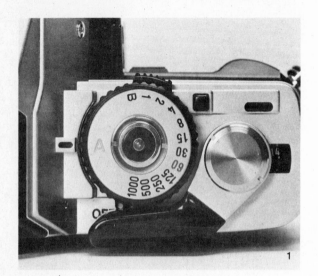

A few cameras will accept only electronic cable releases. Plugging a mechanical cable release into this socket will cause trouble. Be sure to read the camera instruction manual to see which type of release your camera requires. Above

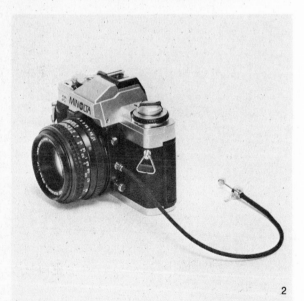

Many of the newer electronic cameras have electronic shutter releases, which have no cable-release sockets (1). With these cameras, the cable-release socket is generally located elsewhere on the camera body (2).

Locking cable releases are the best kind, because they can be locked to hold the camera shutter open (on B setting) for long exposures, thus relieving you of that duty. These come in various forms, but produce the same results.

less jarring is transmitted to the camera.

The most useful type of cable release is the locking variety. This enables you to set the camera shutter on B, open the shutter with the cable release, then lock the release to hold the shutter open for long time exposures, an especially handy feature if your camera doesn't have a T setting. When the proper time has elapsed, just release the cable release lock, and the shutter will close. If you do much night photography, a locking cable release is a must.

The air release has a squeeze-bulb at one end instead of a plunger like a cable release, but the effect is the same. Squeeze the bulb, and air pressure causes the needle at the other end of the cable to push the shutter button.

Soft-release buttons screw onto the shutter-release button and absorb some of the jiggle when you push them.

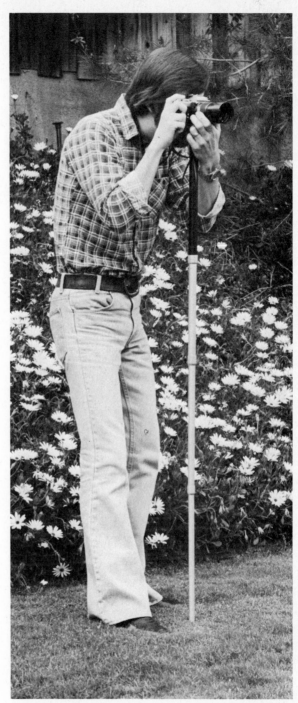

The unipod is a handy device when a tripod would be too cumbersome. It can be used to steady the camera with a long lens at auto races, because it permits panning the camera while providing more steadiness than hand-holding can. It can also be used to take pictures from amusement park rides and for night shots when you want the convenience of a hand-held camera but more steadiness. It's not much harder to carry the unipod on the camera than it is to carry the camera alone.

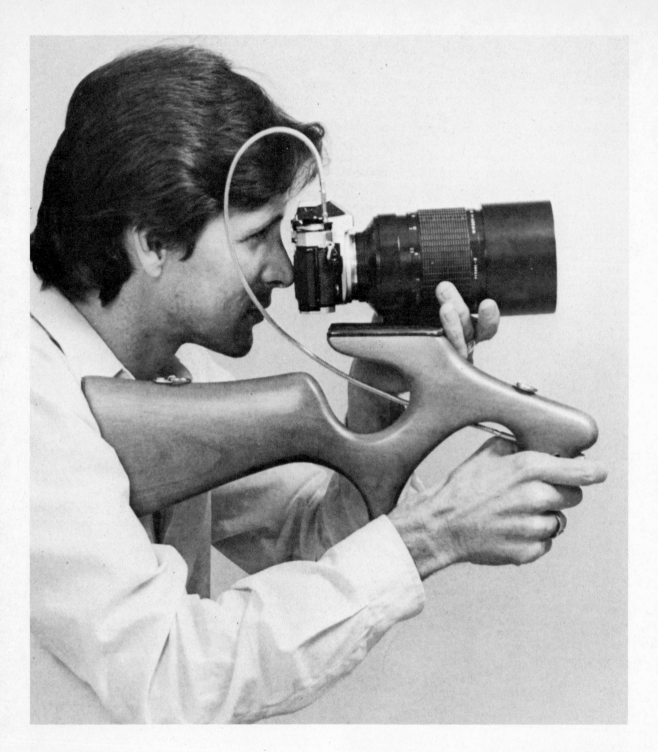

Standard cable releases are about a foot long, but longer ones are also available, permitting you to trip the camera shutter from several feet away, which can be useful for nature photography from a blind.

The cable release screws into the camera's cable-release socket, which is generally on the shutter release button, but is sometimes located elsewhere on the camera body with cameras that have electrical touch release buttons. About the only thing you have to remember about using a cable release is to keep a bend in it (as illustrated), so that you don't accidentally jerk the camera or bind the cable release.

Gunstock mounts, like this one from Kalt Corporation, provide added steadiness when shooting with long lenses, while giving you more shooting freedom than a tripod provides. Left

A Tri-Pad provides support for very-low-level shots. The screw in the bottom can be used to point the camera slightly up, or, by reversing the camera on the unit, slightly down. Above

Foto Pheet (10201 Mason Avenue #89, Chatsworth, California 91311) offer another useful low-level camera support, good for tabletop photography. Screws allow for greater upward pointing of the camera than Tri-Pad's adjustment.

The Magna-Pod attaches magnetically to metal surfaces. The Screw-Ball camera mount holds the camera on the Magna-Pod and allows pointing the camera wherever it is necessary. Both are available from New Ideas, Inc., 7500 Skokie Blvd., Skokie, Illinois 60077. It's a good idea to use a safety line attached to the camera just in case it should fall whenever you use this type of camera-holding device. Above

Air Releases

An air release is a cable release with a rubber ball instead of a plunger at the end. Squeezing the ball releases the shutter. Air releases are useful when your hands are full—you can trip them using your foot, or teeth.

Soft Releases

Soft releases are small button-like devices that screw into the camera's cable-release socket and absorb some of the jiggle when you push them instead of pushing the shutter-release button directly. These are not as efficient as cable releases, but are less expensive.

A commercial rifle stock was adapted to hold this motor-driven camera with a zoom lens.

The leg from a tripod, attached to the front handgrip of the stock, provides additional support when desired. Note how the strap is also used for extra steadiness.

A ball-and-socket camera attachment was fastened to the vise-grips. With this device, the camera can be clamped to any handy object that won't be damaged by vise-grips.

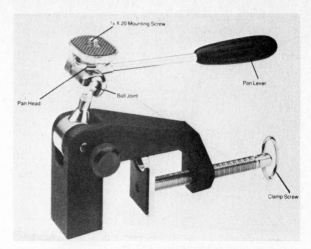

This vise-mount with a pan head from Tasco Sales (1075 N.W. 71st Street, Miami, Florida 33138) can be used to clamp the camera onto a car window or any handy object up to two inches thick.

A bean bag adapts to the shape of the camera and irregular support surfaces, and is especially useful for nature photographers.

Self-Timer

If you have no cable release or soft release, you can eliminate camera jiggle by using the camera's self-timer to release the shutter (if precise timing of the moment of exposure isn't required).

Unipods

Unipods are one-legged tripods. Obviously they won't hold the camera unattended, but they will hold the camera more steadily than when handheld, especially when using a long lens or a slow shutter speed. Unipods are more portable than tripods, and more convenient in many situations. If it is desirable to use the camera in a vertical position with a unipod, either a camera-mounting head like the one used with a tripod can be attached to the unipod, or the unipod can be braced against a wall or other vertical surface.

Attaching a ¼-20-threaded rod to a C-clamp provides another handy camera support that will position the camera almost anywhere for those hard-to-get shots.

Here, a suction clamp has been adapted for camera use by attaching a ¼-20 bolt to hold the camera. Note: Before attaching a suction clamp to the window surface, clean the window, and lightly moisten the rubber base of the clamp, to produce a firm grip.

Miscellaneous Camera Supports

There are all sorts of "oddball" camera supports available to suit specific needs. Here are some of the more useful ones; check your local camera shop for these and others if you have a specific camera-mounting problem.

Do-It-Yourself Supports

If you are unable to find what you need at your local camera shops, and you're handy with your hands, you often can make what you need.

These camera supports were put together by Bill Anneman, president of Perfection Photographic Products, to serve his specific needs. With a little thought, you can make devices to suit your needs. One caution: it's a good idea to employ a safety line that will hold the camera in the event the support device slips. This is true even with commercially made clamping devices.

Straps, Cases and Other Equipment

There are three basic types of camera bags and cases: the eveready camera case that often comes with a new camera, the soft bag, and the hard case.

Eveready cases primarily protect the camera from minor bruises as you carry it around your neck. One section is attached to the camera body, and the other snaps over the lens and top of the camera. When you want to shoot, just un-snap the top portion and let it hang down below the camera.

Soft camera bags provide room to carry the camera and some accessories, such as lenses, filters, meters, and film. They provide some protection against minor bumps and bruises, but their primary function is that of enabling you to carry the equipment you need in one handy container.

An eveready case provides some protection against damage from minor bumps and from the elements while you carry the camera on a strap around your neck.

Nikon offers eveready cases with extended front flaps to accommodate a camera with a zoom lens attached.

1

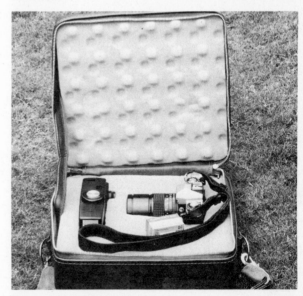

This bag features foam padding with cutouts for equipment. Padding provides some impact protection, and keeps equipment from sliding around in the bag. *Above*

2

Camera manufacturers offer slick-looking bags to hold their equipment. These are from Konica (1) and Minolta (2). Accessory case manufacturers also offer nice carrying bags. *Left*

Hard cases hold the camera and accessories, as bags do, but they also provide maximum impact protection for emergencies (don't *depend* on this protection; always be careful with your equipment).

A bit of advice regarding bags and cases: If you have to carry a lot of gear with you, carry it in two containers rather than overloading one. It's a lot more comfortable to carry two bal-

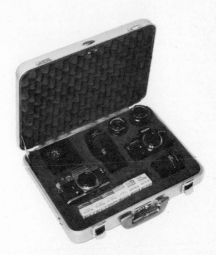

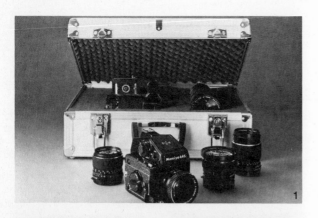

Aluminum cases from Zero Halliburton come in a variety of sizes, in both silver and black finish (silver will keep your equipment cooler if you do a lot of outdoor work). The cases are strong enough to stand on. You can do so if you need to get a shot with your tripod set too high to see through a viewfinder from the ground. These cases are dust and water resistant, and feature tumbler-type three-digit locks.

As is the "case" with bags, hard camera cases are offered by camera manufacturers and independent casemakers. Shown are a heavy-duty aluminum case with cube-cut foam inserts (which you can easily cut to fit the equipment you want to carry in the case) from Mamiya for the Mamiya M645 medium-format camera and accessories (1); and a hard case from TSE, made of G.E. Lexan (the material used to make football helmets) (2).

A Windago Shutterpack Case is a backpack for cameras, ideal for the outdoors photographer and any photographer who prefers free hands while carrying gear. The case is made of nylon and is completely water-resistant, and includes compartments for camera, lenses, filters, exposed and unexposed film and personal gear. A tripod can be strapped on using black diamond-shaped strap brackets at the base.

There's even a case for film, and this one is of particular value to the traveling photographer, because it is lead-laminated and thus protects your film from airport X-ray machines. Space Saver Filmpacks, like the FilmShield bag from Sima, protect film from moisture and dust and take up only one-third the space of regularly packaged film. They save you the problem of wondering what to do with the film box when you open that new roll in a far-away place.

Zone VI meter holsters can be attached to your belt for easy access. They're available from Zone VI Studios, Newfane, Vermont 05345.

The Sports Pouch from Sima Products is inflatable, waterproof, floatable, and shock-resistant, and is handy for the outdoors photographer.

anced loads, one on each side, than it is to try to cart one heavy load on one side.

In choosing the right container for your gear, your main considerations should be quality of workmanship and materials, so you don't have a structural failure; capacity—it should carry what you generally need on a shoot; and convenience—can you get at everything easily, or do you have to sort through everything to find an urgently needed item that's on the bottom? Aside from these considerations, the style of the container is up to your taste; all sorts of styles are available.

A thickly padded Nikon blimp case greatly reduces camera noise, insulates against rain and cold, and is large enough to hold a motor-driven Nikon. A tight elastic sleeve that fits over your right hand provides access to all camera controls, and the window on top of the blimp permits viewing the shutter-speed setting.

A camera isn't the only photographic equipment that has cases. Lens and accessory manufacturers offer both hard cases and soft bags for individual lenses. These provide some protection when individual lenses are carried, as well as added protection when cased lenses are carried in an equipment bag or a hard case.

What to Look for in a Camera Bag

The features a bag offers, and how you pack the bag, can have a lot to do with how satisfactorily the bag does its job for you. The accompanying photos and captions will show you several

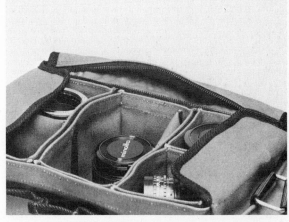

There are many attractive camera bags on the market.

It's important that your bag hold what you want to carry. This Omni bag holds a 35mm SLR camera body, four lenses (24mm, 50mm, 100mm macro, and 200mm), and a spot meter in the main section. The two end pockets hold more than 20 rolls of film. The pouch on the front carries filters and can also hold a spot meter, leaving room for another lens or camera body in the main section.

The main section of the bag has removable compartments, providing from one to six sections. The cover flap has a pocket that carries instruction manuals for whatever equipment is carried in bag.

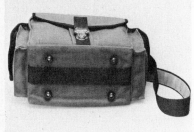

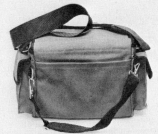

A neck strap is attached directly to the bottom strap, so that it can't tear free from bag material. Anyone who has dropped a bag full of equipment when the strap tore out from the bag material will appreciate this feature in a bag. *Left*

Another handy feature is a body strap, primarily used to keep the bag from swinging too freely while being carried. *Center*
The pockets on the ends of the bag will each hold 10-12 rolls of film in their plastic containers. *Right*

153

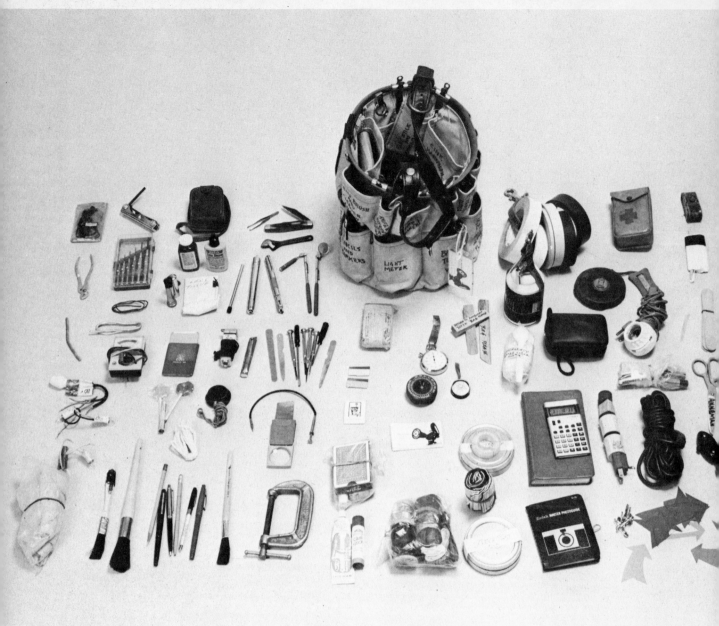

A ditty bag provides a handy way of carrying all sorts of things. The wide opening and many pockets make it easy to get at whatever is needed. The plastic arrows at the bottom right are used to indicate points of interest in shots of machinery and the like; they are cut out of thin colored plastic sheets, so contrasting colors can be used to show up well in the photo.

useful camera bag features and give you some ideas about how to use the space.

The Ditty Bag

The ditty bag is a movie-industry invention (actually, the name comes from sailors of long ago). It's just an open-mouthed bag that holds all those things you wind up needing on location that don't really seem to belong (or fit) in your camera case. Shown is a homemade ditty bag belonging to movie and still-photographer

Bill Anneman (he used an 800-foot 16mm film can as the bottom and a heavy wire band as the top and connected them with heavy-duty canvas), but ready-made ones are available from motion-picture equipment houses.

The large clip at the top of the straps lets you hang the ditty bag from any handy location. One of the best places is from your tripod, because then the bag is accessible and the tripod is more stable for the weight. *Above left*

An air can, a C-clamp, and a leather strap containing rolls of various types of tape are clipped to the straps. *Above center*

Yellow canvas pockets contrast with the blue bag. Each pocket is labeled so things get put back where they belong and can be found again next time they're needed. Leather straps are riveted to the canvas just below the heavy wire top. *Above right*

A short leather strap that attaches to the camera, and to which the camera strap hook is attached, will prevent damage to the camera finish if the O-ring to which it is attached is small enough so that the leather and not the O-ring rubs against the camera.

Camera Straps

Camera straps serve two functions: They enable you to keep the camera with you (so no one walks off with it) while leaving your hands free to do necessary chores, and they prevent the camera from falling to the ground or into the water should you happen to drop it while you are shooting.

The safest way to carry a camera using a camera strap is in front of you, with the strap around your neck. If you carry the camera strapped over one shoulder, it could slip off, even if the strap has a non-slip lining. Also, with the camera in front of you, it's ready to use and you're less likely to have it swing into things as you walk. One thing you want to avoid if you value your camera's appearance is metal-to-metal contact, as shown here. The metal strap hook will scratch the camera's finish in short order with this setup.

Because this camera's strap eyelet is higher, the O-ring rubs against the finish, and you can see what has happened as a result.

Most cameras come with a strap, and this standard strap does serve its two basic functions. But it is generally quite thin, and therefore uncomfortable to wear for long periods of time. For this reason, many accessory manufacturers offer camera straps that are more comfortable to use. These straps come in all sorts of styles and materials. You can get straps that look like the hippie-style guitar straps of the '60s, wide

Another solution to the camera-scratching problem is a small leather piece that fits over the camera-strap eyelet and prevents metal-to-metal contact.

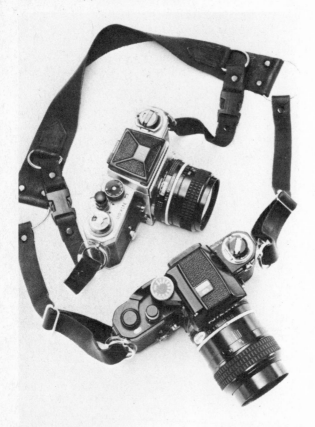

A Hervic Comfortstrap II holds two cameras and features protective plastic around the camera-mounting rings. *Above*

Perfect Poser from New Ideas (7500 Skokie Blvd., Skokie, Illinois 60077) is a lightweight, unbreakable Lucite mirror that attaches around the lens with a wire clip. It allows your subject to see what he/she looks like during a photo session. Most models think it's just great. *Above right and Right*

ones with gaudy designs. You can get custom soft leather straps with quick-release hooks (these are probably the best choice because they are very comfortable and allow you to quickly detach the camera for shots where a strap would get in the way). You can get adjustable or nonadjustable straps (if the nonadjustable one happens to be just the right size, then you won't need an adjustable one, but if you have more than one camera, or expect to continue growing, you might want an adjustable one). You can get straps that hold two cameras—a good idea if you want to shoot both black-and-white and color pictures of a subject—but remember that two cameras will get pretty heavy after a short period of hanging around your neck. And you can get straps that hold extra rolls of film as well as your camera.

Want to take pictures through a telescope? These simple adapters from Edmund Scientific Company (7082 Edscorp Building, Barrington, New Jersey 08007) are all you need to attach a 35mm single-lens reflex camera to a telescope. The adapter has a camera mount at one end and a mount for a telescope at the other end. The telescope adapter attaches to a camera adapter ring and slips into a telescope eyepiece holder. Adapter rings are available for most 35mm SLRs; telescope adapters are available for both American and Japanese telescopes. Camera-to-telescope adapters are also available from Celestron (2835 Columbia St., Box 3578, Torrance, California 90503). Above

An off-axis guider permits direct viewing of the same image being recorded by a camera when photographing through a telescope and permits exact tracking for very long exposures (astronomical exposures often exceed an hour). This is an Edmund Scientific unit; Celestron also offers a unit for its telescopes. Above left

A field data guide from Zone VI Studios (Newfane, Vermont 05345) is a handy way to keep track of exposures in the field, especially for Zone System users. Above right

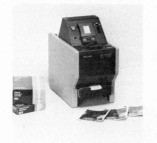

A Polaroid Polaprinter Slide Copier isn't a camera-attaching copier; it's a complete, self-contained copier that produces color or black-and-white Polaroid print copies of slides in just seconds. (If you use Polaroid Type 665 Positive/Negative film, you'll have a black-and-white negative from which blow-ups can be made.) The unit is simple to operate, and produces quite good results. Above left

Voltage converters, like this Franzus model from Kalt, are useful to internationally traveling photographers who encounter all sorts of voltages in foreign countries. A converter can make foreign voltages suitable for a photographer's electronic photo equipment. Above right

Protection and Cleaning Equipment

Major camera or lens cleaning should be left to a qualified repair person. If you have serious problems with your camera or lens, take it to the repair shop and have it cleaned professionally, because you are likely to damage something if you undertake a major cleaning operation yourself.

Routine camera cleaning procedures, however, can be performed by the camera owner. To clean the outside of the camera body, a soft camel's hair brush or a chamois will do nicely. To clean the viewfinder window, gently use a lens tissue or a cotton swab. Using just about anything else could scratch the window, and trying to focus with a scratched viewfinder window is very difficult.

Each time you load the camera (actually, just before you load it) use a blower brush to blow away dust or film chips, and gently dust the metal film-roll compartments with the blower brush or a Staticmaster. Do not touch the shutter curtain, and be very gentle with the pressure plate on the camera back. If this procedure doesn't clean the inside sufficiently, see your camera repair person.

To clean a lens, first gently blow the dust off with a blower brush or air spray can, blowing at an angle to the lens, not directly at it. Don't use the air can for the inside of the camera, because it might be powerful enough to damage the shutter curtain. Once the dust has been removed, apply a small drop of lens cleaning fluid (use only fluid specifically made for this purpose) to a piece of lens tissue (not facial tissue

A soft camel's hair brush is used to brush off the exterior of the camera body.

A blower brush is used to clean the inside of the camera and to remove dust from lens surfaces before using lens cleaner.

Lens cleaner made for photographic lenses is the only liquid that should be used on your lenses. Apply a drop to the lens tissue; apply to the lens with the tissue, starting in the center. Never apply cleaner directly to the lens.

Lens-cleaning kits that specify they are for photographic lenses, such as these from Falcon (1) and Sima (2) contain all you'll need to keep your lenses clean.

or your T-shirt), and gently clean the lens in a circular motion, starting in the center of the glass and moving toward the edges. Never apply lens cleaner directly to the lens, because it could seep down between the edge of the glass and the lens barrel and cause trouble. Be very gentle; it's not difficult to scratch the delicate coatings used on lenses. Scratching the coatings is more likely than scratching the glass, but the result is the same: unsharp pictures.

There are several lens cleaning kits on the market. These contain all the items you'll need; just make sure they specifically state that they are for cleaning photographic lenses.

One more useful piece of care equipment for photographic equipment and film is a desiccant, such as silica gel. Moisture is bad for everything in photography—cameras, lenses, meters, film— and a desiccant will absorb moisture and keep it away from your gear.

Caps

Probably the best thing you can do to protect your lens when you are not using it is to keep the lens cap in place. If you buy the lens with a camera body, the lens will come with a front lens cap; if you buy the lens alone, it should come with both front and rear lens caps and a case as well. Keep it capped and in the case whenever you aren't using it. If you find doing this intolerably inconvenient, at least keep the lens capped and in your camera case/bag when it isn't on the camera, and the front capped whenever it isn't being used.

Staticmaster is a good all-around photographic brush for dusting the camera, lenses and negatives. It contains an anti-static device that helps keep dust from clinging to the object being cleaned.

A lens should be cleaned only with lens tissue, not with T-shirts, facial tissue, paper towels or any other substitute.

Dri-Can from Multiform Dessicant Products is a reusable dessicant that absorbs moisture and keeps it away from your equipment. When the Dri-Can unit becomes saturated, put it in the oven to restore it.

A can of air spray is handy for blowing dust off camera, and other equipment.

1. If a lens is stored off the camera, be sure to keep both ends capped.

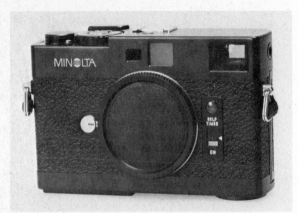

3. The camera body's inside mechanism should never be left exposed; always cap the body if no lens is attached.

If you tend to lose lens caps, there are various devices on the market that attach the lens cap to the lens, so that it hangs from the lens while you're shooting. That might look a bit strange, but at least you'll know where you left the lens cap when it comes time to cap the lens again.

Camera bodies have caps, too, although you probably didn't receive one if you bought a lens with your camera. If you ever keep the camera stored in your bag without a lens attached, be sure to have the camera body cap attached. Otherwise dirt will enter the camera body and cause all kinds of problems.

If you use an incident-light meter, sooner or later you'll squash the translucent hemisphere. To prevent this, these meters generally come with a protective cap that covers the hemisphere. Use it. An extra advantage of a cap is that it protects the meter cell should you accidentally expose the meter to sunlight while it is set for low-range sensitivity.

2. If you tend to lose lens caps, devices such as this Capguard are just what you need.

4. A cap for an incident-light meter's translucent hemisphere protects both the hemisphere and the metering cell.